PARIS

IN THE AGE OF
IMPRESSIONISM

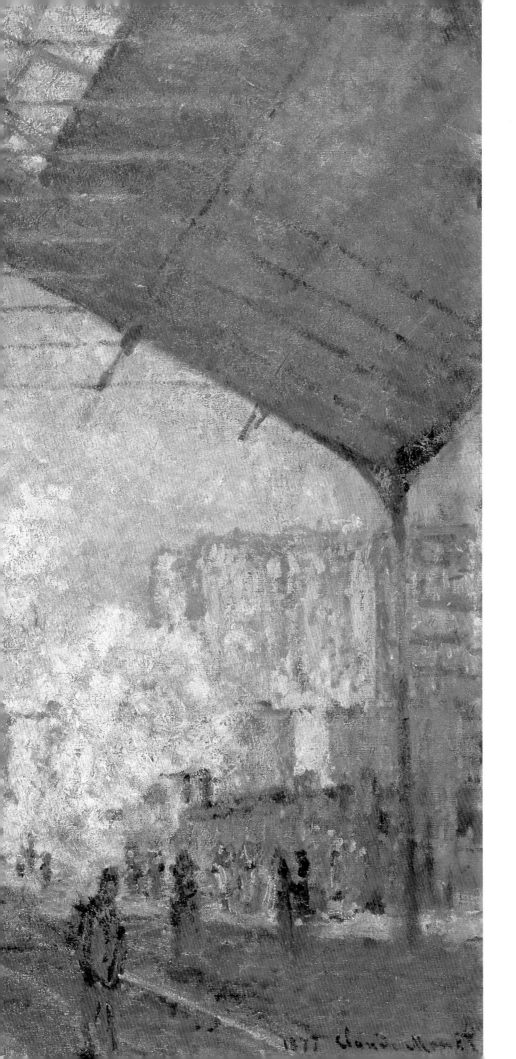

PARIS

IN THE AGE OF
IMPRESSIONISM

MASTERWORKS
FROM THE
MUSÉE D'ORSAY

David A. Brenneman

Mary G. Morton

Caroline Mathieu

Marc Bascou

HIGH MUSEUM OF ART, ATLANTA

in association with

HARRY N. ABRAMS, INC., NEW YORK

The exhibition and its national tour are made possible by

 GE Power Systems

Presenting sponsor of the exhibition in Atlanta is SunTrust

Additional support is provided by the Rich Foundation.

This exhibition is supported by an indemnity from the Federal Council on the Arts and the Humanities.

Paris in the Age of Impressionism: Masterworks from the Musée d'Orsay was organized by the High Museum of Art, Atlanta, in collaboration with the Musée d'Orsay, Paris.

Paris in the Age of Impressionism: Masterworks from the Musée d'Orsay was on view at the High Museum of Art, Atlanta, from November 23, 2002, to March 16, 2003; and at the Museum of Fine Arts, Houston, from April 6 to June 29, 2003.

Library of Congress Cataloging-in-Publication Data

 Paris in the age of Impressionism : masterworks from the Musée d'Orsay / David A. Brenneman ... [et al.].

 p. cm.

 Catalog of an exhibition held at the High Museum of Art, Nov. 23–Mar. 16, 2003 and the Museum of Fine Arts, Houston, Apr. 6–June 29, 2003.

 Includes index.

 ISBN 0-8109-3542-2 (hardcover : alk. paper)

 1. Impressionism (Art)—France—Paris—Exhibitions. 2. Musée d'Orsay—Exhibitions. I. Brenneman, David A. II. High Museum of Art. III. Museum of Fine Arts, Houston.

ND547.5.I4 P37 2002 2002010286

Distributed by Harry N. Abrams, Inc., New York

FOR THE HIGH MUSEUM OF ART

Kelly Morris, Manager of Publications

Nora E. Poling, Associate Editor

Janet S. Rauscher, Assistant Editor

French translated by Meghan Clune Ducey

Page 1: Théophile Féau, *The Eiffel Tower under Construction* (detail), see page 93.

Pages 2–3: Claude Monet, *Gare Saint-Lazare* (detail), see page 36.

Designed by Susan E. Kelly

Proofread by Jennifer Harris

Indexed by Frances Bowles

Color separations by iocolor, Seattle

Produced by Marquand Books, Inc., Seattle

 www.marquand.com

Printed by SDZ, Ghent, Belgium

CONTENTS

ATLANTA PRESENTING SPONSOR'S STATEMENT

SINCE 1891, SUNTRUST HAS BEEN COMMITTED TO WORKING WITH local arts, education, and community service organizations to make Atlanta a better place in which to live and work.

SunTrust is proud to be the Presenting Sponsor of *Paris in the Age of Impressionism: Masterworks from the Musée d'Orsay* here in our hometown of Atlanta.

We're proud to be a part of this rare opportunity, and we salute the High Museum of Art for bringing this exceptional exhibition of nineteenth-century French art to Atlanta.

E. Jenner Wood
Chairman, President and CEO
SunTrust, Atlanta

JOHN RUSSELL

FOREWORD

ONE OF THE BEST THINGS THAT HAPPENED TO PARIS IN THE LAST YEARS of the twentieth century was that a great train station, the Gare d'Orsay, was metamorphosed into a great museum, the Musée d'Orsay. In the matter of the Musée d'Orsay, I go way back. When still in short pants, with World War II not yet in sight, I haunted the great hall of the Gare d'Orsay. While monitoring the coming and going of the trains, I looked up in awe at the metallic bone-structure of that stupendous interior. A hundred and forty meters long and forty meters high, it was lofted high in the air in ways perfected in the 1890s. The metallic structure was said to weigh about twelve thousand tons, as against the 7,300 tons that the Eiffel Tower had weighed before it was equipped and ready to go into service.

The Gare d'Orsay was completed in 1900 as the result of an adventure in which the end of the nineteenth century and the beginning of the twentieth century had been joined. That it would one day be no more than a penciled question mark on the map of central Paris was unimaginable to me. How could the Parisians desert their historic station and the trains that patrolled so much of central France and the Hotel Terminus, which had four hundred stylish rooms and a restaurant that was stylish but not intimidating? But after World War II the train service petered out, the hotel restaurant gradually folded, and the station became a ghost of itself. Orson Welles made a film there, and Madeleine Renaud and Jean-Louis Barrault, the foremost French players of the day, tried out the space. But fundamentally this was a huge and largely derelict structure on prime land that nobody knew what to do with.

And then, in the last twenty years of the twentieth century, a solution presented itself that was not only ideal in itself but had the support of an almost fanatical public demand. To put it simply: great cities the world over were being judged by the vitality of their museums. This was true of the United States, nationwide. It was true of London, Berlin, Vienna, Madrid, Amsterdam, Basel, Stockholm, and Copenhagen. A city that did not have one or more much-talked-of museums was disgracing itself.

Paris did not give this matter first priority until the late 1970s, when the Pompidou Center endowed Paris with its first full-scale, multifunctional Museum of Modern Art. But there remained the triumphal progress of French nineteenth-century painting—Ingres and Delacroix to Courbet, Daumier, Cézanne, Degas, Manet, Monet, Renoir, and Pissarro, with Bonnard to show that the succession was in good hands. There was no one museum in Paris in which these painters could be seen together and in depth. And where could suit them better than a reinvented Gare d'Orsay, just across the river from the Louvre?

This view prevailed. The Musée d'Orsay got the go-ahead in 1978 and opened in 1986. This was the period of what in Paris was called the Great Undertakings ("Les Grands Travaux"). The most majestic of these

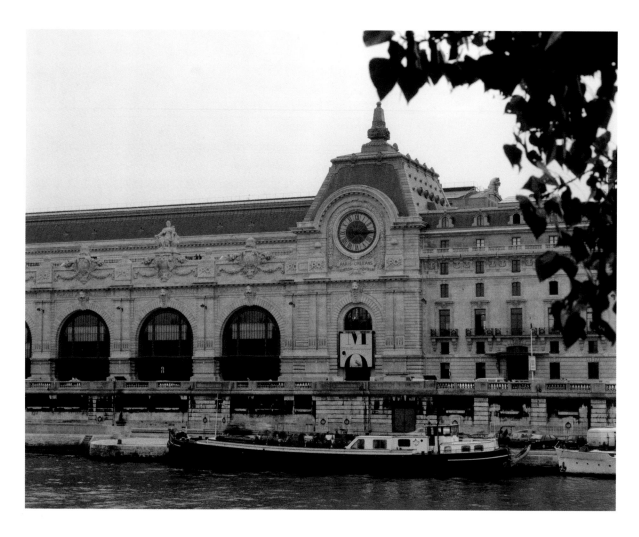

undertakings was the remodeling of the Louvre. This had the sustained and heartfelt approval of the head of state, François Mitterand, who had announced at his first press conference in September 1981 that France's Finance Minister could no longer occupy his majestic offices in the Louvre. For this and other reasons the "Grand Louvre" was for years the subject of violent controversy in France.

This notwithstanding, the Grands Travaux went ahead. The Grand Louvre was completed. The Bibliothèque Nationale, a beloved but inadequate facility, was rebuilt on a grand scale on the left bank of the Seine. Elsewhere music, musicians, and audiences were given the freedom of a cluster of buildings to be known as "La Cité de la Musique." Meanwhile, the Musée d'Orsay did not arouse the political and personal hatreds that the Grand Louvre had to overcome. It was to everyone's advantage that a majestic setting should be found for the work of a period—roughly from 1848 to 1905—in which French art was generally regarded as better than any other. It was this French

art, above all, that most foreign visitors wanted to see, and they wanted to see it in Paris.

It is to the credit of the national museums of France that they did not devise a victory dance in this context. On the contrary, Françoise Cachin, the first director of the Musée d'Orsay, and Michel Laclotte, at that time the director of the Louvre, urged the curators of the Musée d'Orsay to give time and place to substantial artists from other countries who had never had a fair shake from French officialdom. The Musée d'Orsay was to be one of the great museums, but it was not to be xenophobic. This is why Winslow Homer, Thomas Eakins, and William Merritt Chase represent the United States in the Musée d'Orsay, along with Leonid Pasternak, the father of Boris Pasternak, with a portrait of Tolstoy, and Roger Fry, the ranking English critic of his day, with a painting of the Matisse room in a historic exhibition in London in 1912.

The present exhibition of more than a hundred objects from the Musée d'Orsay is an original and a highly evocative affair.

But it is not simply a show of marvelous paintings, though the contributions of Cézanne, Manet, Monet, Gauguin, van Gogh, Bonnard, Vallotton, Derain, and others cannot be faulted in that regard. What we have is a self-portrait of Paris and the Parisians in the second half of the nineteenth century. Conceived in terms not only of painting and sculpture but also of photography, the decorative arts, and memorabilia, it is a panoramic walk-through that in every instance has something to tell us about how people lived and looked in Paris during one of the great periods of European civilization. We see how they dressed up. And we also see how they dressed down. We see how they enjoyed them-selves. But we also see what it was like to be homeless and at the mercy of the police. The exhibition draws upon the multifarious resources of a great museum, but it is not a greedy, mainline, masterpieces-only affair. Gauguin and van Gogh have one paint-ing apiece, but among the decorative arts there are six examples of Lalique and six from the Gallé studio.

The Musée d'Orsay stands for an opportunity that might never have recurred. The vaulted roof space of the great hall was kept intact, and the central walkway below still follows the alignment of the old railway lines. The adventure is one in which the end of the nineteenth and the beginning of the twentieth century join hands. It is also one in which both look their best.

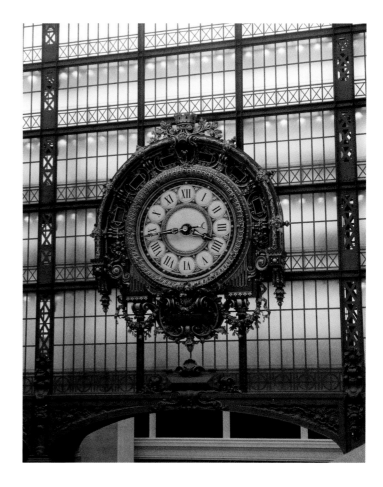

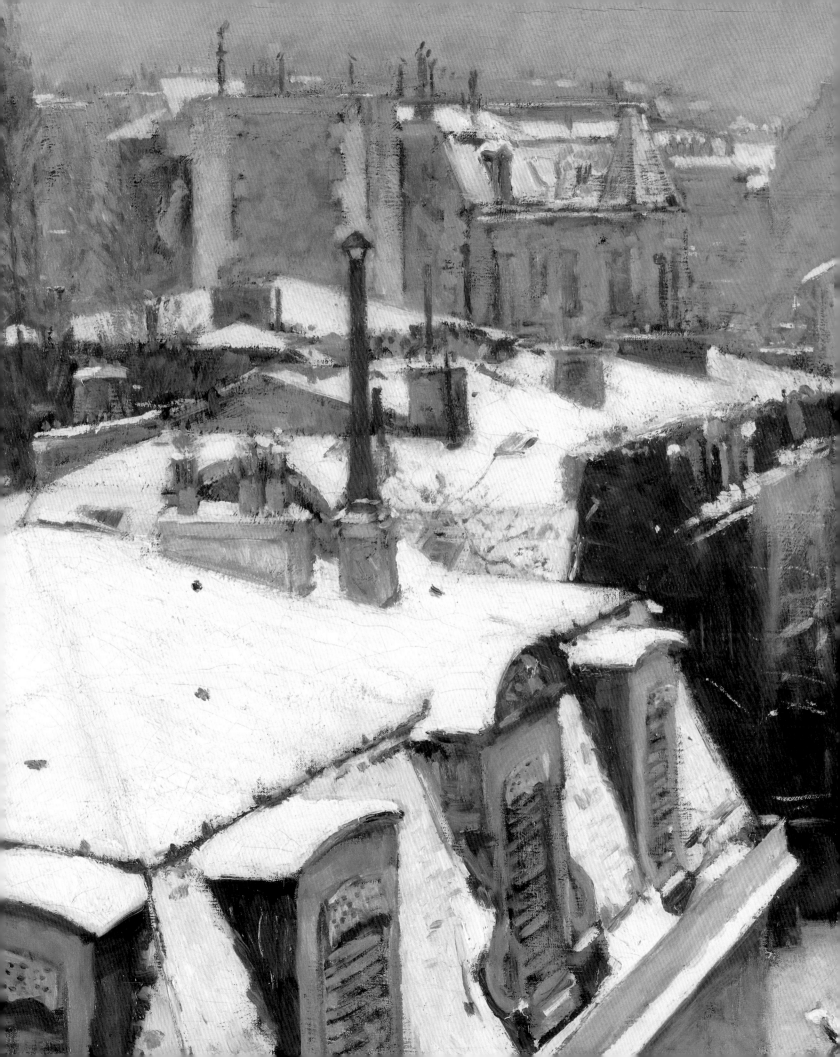

MARY G. MORTON

INTRODUCTION

ORIGINALLY DESIGNED AS A TRAIN STATION AND HOTEL, THE BUILDING
that houses the Musée d'Orsay is grandly scaled, capitalizing on developments in modern engineering and architecture circa 1900. Its impressive steel and glass structure, stucco decoration, and Beaux-Arts facade exemplify the spirit of Paris at the turn of the twentieth century. At that moment, Paris was the technological and cultural capital of the modern world, and the Musée d'Orsay's collections reflect the richness of the era. *Paris in the Age of Impressionism* draws on this extraordinary collection.

When the old Orsay train station reopened in 1986 as one of France's National Museums, it was a major event in the international museum world. The project was enormously ambitious, not just in size and scope, but in mission. In the early 1970s, it had become clear that the Jeu de Paume pavilion in the Tuileries Gardens, which had housed the French State's holdings of Impressionist and Post-Impressionist paintings, could no longer accommodate its growing collection. A new home had to be found. In transforming the Orsay station into a new museum, French officials took account of shifts in scholarly thinking that considered nineteenth-century art history in interdisciplinary terms and focused less exclusively on a sequence of movements in painting and sculpture. Instead of presenting a "greatest hits" display of Impressionist and Post-Impressionist painting, the organizers set out to tell a broader story of art in the second half of the nineteenth century, with an emphasis on social and artistic context. Museum visitors would see both officially sanctioned and avant-garde artistic production in various media, including posters, prints, photography, architectural materials, and decorative arts.

This display of the "new nineteenth century" (as it became known) was to be housed in a symbolically appropriate building—the old Gare d'Orsay, inaugurated as a railroad station and hotel in 1900 in the midst of the last and greatest World's Fair of the era (fig. 1). Designed by Victor Laloux, the Gare d'Orsay resembled the other major building of the Exposition Universelle of 1900, the Palace of Fine Arts, known today as the Grand Palais and used as a primary temporary exhibition space for European art in Paris. The painter Édouard Detaille presciently commented on the Gare d'Orsay in 1900: "The train station is magnificent and looks like a palace of fine arts, and since the Palace of Fine Arts looks like a train station, I suggested to Laloux that he switch them if there was still time."[1]

The expansion of the French railroad system in the second half of the nineteenth century was among the definitive forces of the period. By the end of the century, every province in France was accessible by rail from the center of Paris—all rails led to the French capital. New stations sprang up to serve the rapidly expanding suburbs, places immortalized by the Impressionists—Argenteuil, Bougival, Le Grenouillière, Asnières, and

Gustave Caillebotte, *Rooftops in the Snow*
(detail), see page 31

Chatou. The steam engine came to symbolize the dynamism of modernity: speed, combustion power, and the acceleration of transportation and communication (fig. 2). With few exceptions, every artist and designer whose work is represented in the Musée d'Orsay collections was affected by the advent of the modern rail system. Claude Monet's spectacular series on the Gare Saint-Lazare (see page 36)—in which iron tracks, the steel and glass of the station's architecture, and Haussmannian apartment buildings are dissolved by engine steam into fantastic visions of splendid color—is a response of visual ecstasy to this force of modernity.[2]

Paris in the Age of Impressionism conveys the excitement of Paris in the last third of the nineteenth century and points to the central role the city played in the cultural production of those decades. The physical city, its grand boulevards and squares, cafés and theaters, gardens and monuments—with the river Seine threading through the center—its cosmopolitanism and its electric spirit inspired an extraordinary level of innovation in

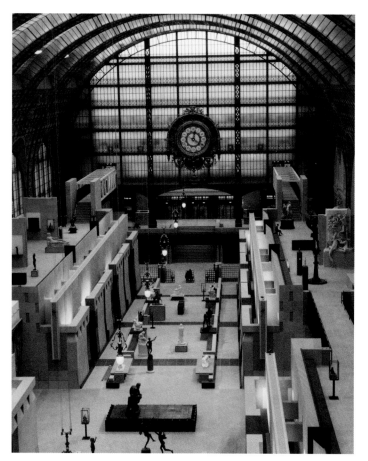

Fig. 1. The Great Hall reborn as a gallery for art.

all of the arts. In the field of painting in particular, traditions and conventions two centuries strong were sidestepped in favor of radical new forms of representation. The paintings of that now most beloved of art movements, Impressionism, would have been unthinkable without Paris.

The age of Impressionism was a dynamic moment in the city's history. During the 1850s and 1860s, the city had undergone a massive renovation, masterminded by Napoleon III's urban planner, Baron Georges-Eugène Haussmann. Many of the characteristics that come to mind when we think of Paris were installed during those two disorienting decades: the *grands boulevards* connecting major points in the city, the equally grand public spaces, the Opéra (which though initiated in 1863 was not completed until 1875), and the uniform four-story apartment blocks. Old neighborhoods were demolished or carved up in the process, and hundreds of (mostly poor) people and their businesses were evicted. The city as a network of small *quartiers* was no more. In its place was a cleaner, more coherent, more efficient capital city. The urban renewal project was a boon to the city's economy, creating a class of *nouveaux riches* entrepreneurs who increasingly dominated society.

Paris celebrated its modern face and newfound wealth in the Expositions Universelles, or World's Fairs, hosted each decade between 1855 and 1900. World's Fairs celebrated the achievements of industry, commerce, and the arts in displays of products and commodities. The 1867 Exposition Universelle, the first following the completion of Haussmann's project, was explicit in showcasing the "new Paris." Jacques Offenbach wrote *La Vie Parisienne* for the crowds attending the fair, and the *Paris Guide* of 1867 included entries by such literary luminaries as Victor Hugo, Georges Sand, Maxime Du Camp, and Jules Michelet. Walter Benjamin wrote that in the 1867 Exposition Universelle the "phantasmagoria of capitalist culture reaches its most brilliant display," reaffirming Paris as the capital of luxury and fashion.[3]

Charles Baudelaire, the poet and influential art critic of the period, called for artists to picture life in this new and exciting, if less humane, capital. In his poetry and essays, he encouraged the delectation of Paris as a visual spectacle and heralded the degree to which life in Paris *was* spectacular. Many of the Impressionists found life on the new boulevards and in the cafés and theatres appealing as artistic subjects. Certainly, one of the qualities that binds Impressionism as a movement is the artists' commitment to

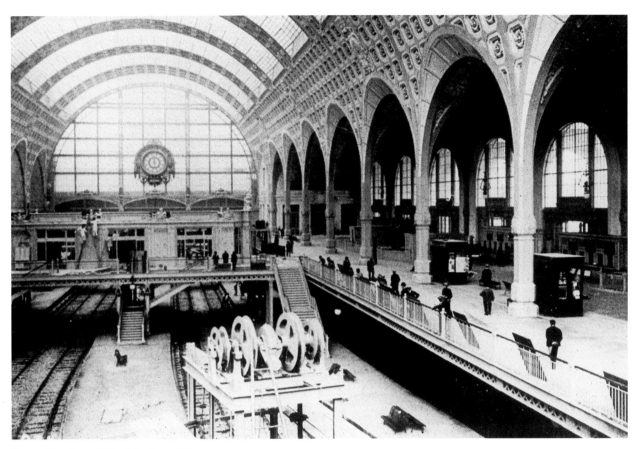

Fig. 2. The Great Hall of the Gare d'Orsay.

contemporary subject matter, a radical move within the context of conventional Salon painting, which favored more historical subjects.[4] The innovation of Impressionism goes well beyond a change in subject matter, however. The paintings shown by Edgar Degas, Claude Monet, Berthe Morisot, Camille Pissarro, and Pierre-Auguste Renoir at the first Impressionist exhibition in 1874 were much more shocking in their mode of representation than in what they represented—they looked like nothing anyone had seen before.

The revolution enacted by the Impressionists relied on the kinds of educational, financial, and communal opportunities only Paris had to offer. Though most of the Impressionists did not attend the École des Beaux-Arts, they availed themselves of the instruction offered in teaching studios attached to the École or attended private establishments like the Académie Julian. They copied paintings in the Louvre, the greatest public museum in the world, and used the Louvre as a gathering site. They developed their ideas together at daily meetings in cafés around the city. Though artists such as Degas, Monet, and

Renoir were fiercely independent spirits, there is no doubt that they fed off one another and inspired other artists in their wake (fig. 3).

The annual Salon exhibitions were not only popular, drawing hundreds of thousands of Parisians and tourists during two-month runs at the Palais de l'Industrie, but crucial touchstones for contemporary artists. The Salons defined successful painting, and legions of artists organized their careers around the mammoth displays. Salon painting was the stylistic establishment against which painters defined themselves. And the oppositional spirit in which the independent Impressionist exhibitions were staged surely energized the movement.

The eight Impressionist exhibitions between 1874 and 1886—and the independent exhibition groups they spawned, such as the Société des Artistes Indépendants, the Société Nationale des Beaux-Arts, and Les XX in Brussels—signaled a profound shift in the art market. Before Impressionism, artists had few alternatives to the official Salon to exhibit their work and gain access to patrons and collectors. For centuries the French art trade had

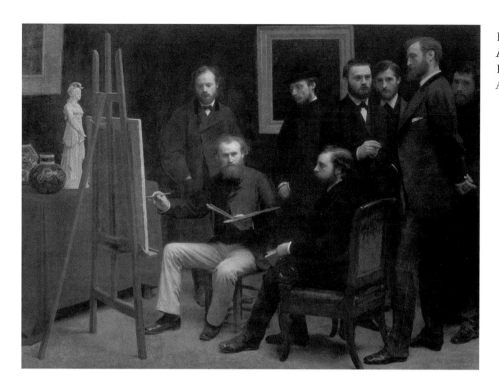

Fig. 3. Henri Fantin-Latour, *Studio in the Batignolles,* 1870, oil on canvas, Musée d'Orsay, Paris. Pictured are Scholderer, Manet, Renoir, Astruc, Zola, Maître, Bazille, and Monet.

relied on the patronage of the state and wealthy aristocrats. Then, during the Second Empire and Third Republic, a large new class of collectors developed out of the burgeoning *haute bourgeoisie.* The system of private commercial galleries that sprang up to meet this new demand made the Impressionists viable as professional artists. The business of dealers like Louis Martinet, Adolphe Goupil, and Paul Durand-Ruel (and later, Georges Petit and Alexandre Rosenberg) marked the beginning of art as an area of investment and speculation.

All of these historic forces—Haussmann's urban renewal, the increasing wealth and power of the upper middle class, Parisian café culture, the development of private collectors and dealers—played a hand in one of the most extraordinary periods in the history of painting. Impressionism has become so familiar to museum goers that it is difficult to comprehend the intensity of freshness and radicalism of the work of Monet, Degas, and Renoir in the 1870s and 1880s. These artists confidently challenged what was by many critical accounts a moribund tradition of French painting. They succeeded in redirecting ambitious painting away from the dictates of the French Academy and its annual Salon toward "the painting of modern life."

One of the most edifying features of the Musée d'Orsay is the opportunity to see in the same series of galleries the work of traditional artists such as Alexandre Cabanel, Jean-Leon Gérôme, and William Adolphe Bouguereau alongside the contemporaneous work of the avant-garde. We can enjoy and appreciate the high level of skill and craftsmanship employed by the academic artists as well as their appealing (if at times sentimental and titillating) subjects. And we can marvel anew at the originality of the Impressionists, who constructed their style in counterpoint to these academics. The function of the Musée d'Orsay, and the challenge to its visitors, is to divine in works by both academic and avant-garde artists a sense of what it was like to live in Paris during the advent of "modernity."

Much has been written about the historical phenomenon of "modernity," the art historical moment of "modernism," and the relationship between the two. Beyond the historical facts of modernity—the rapidly evolving states of industry, technology, and economy—many writers try to account for a broad psychological and spiritual shift in the nineteenth century. Modernity has been described as a "post-traditional order," in which the sureties of custom and habit have been undercut by the dynamism of modern institutions.[5] Modernity has also been associated with the concept of contingency, defined as the turning away from the past and past authorities toward the future—the acceptance of risk, the omnipresence of change, and the malleability of time and space.[6] Accounts of modernism often

refer to an increased self-consciousness on the part of artists, a heightened individualism that could be alternately alienating and liberating.

That Paris was the central location of this phenomenon in the Western world at the end of the nineteenth century is one element of the story of modernism on which most writers agree. For the works in this exhibition, Paris either plays a starring role or is looming just offstage. Degas's *Orchestra of the Opéra* (page 46) and his *Absinthe* (page 76) depict specifically Parisian forms of "high" and "low" entertainment, respectively. Maximilien Luce's *Quai Saint-Michel and Notre-Dame* (page 40) is a classic view of the city, while Monet's *Men Unloading Coal* (page 73) shows industrial Paris spreading out to the suburbs. And van Gogh's *The Italian Woman* (page 143) is a portrait of a person living far from Paris, but it carries the effect of the city both in its aesthetic lineage (van Gogh's avant-garde style was forged in Paris) and in the artist's conception of this woman as the anti-Parisienne. Particularly at the end of the century, Paris served some artists as an inspirational opposite, helping them to define themselves and their art *against* the capital of modernity. Given their historical and locational specificity, it is remarkable that the group of works in this exhibition—through their original and sometimes outrageous use of color and manipulation of space and composition—continue to engage and excite viewers even today.

NOTES

1. Quoted in Françoise Cachin and Xavier Carrère, *Treasures of the Musée d'Orsay* (New York: Artabras, 1995), p. 7.

2. One of the extraordinary pleasures of the recent exhibition organized by Juliet Wilson-Bareau on paintings of the Gare Saint-Lazare was the opportunity to see so many of Monet's Gare Saint-Lazare series together. See Juliet Wilson-Bareau, *Manet, Monet and the Gare Saint-Lazare* (Washington: National Gallery of Art; New Haven: Yale University Press, 1998).

3. Walter Benjamin, "Paris, Capital of the Nineteenth Century," in *Reflections: Essays, Aphorisms, and Autobiographical Writings*, trans. Edmund Jephcott (New York: Harcourt Brace Jovanovich, 1978), p. 153.

4. The Impressionists' turn away from history painting was a continuation of Gustave Courbet's Realism of the 1850s and 1860s. The Impressionists, however, tended to focus on the life of the middle class, whereas Courbet most notoriously presented images of the working class.

5. Anthony Giddens, "Modernity and Self-Identity: Self and Society in the Late Modern Age," in *Art in Modern Culture: An Anthology of Critical Texts*, ed. Francis Frascina and Jonathan Harris (London: Phaidon Press in association with the Open University, 1992), pp. 17–22.

6. T. J. Clark, *Farewell to an Idea: Episodes from a History of Modernism* (New Haven: Yale University Press, 1999), p. 10.

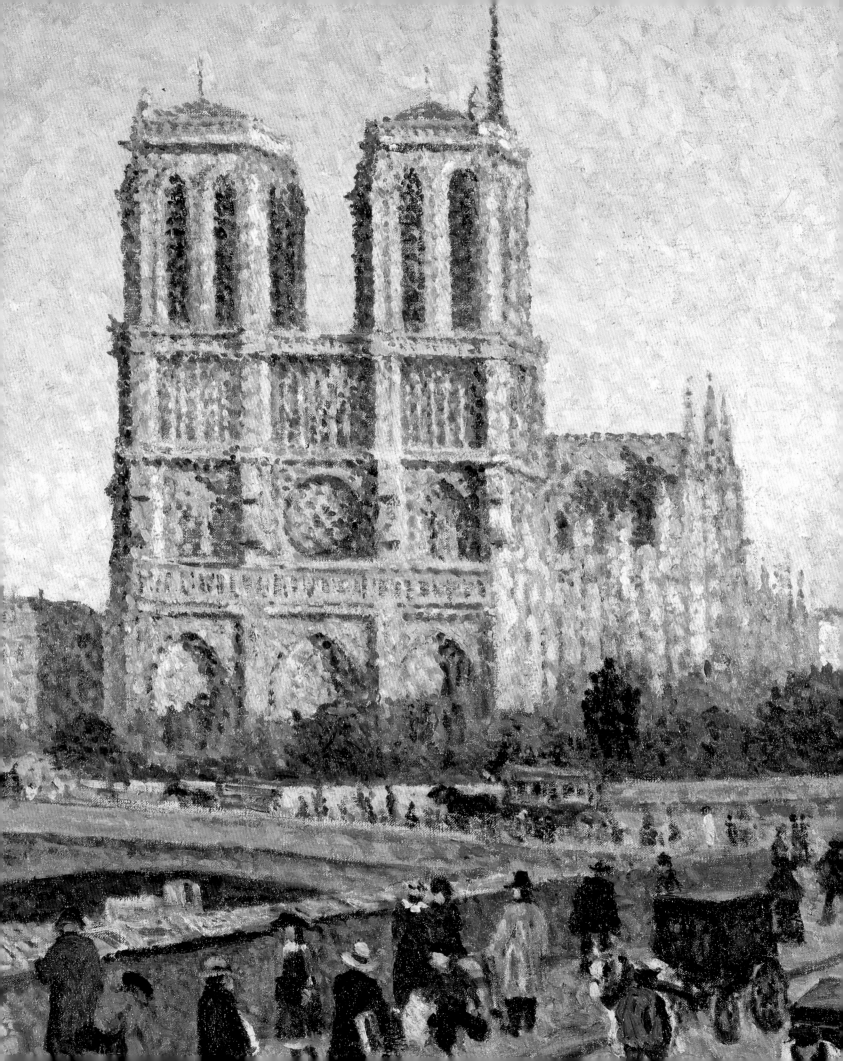

CAROLINE MATHIEU

PARIS, THE MODERN CITY

Paris! Principe et fin!
Paris! Ombre et flambeau!

(Paris! First and last!
Paris! Shadow and flame!)

ALFRED DE VIGNY

Maximilien Luce, *Quai Saint-Michel and Notre-Dame* (detail), see page 40

Paris Demolished (ÉDOUARD FOURNIER, 1855), *Paris Past and Paris to Come* (Alfred Delvau, 1859), *Paris in its Splendor* (M. Audiganne and P. Bailly, 1861–1863), *The New and Future Paris* (Victor Fournel, 1865),[1] the city transformed by Napoleon III and Baron Haussmann inspired these book titles and was central to Emile Zola's novels, in which the characters are fascinated by this Paris, "slashed by saber strikes, open-veined, providing for one hundred thousand unskilled laborers and masons."[2] Paris the melancholy, Paris the modern capital par excellence, Paris "the American Babylon of the future," as the Goncourt brothers called it, but also Paris the lively, with cleared and light-filled spaces that so many would paint. The modern city offered artists new motifs, leading them to a fresh view of urban life, depicted by some in new ways that seemed to embody modernity.

"No one heeds the wind that will blow tomorrow, yet the heroism of modern life surrounds and presses upon us,"[3] wrote Charles Baudelaire. Feverish and anxious, he urged his contemporaries—especially artists—to seek "the epic side of modern life," to prove that their era "is no less fertile in sublime motifs than the ancient ones."[4] His poetry, notebooks, and reviews of the Salons are filled with this desire for the new, with this quest for modern beauty. For him, this beauty was intimately bound to "the black majesty of the most disturbing of capitals,"[5] to a Paris he both loved and hated, from which he could not remain separated without suffering.

Paris Transformed

The Paris of 1850 did not differ much from the Paris of 1789: "The city still offered the most incoherent and the most picturesque jumble of dwellings of all ages: houses with pointed gables, turreted houses, dilapidated wooden and brick cottages, noble hotels with pilasters and pediments. Around the palaces, one still found the same maze of sordid and nauseating narrow streets."[6] It was impossible to cross town due to the barriers created by the dense crowding of houses, pierced only by the occasional minuscule alley. Along the Seine, houses and shacks descended all the way down to the riverbank (fig. 1). On the right bank, the Louvre was practically choked by other buildings.

Napoleon III and Haussmann totally remodeled the city, creating the twenty arrondissements of today's Paris, requiring the building of town halls, churches, schools, and central food markets. Haussmann's vision was extensive, imposing order on a monumental Paris arranged around new thoroughfares, squares, boulevards, and avenues. The first principle of this revision was to restructure the city by tracing new routes across the existing urban fabric. Priorities included insuring district intercommunication, easy access to train stations, clearing space around public monuments, providing

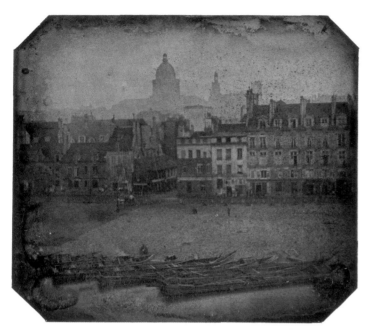

Fig. 1. Paul Hossard, *Paris, Barges of the Seine with the Silhouette of the Panthéon*, 1843, daguerreotype, Musée d'Orsay, Paris.

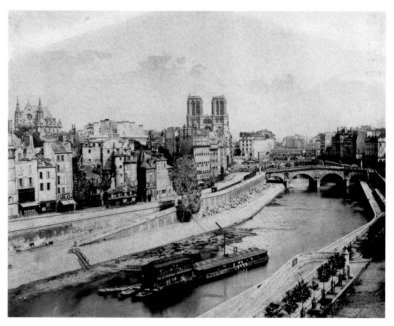

Fig. 2. Louis-Adolphe Humbert de Molard, *Paris, The Embankments of the Seine, view toward Notre-Dame*, 1852, gelatin silver print, Musée d'Orsay, Paris.

for the creation of a large administrative center—the Louvre and the Ile de la Cité (fig. 2)—and, for the Parisians' health and leisure, the creation of public gardens and parks.

As the city grew westward, in 1867–1879, the area surrounding Charles Garnier's new Opéra was being developed. On the left bank, the boulevard Saint-Germain was opened up; on the right, the older boulevards were widened. All were planted with trees, equipped with wide asphalt pedestrian sidewalks, and lined with monumental buildings.

Parisian architecture developed in an extraordinarily consistent way, suggesting that strict discipline was imposed upon the architects, who were allowed to really express themselves only in decoration. Restraint, sobriety, and discretion characterize the building of the period.

Views of the City

Baudelaire wrote: "Parisian life is rich with poetic and amazing subjects. The marvelous envelops us and showers upon us like the atmosphere; but we don't see it."[7] The new life generated by the Haussmannian city could be seen everywhere, all along the open streets and boulevards, where the cafés and brasseries painters would make famous overflowed onto the wide asphalt sidewalks. Compared to Jean Béraud's (see page 84) and

Giuseppe de Nittis's narrative and picturesque scenes, Manet and Degas, Monet, Pissarro and Renoir, Caillebotte and Toulouse-Lautrec together created a radically new image of the city, portraying it as a moving thing swarming with inhabitants, leaving aside monuments and anecdotes, in pursuit of the modern "marvelous" extolled by Baudelaire. This quest can be seen in the photography of the period as well, which captures the vitality and drive of Paris and its people while celebrating its smallest occupations and popular customs (pages 34–35, 85).

Manet, the most Parisian of the painters, hating the countryside, haunted the boulevards and cafés, and was the first to turn toward modern subjects. Monet and Renoir painted a few of the vast spaces cleared and brought into light by Haussmann, such as Saint-Germain l'Auxerrois, the Place du Carrousel, and the Pont des Arts. But it was only much later, in 1873–1875, that they discovered the life and architecture of the boulevards. While Monet felt wonder for the new Paris, Renoir shared the widespread opinion and criticized Haussmannian constructions as "cold and lined up like soldiers on parade."[8] Monet's *Boulevards des Capucines* (fig. 3), like Pissarro's *Boulevards des Italiens*, is an overall view, seen from above, so as to profile the long Haussmannian perspectives inundated with light and air.

Near the end of 1897, Pissarro devoted a group of paintings to the most Haussmannian of landscapes, the Avenue de l'Opéra.

But as early as 1901, seeking softer, more solitary sites, he turned toward the Seine and the Louvre, where sky and water took on new importance (see page 41). For several years, life on the city streets remained one of the Impressionists' favorite themes. Painting it, they could evoke contemporary life and apply their findings on the translation of light using rapid, spontaneous brush strokes, concentrating on atmosphere and movement. Such was the case for *Rue Montorgueil, Festival of June 30, 1878* (page 37), in which Monet expresses the effervescence of the idle crowd, cheerfulness, wind, and the flags' flying by brush stroke and color alone.

Gustave Caillebotte also embraced the Haussmannian aesthetic. Born in 1848, he witnessed the burgeoning of the new city and never really knew the Paris of old. His *Rooftops in the Snow* (page 31) portrays the atmosphere of a winter day with a low gray sky imparting its color to the snow-covered roofs.

For the Impressionists, the power and enchantment of the industrial world were associated with the Gare Saint-Lazare, overlooked by the Pont de l'Europe. Again, Manet was the first to paint this symbol of modernity, in his surprising masterpiece *The Railway* (fig. 4), a subtle evocation of the industrial world. In 1876, Caillebotte studied the Pont de l'Europe (fig. 5), the structure of which, so strong, so new to Parisian eyes, became

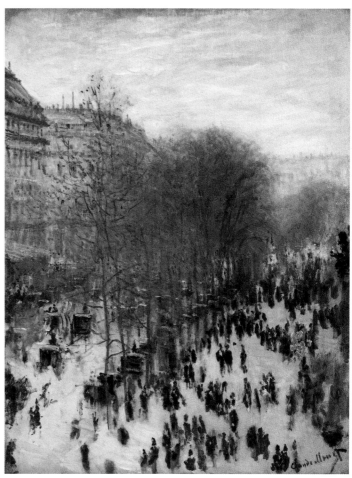

Fig. 3. Claude Monet, *Boulevard des Capucines*, 1873–1874, oil on canvas, The Nelson-Atkins Museum of Art, Kansas City, Missouri, purchase, the Kenneth A. and Helen F. Spencer Foundation Acquisition Fund.

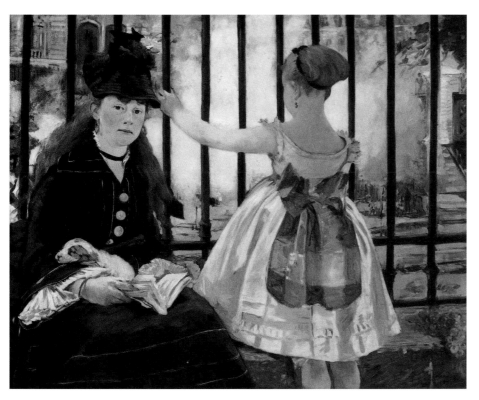

Fig. 4. Édouard Manet, *The Railway*, 1873, oil on canvas, National Gallery of Art, Washington, gift of Horace Havemeyer in memory of his mother, Louisine W. Havemeyer.

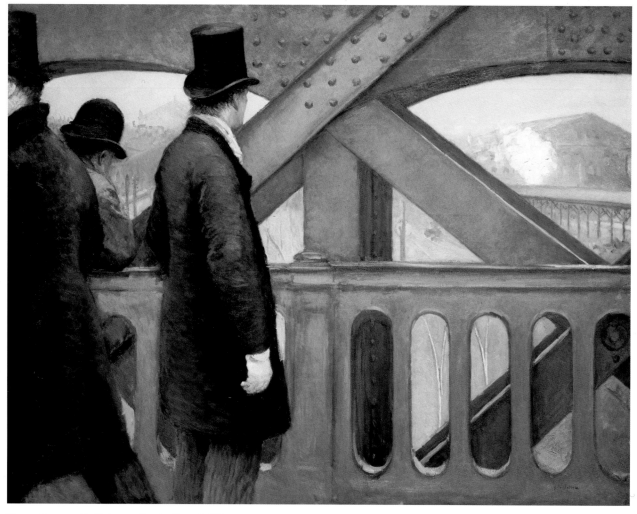

Fig. 5. Gustave Caillebotte, *On the Pont de l'Europe*, 1876–1877, oil on canvas, Kimbell Art Museum, Fort Worth, Texas.

a salient motif, symbolizing in an inventive, radical way the brutal strength of industry triumphant. Monet, on the contrary, in his series of seven paintings devoted to the Gare Saint-Lazare (see page 36), explored the unprecedented beauty of the locomotives, drowning, lost in the swirling coils of white and blue smoke.

At the end of the nineteenth century, cafés and cafés-concert had become the nexus of urban life, resplendent at night in the glow of gas lamps. Degas evoked this atmosphere in a few of his pastels. His very dark vision also comes to mind, as depicted in one of his most famous paintings, *Absinthe* (page 76). Toulouse-Lautrec pursued this quest further, finding beauty in the sordid (see pages 86–87).

The Haussmannian city provided ample inspiration to artists, and again it was Manet who paid the highest tribute to the Baron, this time in the proposal he submitted for the decoration of the Hôtel de Ville de Paris in 1879: "To paint a series of compositions representing, to use a popular expression which conveys my meaning well, 'the belly of Paris,' with the diverse corporate bodies moving in their circles, the public and commercial life of our times. I would have Paris Markets, Paris Railways, Paris Port, Paris Underground, Paris Racetracks and Gardens. For the ceiling, a gallery, around which would circulate, in appropriate poses, all the living men who, in the civic world, have contributed or do contribute still to the grandeur and the wealth of Paris."[9]

NOTES

1. The original titles: *Paris démoli; Paris qui s'en va et Paris qui vient; Paris dans sa splendeur;* and *Paris nouveau et Paris futur.*

2. Emile Zola, *La curée* (1871; reprint, Paris: Gallimard, 1960), book 1, p. 389.

3. Charles Baudelaire, *Curiosités esthétiques, L'art romantique, et autre Oeuvres critiques,* ed. Henri Lemaître (Paris: Éditions Garnier Freres, 1971), p. 85.

4. Charles Baudelaire, *Salon de 1846,* "De l'héroïsme de la vie moderne," *Curiosités esthétiques,* p. 195.

5. Charles Baudelaire, *Salon de 1859, Curiosités esthétiques,* p. 380.

6. Maxine Du Camp, quoted in André Morizet, *Du vieux Paris au Paris moderne* in *Haussmann et ses prédecesseurs* (1932; reprint, Paris: Librairie Hachette, 1937), p. 13.

7. Charles Baudelaire, *Salon de 1846,* p. 198.

8. Renoir to Georges Rivière, editor of *L'Impressionniste,* a short-lived journal published with Renoir's assistance in 1877; quoted by Robert Herbert, *L'impressionnisme, les plaisirs et les jours* (Paris: Flammarion, 1988), p. 15.

9. Françoise Cachin et al., *Manet, 1832–1833* (New York: Metropolitan Museum of Art; Abrams, 1983), p. 398. "The Belly of Paris" is from an Emile Zola novel by the same name.

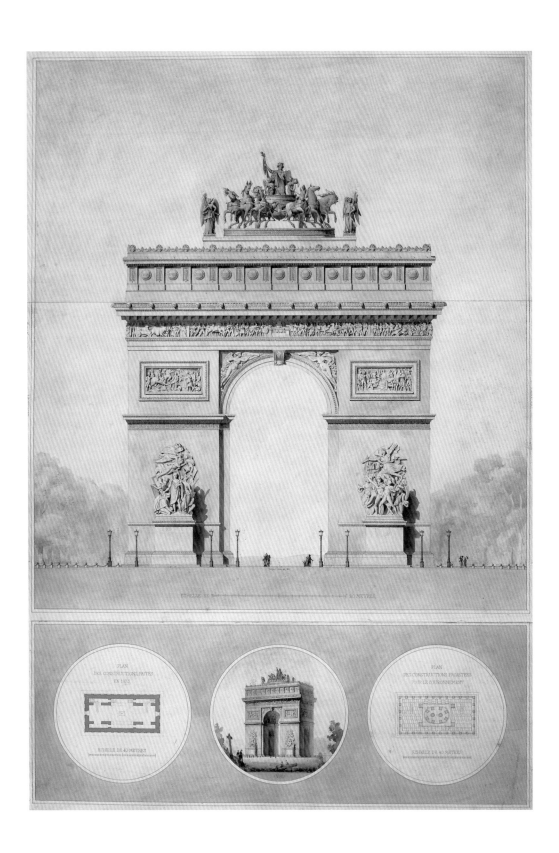

GABRIEL BERNARD SEURRE
Project for the Crowning of the Arc de Triomphe de l'Étoile, 1833
Graphite, black ink, wash-drawing, and watercolor on paper

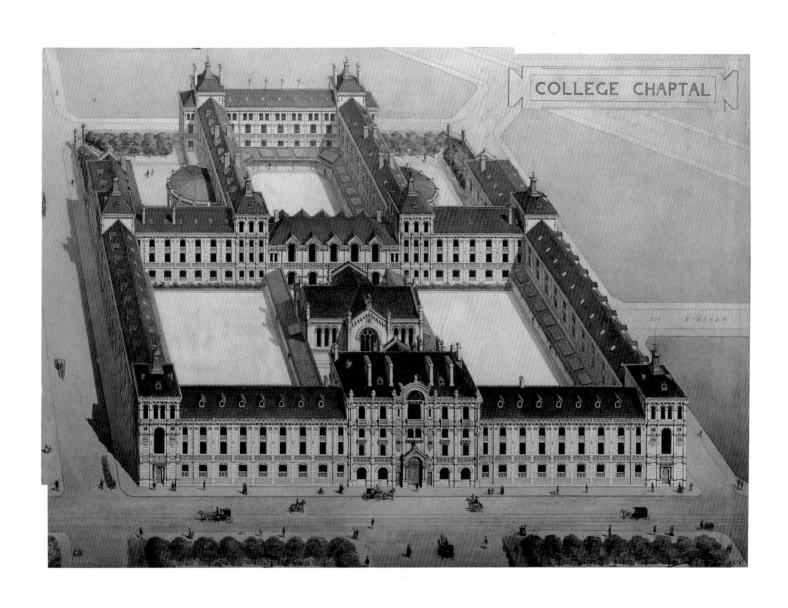

COLLEGE CHAPTAL

EUGÈNE TRAIN
Collège Chaptal in Paris, Bird's-Eye View, 1875
Pen and black ink and watercolor on paper

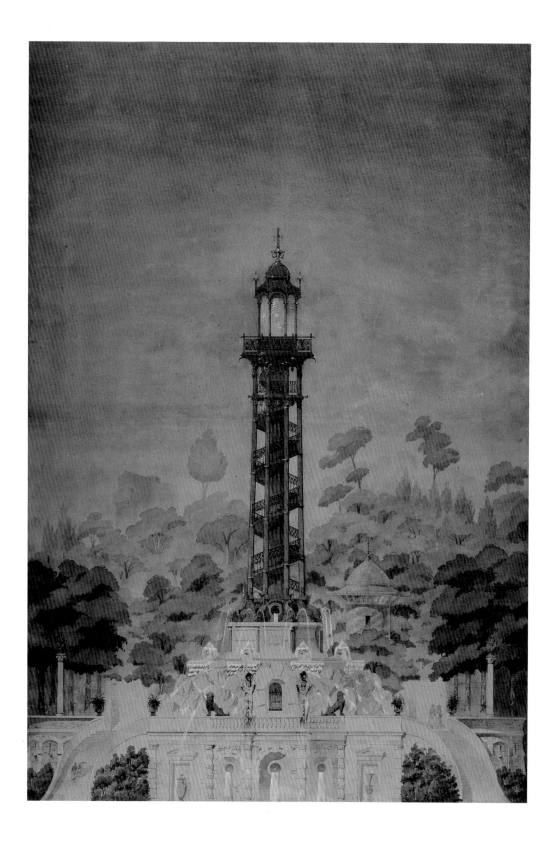

ADOLPHE ALPHAND, JEAN DARCEL, AND
ÉMILE REIBER
Project for a Cast-Iron Tower for the Artesian Wells in Passy, 1857
Watercolor with white gouache touches on paper

ANONYMOUS
Project for the Monument to be Built on the Site of the Palais des
Tuileries, ca. 1880–1885
Pencil, black ink, and watercolor on paper

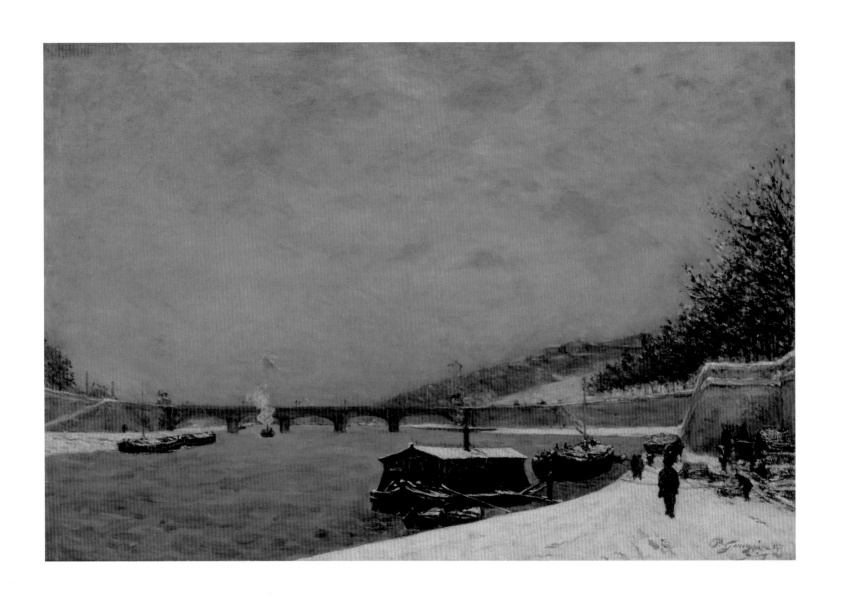

PAUL GAUGUIN
The Seine at the Pont d'Iéna, 1875
Oil on canvas

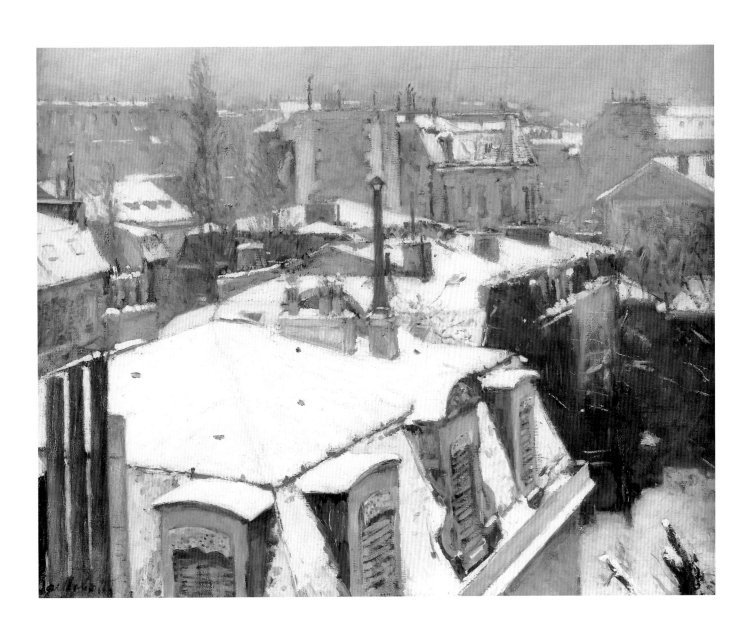

GUSTAVE CAILLEBOTTE
Rooftops in the Snow, 1878
Oil on canvas

ALPHONSE-ALEXANDRE DEFRASSE
Project for the Nouvelle Sorbonne, Elevation on the Rue Saint-Jacques, 1882
Black ink, watercolor, and wash-drawing on paper

HENRI RIVIÈRE
Couple Entering a Public Building, ca. 1889
Gelatin silver print

PAUL GÉNIAUX
Students on the Day of la Mi-Carême, ca. 1900
Aristotype

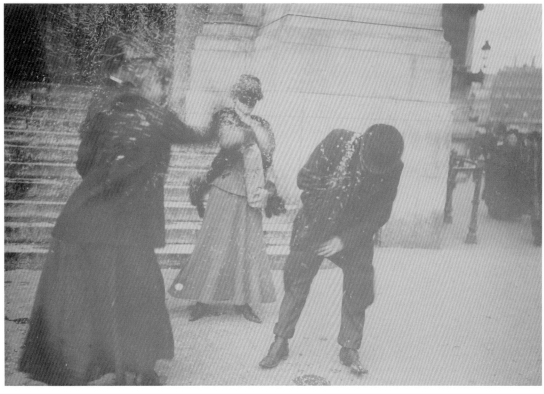

HENRI LEMOINE
Secondhand Booksellers on the Quai Conti,
ca. 1900
Gelatin silver print

HENRI LEMOINE
Les Halles, ca. 1900
Gelatin silver print

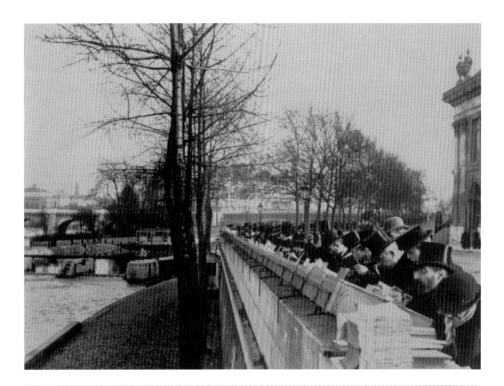

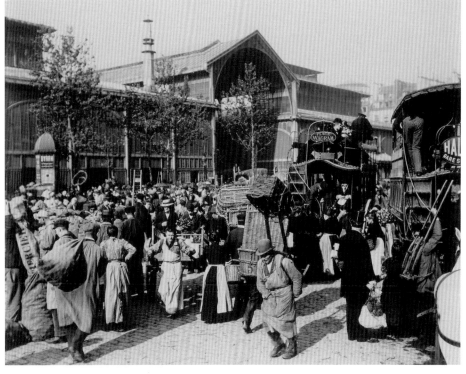

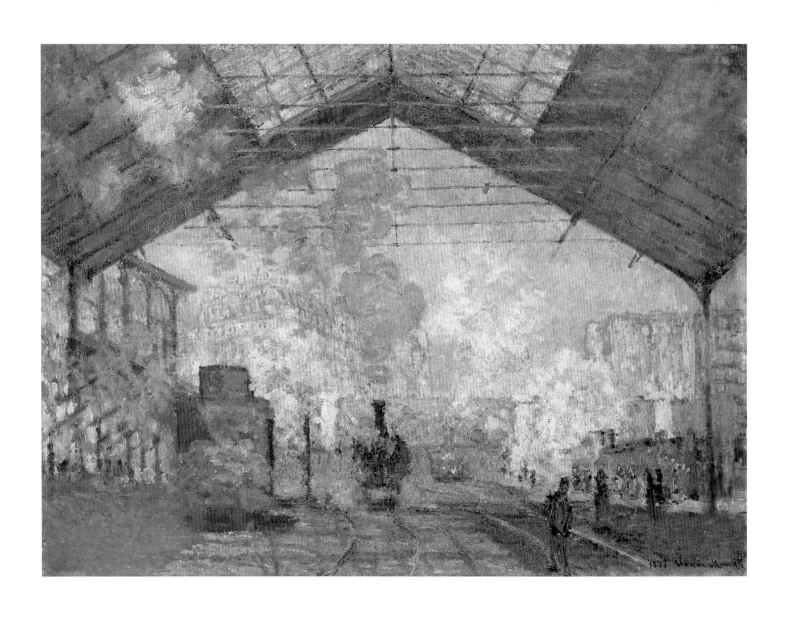

CLAUDE MONET
Gare Saint-La\zare, 1877
Oil on canvas

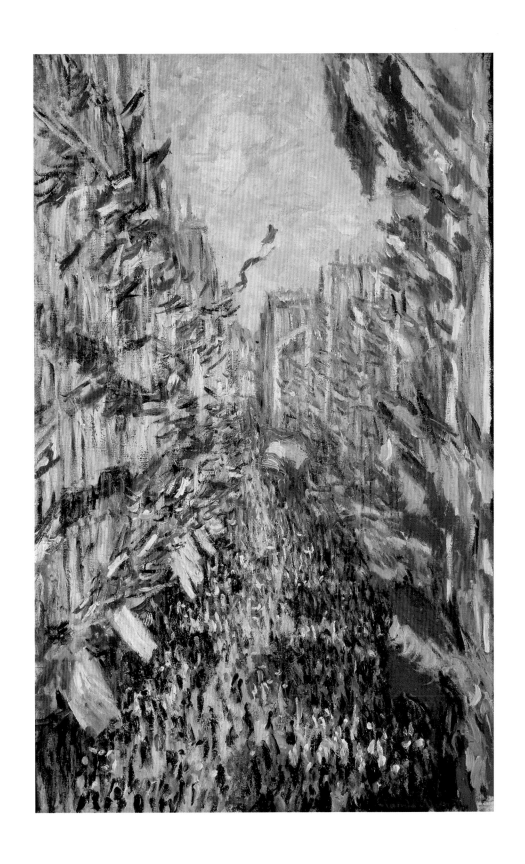

CLAUDE MONET
Rue Montorgueil, Paris, Festival of June 30, 1878, 1878
Oil on canvas

VICTOR BALTARD
The Saint-Augustin Church in Paris, Elevation of the Principal Facade, ca. 1867–1868
Pen and black ink, watercolor touches, and gold on paper

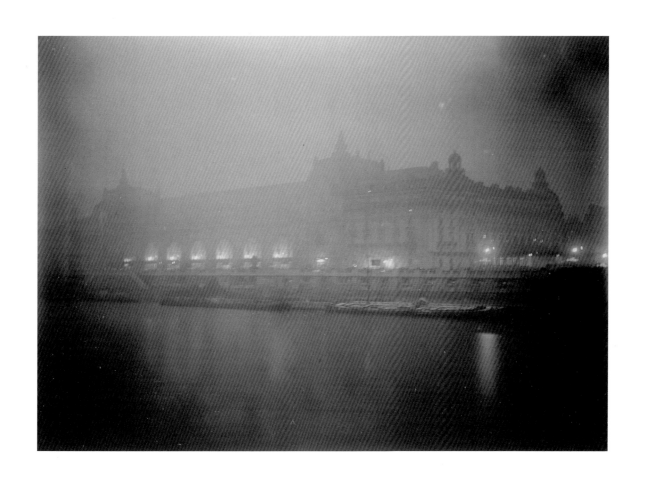

Louis-Gabriel Loppé
Gare d'Orsay at Night, ca. 1900
Gelatin silver print

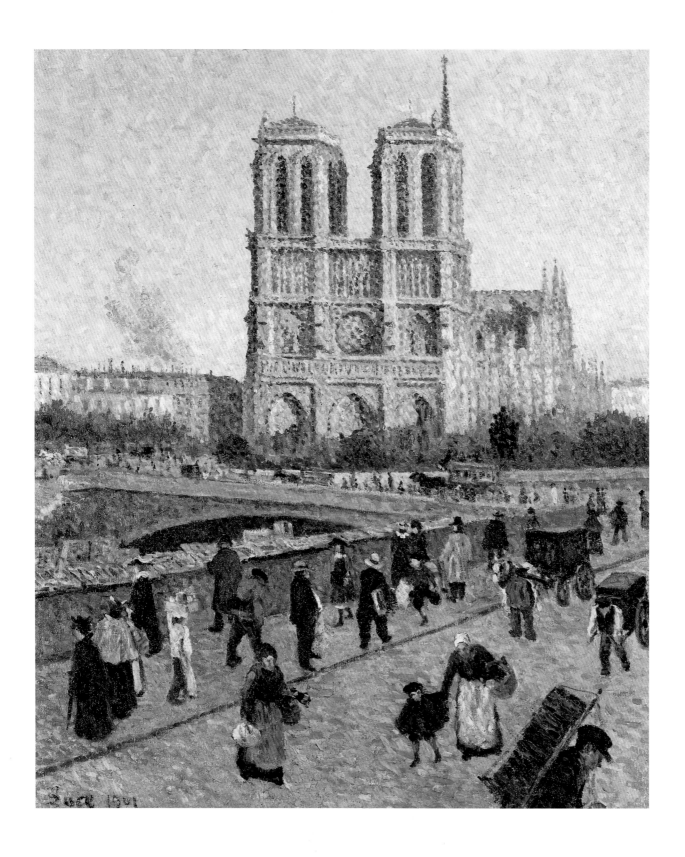

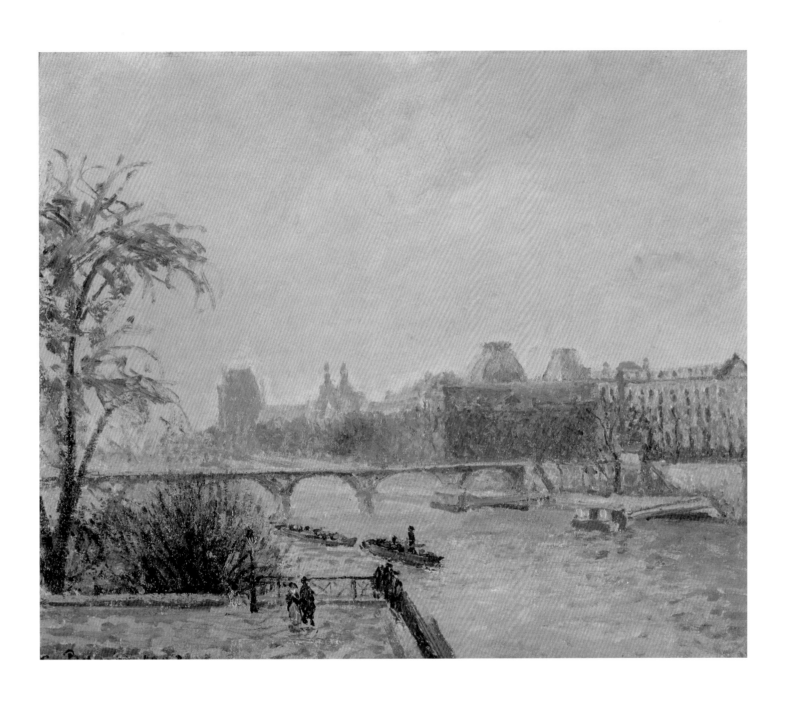

CAMILLE PISSARRO

The Seine and the Louvre, 1903
Oil on canvas

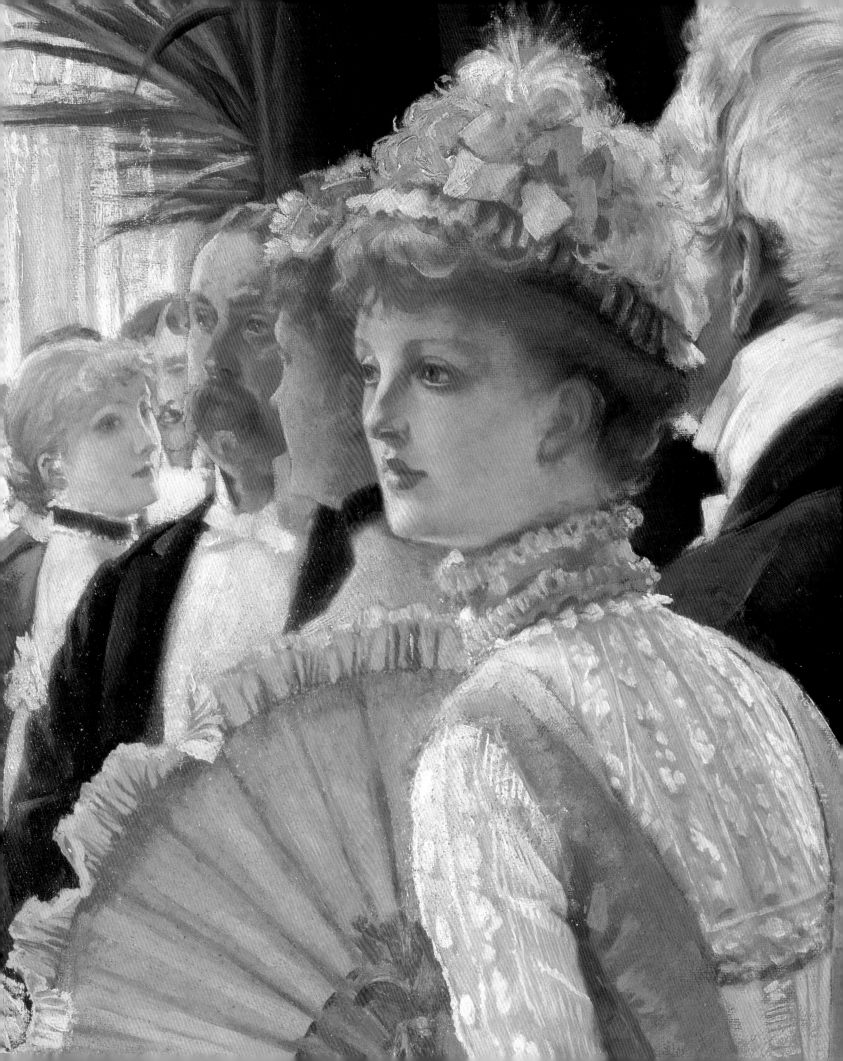

MARY G. MORTON

HIGH SOCIETY

S EARLY AS 1846, THE POET AND CRITIC CHARLES BAUDELAIRE WAS calling in his Salon reviews for a new kind of painting that could express what he called "the heroism of modern life." Baudelaire (fig. 1) felt that after a two-hundred-year reign, the great tradition of French painting had fallen into a state of decadence, recycling old subjects and formulas, out of step with the contemporary world. "The pageants of fashionable life and thousands of floating existences—criminals and kept women—which drift about in the underworld of a great city . . . we have only to open our eyes to recognize our heroism. . . . The life of our city is rich in poetic and marvellous subjects. We are enveloped and steeped as though in an atmosphere of the marvellous; but we do not notice it."[1]

The Impressionists and some of their academic contemporaries seemed to respond to Baudelaire's call for a new kind of painting, offering a pictorial history of Parisian life during the Second Empire and into the Third Republic. Artists like Alexandre Cabanel, Claude Monet, Édouard Manet, Jean Béraud, James Tissot, and Edgar Degas presented images of the capital city's social and cultural elite, famously fashionable and ardently entertained. Cabanel's ravishing portrait of the Countess of Keller (page 48) is a superb example of the kind of painting that overwhelmed the walls of the annual Salon in the middle of the century. Portrait painters were very prolific in the middle decades of the nineteenth century as the newly wealthy flocked to artists' studios to avail themselves of a privilege previously accessible only to nobility. Standing before *Comtesse de Keller*, one is dazzled not only by the lovingly described gown, fur, jewels, and the porcelain features of this darkhaired beauty, but also by the physical and psychological presence of the sitter. Traditional portraiture sought to both acknowledge the prestige of the sitter and represent the "soul" of the sitter. The function of such portraiture was to exalt the individuality of the sitter, the bourgeois value par exellence.[2]

Though bearing some of the trappings of traditional portraiture, Monet's *Madame Louis Joachim Gaudibert* (page 47) is more artistically progressive. Marguerite Gaudibert averts her glance, denying us access to her "soul," or even intimations of her personality. We are left to concentrate on her sumptuous copper-colored dress, set off by the hot hues of her shawl, and the cool gray-blue of the curtained backdrop. Rather than aiming to present the inner life of his sitter, Monet painted the material signs of the sitter's status with his extraordinary sense of color and free brushwork. This portrait, commissioned by a shipowner and businessman from Monet's hometown of Le Havre, proved a godsend to the struggling artist, who was married and penniless with a child on the way. Monet was still decades away from the life of comfort he would build on the patronage of upper-middle-class businessmen like Gaudibert.

James Tissot, *The Ball* (detail), see page 51

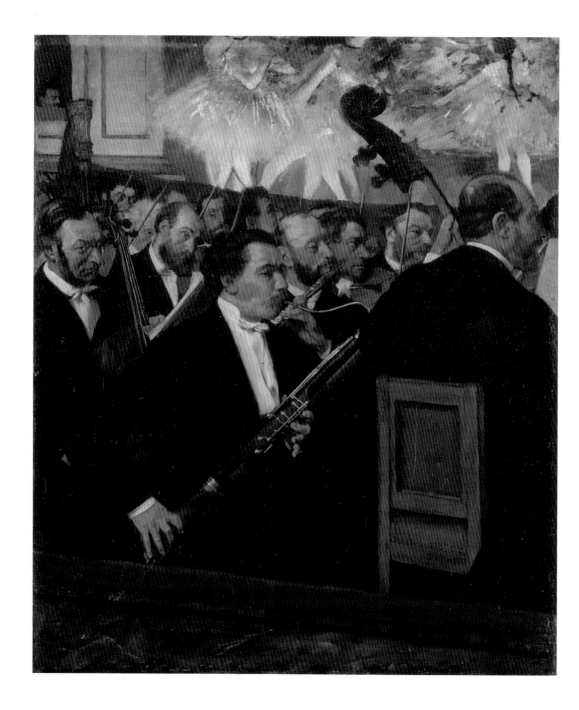

Fig. 1
Baude

W
differ
of th
and (
litera
her s
at th
costι
lips]
the i
bare
thicl

A
vent
the (

EDGAR DEGAS
The Orchestra of the Opéra, 1870
Oil on canvas

CLAUDE MONET
Madame Louis Joachim Gaudibert, 1868
Oil on canvas

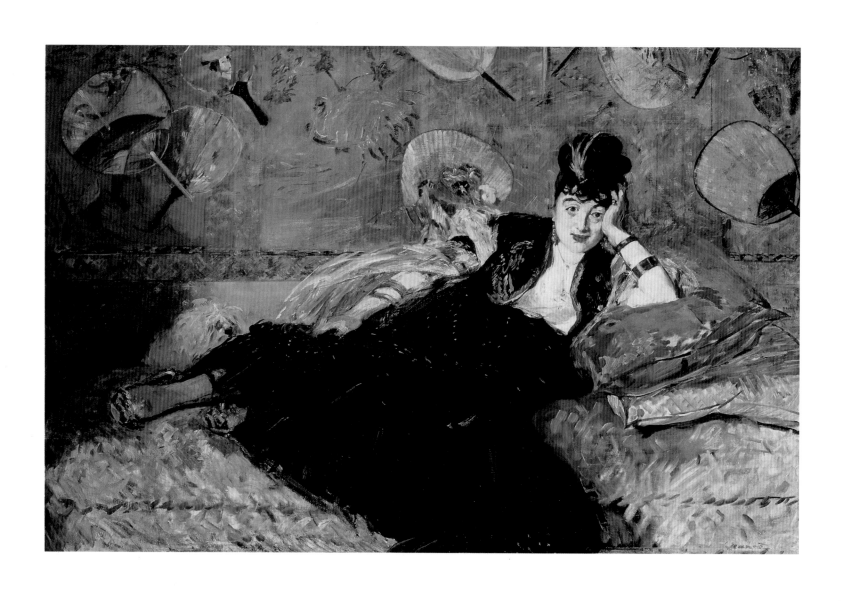

ÉDOUARD MANET
Woman with Fans (Nina de Callias), 1873
Oil on canvas

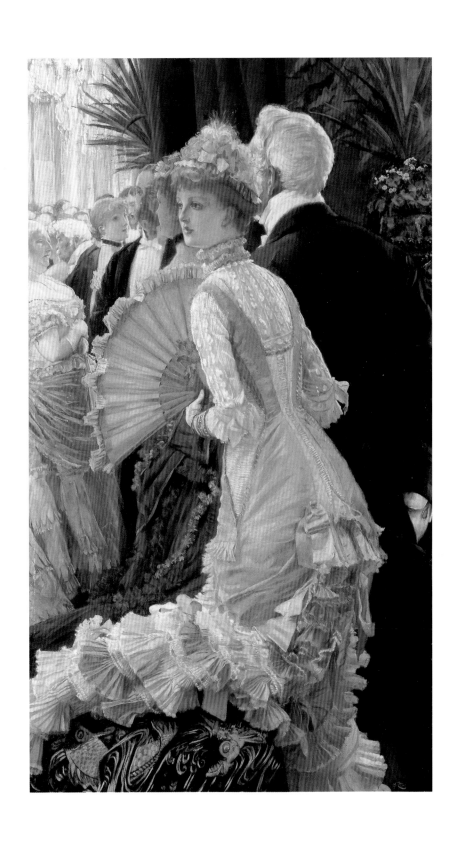

JAMES TISSOT
The Ball, ca. 1885
Oil on canvas

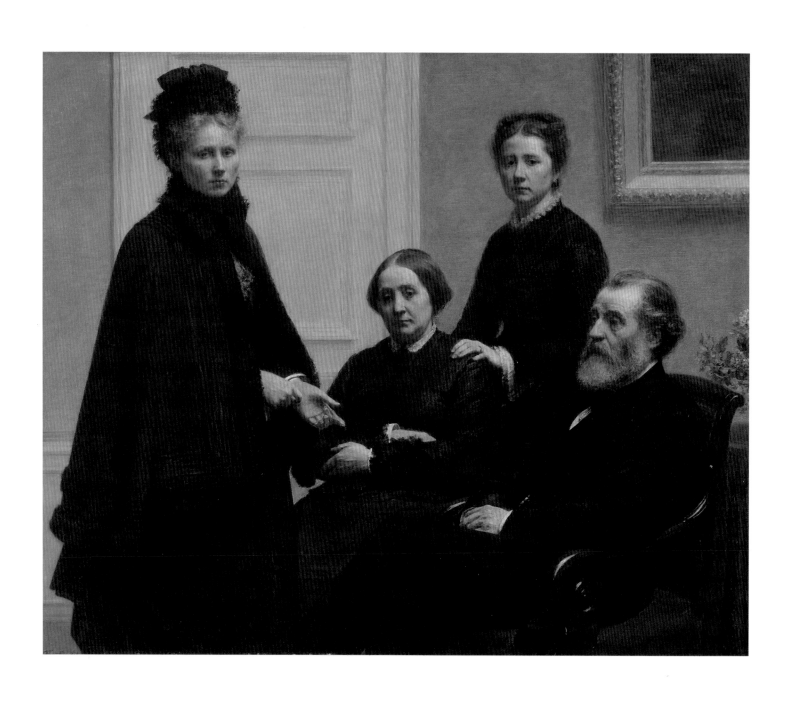

HENRI FANTIN-LATOUR
The Dubourg Family, 1878
Oil on canvas

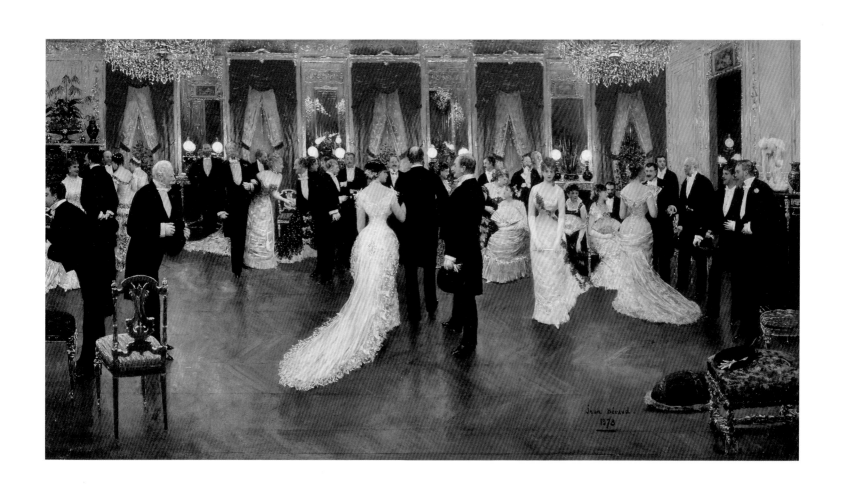

JEAN BÉRAUD
A Party, 1878
Oil on canvas

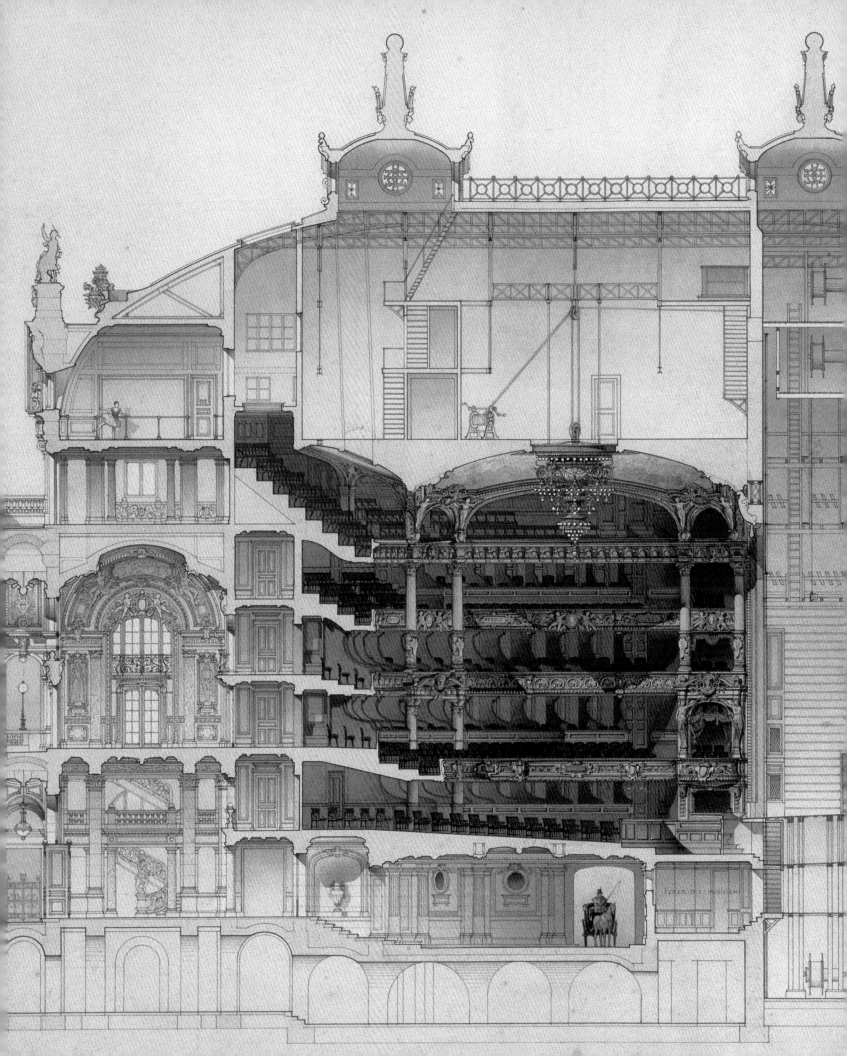

FOYER DES INVALIDES

CAROLINE MATHIEU

GRAND THEATERS

"**I**T IS IMPOSSIBLE TO SPEND A FEW WEEKS IN PARIS AND NOT SEE THAT the theater plays an essential role in French civilization," wrote Henry James. Theaters, operas, and cafés-concert were the settings of choice for displays of Parisian society life, which peaked during the Second Empire.

The creation of the great boulevards involved the destruction of many theaters. Some were rebuilt in the center of the city, like the Châtelet by Gabriel Davioud (fig. 1) and the Gaîté by Alphonse Cusin (fig. 2); others were located on the new boulevards. Architects wanted to design buildings adapted to urban, modern forms of entertainment, without being as ruinously expensive as the Nouvel Opéra de Paris. Almost all in the Italian Renaissance style, the theaters were often surrounded by monumental buildings so as to blend into the Parisian architectural aesthetic. This was true for Auguste-Joseph Magne's 1868 theater, the Vaudeville (page 62), which opens in a rotunda on the Boulevard des Capucines.

Many of the structures were destroyed by fire: the Théâtre de la Porte Saint-Martin burned in May 1871 during the Commune and was entirely rebuilt in 1873 (page 61). Fire also marked the fate of the Opéra Comique, completely destroyed in 1887. In 1893, its reconstruction prompted an important competition. Eighty-four proposals were submitted (for Henri Schmit's entries, see pages 63–65), and the architect Louis Bernier won first prize. In the boxes of these Italianate theaters, rented by the year, fashionable society saw and was seen, and handled business of all kinds, just as at the Salons. It was good form to arrive late, talk loudly, and observe the pretty women seated in the front box seats, their bouquets and shawls laid on the railings. It was only in 1876, when the Festspielhaus in Bayreuth was built, with its very few center boxes, that the artists took revenge on the frivolity and vanity of the elite audience.

The Cathedral of High Society

One major project of the Second Empire was the building of the Nouvel Opéra de Paris. One hundred seventy-one proposals were submitted in the 1861 architectural competition, and the winner was an unknown architect of thirty-six years named Charles Garnier (fig. 3, see page 60).

On a site determined by Haussmann as early as 1858, the first stone was laid in 1862; the facades were finished in 1867. Construction was interrupted by the Franco-Prussian War, and the Nouvel Opéra was finally inaugurated on January 5, 1875 (figs. 4, 5). An emblem of the Second Empire, the Opéra clearly rejects everything characteristic of architecture of the period, preferring the curve to the straight line, the picturesque in place of symmetry, ornamental exuberance instead of austerity—seeking resonance in the polychrome

Henri Schmit, *Project for the Nouvel Opéra-Comique de Paris* (detail), see page 65

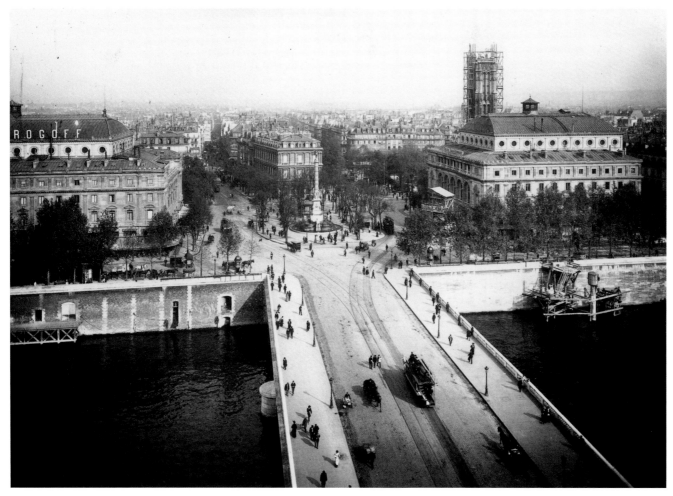

Fig. 1. Seeberger Frères, *The Place du Châtelet after the work of Haussmann,* Archives photographiques, Paris.

Fig. 2. Alphonse Adolphe Cusin, *Théâtre de la Gaîté, Elevation of the Principal Facade,* 1862, graphite, pen and black ink, and watercolor on paper, Musée d'Orsay, Paris.

of marbles and green and pink porphyries, gleaming bronze, and the sparkling copper of the cupola—all in contrast to the sober colorlessness of the Haussmannian buildings surrounding it.

The Opéra was built according to a masterly, rational plan. The composition and the gradation of the architectural masses, the interplay of roof treatments, the harmonious relationship of the separate parts, and the scale and generosity of the interior layout are among the salient features of the building. (Garnier's Opéra became a point of reference, and many theaters in France and around the world, as far away as Brazil, adopted its forms and layout.) Garnier chose to treat the theater itself in a subdued way, so as not to distract the public from listening to the music, saving expressive flamboyance for the foyer and grand staircase, a grandiose space in which the spectators themselves were on stage (fig. 4). The Opéra is also a fine example of artistic diversity and synthesis (fig. 5). Garnier, wanting to integrate all kinds

of decorative arts in his building, personally supervised the work of the painters, sculptors, stucco workers, and mosaic artists commissioned for the project.

Jean-Baptiste Carpeaux made the most daring decorative contribution (see page 59). Garnier had given the artist the idea of a sculptural ring symbolizing the dance: Carpeaux's own ardor and enthusiasm drove him to continue adding characters, until at one time his plans included seventeen figures. The final composition took three years to finish. Unveiled in 1869, *Dance* caused a scandal and was branded as an "insult to public morality."

Next Garnier built the casino-opera of Monte Carlo (1878–1879). Soon afterward, other spa and resort towns—such as Vichy and Enghien—began building their own casinos, operas, or theaters. After 1890, having exhausted the Italian Renaissance style, architects devoted themselves to Rococo creations or worked in the Louis XVI style, especially in the north of France and in some of the more surprising private theaters, such as that of the Schneider family in le Creusot (1905).

The 1913 opening of the Théâtre des Champs-Elysées is an important date in the history of architecture as well as in Parisian life. In a reaction against historicism, the services of Henry van de Velde, a leading Belgian Art Nouveau architect, were solicited, but he resigned following a disagreement with Auguste and Gustave Perret. These two entrepreneur engineers, known for

Fig. 3. Paul Jacques Aimé Baudry, *Portrait of Charles Garnier*, 1868, oil on canvas, Musée d'Orsay, Paris.

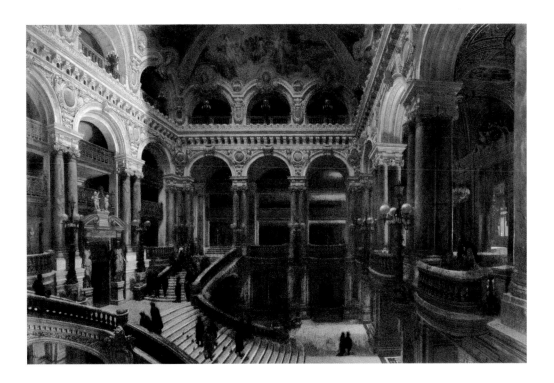

Fig. 4. Victor Navlet, *Staircase of the Opéra*, 1861, oil on canvas, Musée d'Orsay, Paris.

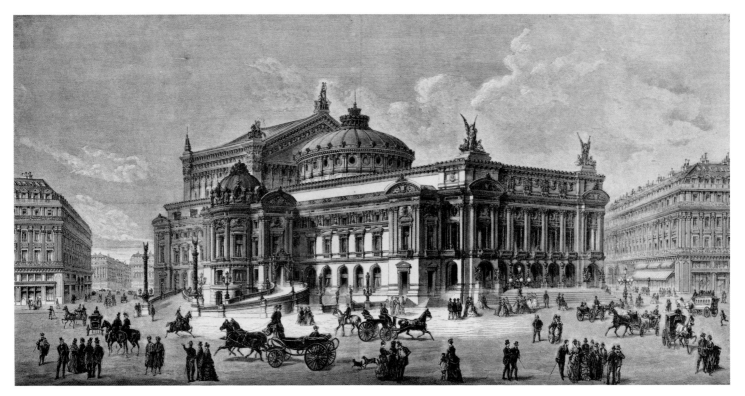

Fig. 5. *General View of the Nouvel Opéra*, 1875, L'Univers Illustré.

Fig. 6. Émile Druet, *Plaster Model (destroyed) of the Théâtre des Champs-Élysées, Realized by the Perret Brothers*, photograph, Institut Français d'Architecture, Paris.

their innovative use of reinforced concrete, initiated the movement toward pure and functional form. The Théâtre des Champs-Élysées (fig. 6) is also important because the decoration was entrusted to some of the most progressive artists of the period: Maurice Denis, Édouard Vuillard, Ker Xavier Roussel, and Émile-Antoine Bourdelle. And as for music, there it reigned supreme; during the theater's inaugural year, both Igor Stravinsky's *Le Sacre du Printemps* and Claude Debussy's *Jeux* were produced for the first time.

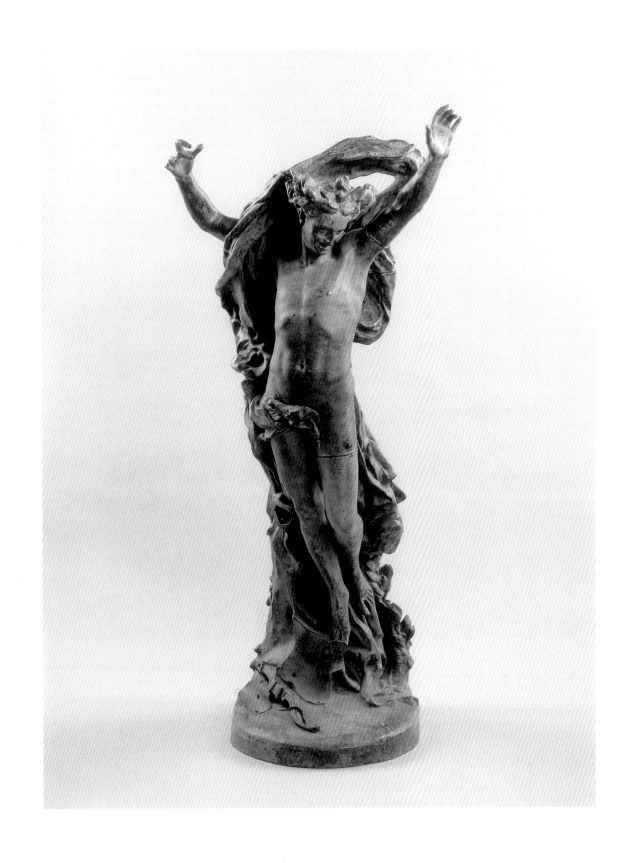

JEAN-BAPTISTE CARPEAUX
The Spirit of Dance, ca. 1865–1869
Bronze

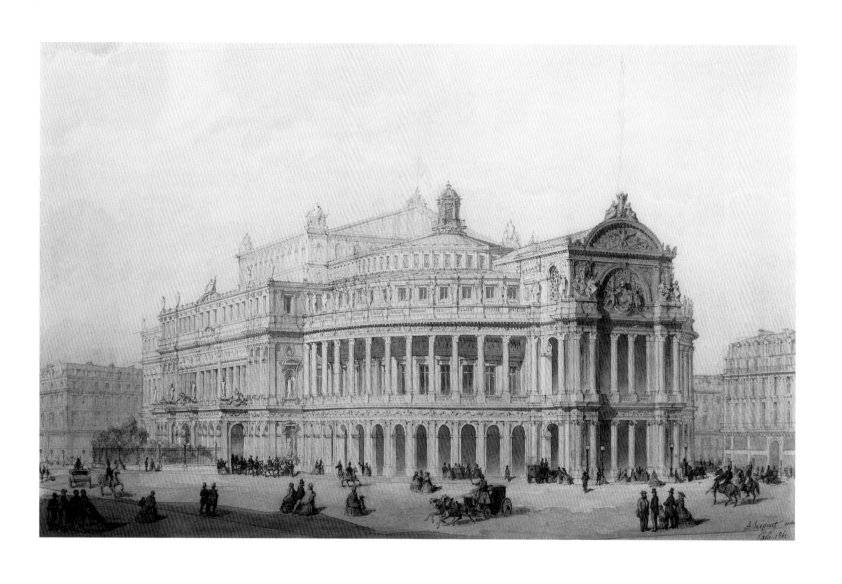

ALPHONSE-NICOLAS CRÉPINET
Nouvel Opéra, Perspective View, 1861
Graphite and watercolor on paper

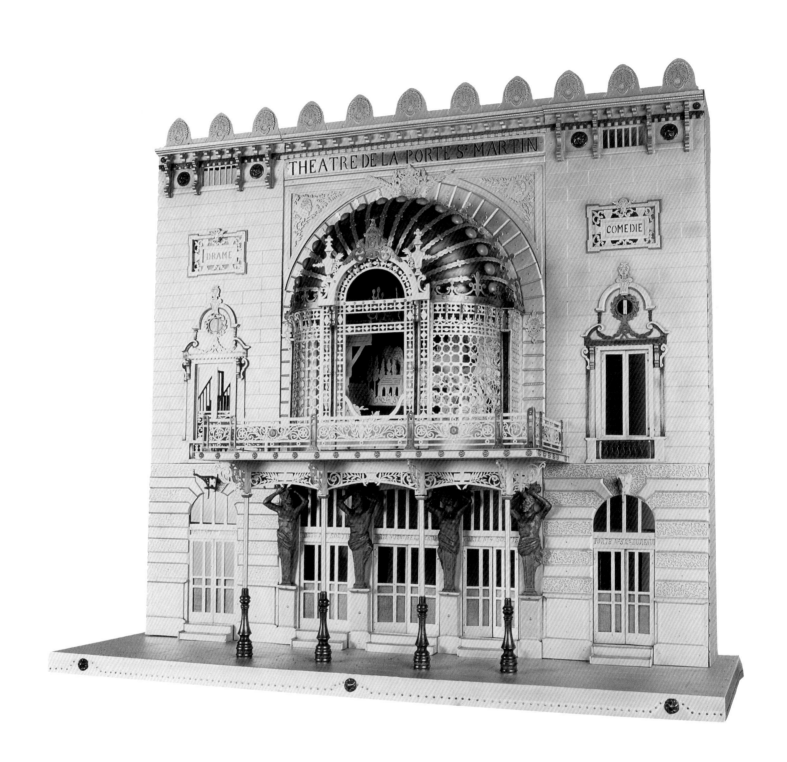

ANONYMOUS
*Model of the Facade and the Veranda for the Théâtre de
la Porte Saint-Martin*, 1892
Aluminum, brass, and glass on wooden core

AUGUSTE-JOSEPH MAGNE
Théâtre du Vaudeville, Elevation of the Principal Facade, 1870
Graphite, gray ink wash-drawing, watercolor, and pen and
black ink, with gouache touches, on paper

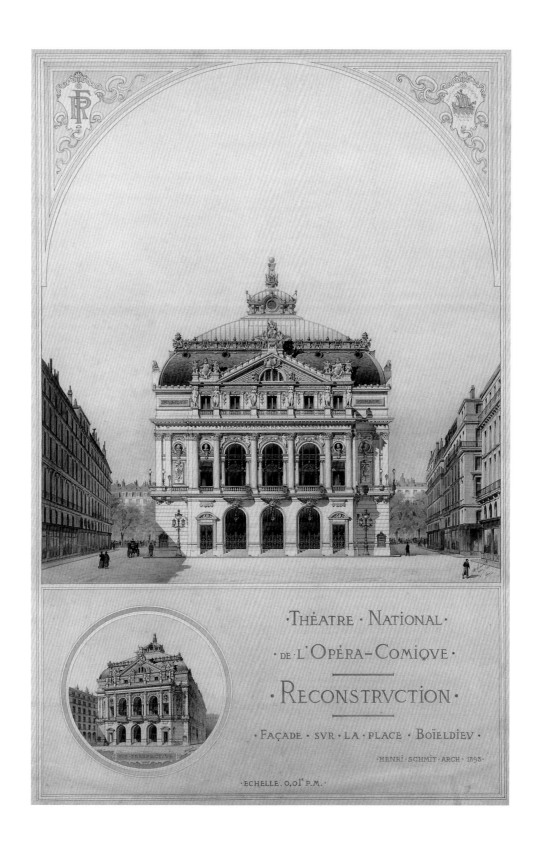

HENRI SCHMIT

Project for the Nouvel Opéra-Comique de Paris, Principal Facade
on the Place Boïeldieu and Perspective View, 1893
Pen, watercolor, gouache, and gold touches on paper

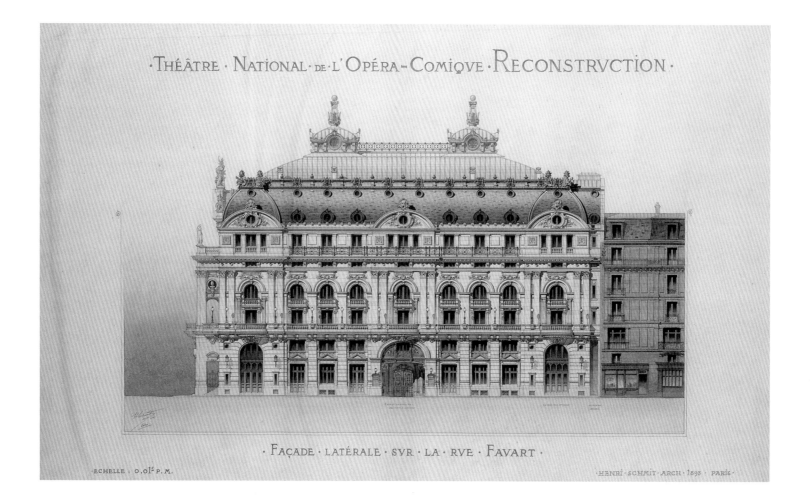

· THÉÂTRE · NATIONAL · DE · L'OPÉRA – COMIQVE · RECONSTRVCTION ·

· FAÇADE · LATÉRALE · SVR · LA · RVE · FAVART ·

ECHELLE : O.OI⁵ P.M.

HENRI · SCHMIT · ARCH · 1893 · PARIS ·

HENRI SCHMIT
Project for the Nouvel Opéra-Comique de Paris,
Lateral Facade on the Rue Favart, 1893
Pen, watercolor, gouache, and gold touches on paper

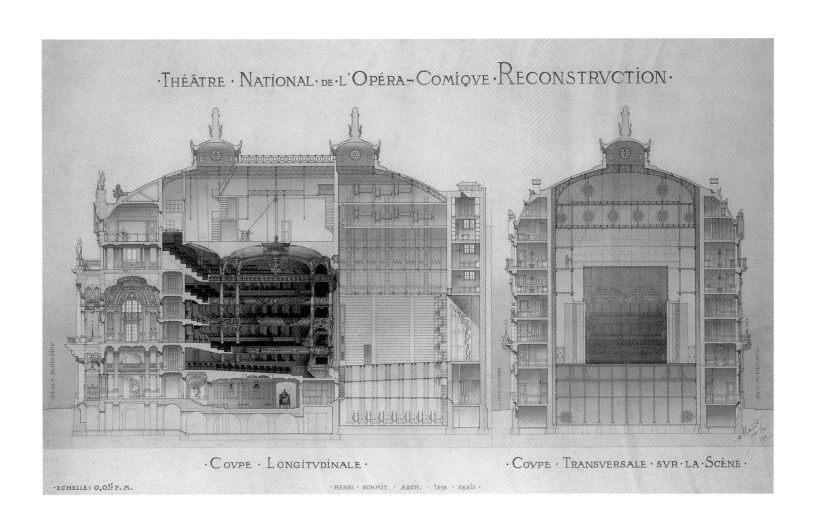

·THÉÂTRE · NATIONAL · DE · L'OPÉRA—COMIQVE · RECONSTRVCTION·

· COVPE · LONGITVDINALE · · COVPE · TRANSVERSALE · SVR · LA · SCÈNE ·

·ECHELLE: 0,01ᵐ P. M. · HENRI · SCHMIT · ARCH · 1893 · PARIS ·

HENRI SCHMIT
*Project for the Nouvel Opéra-Comique de Paris, Longitudinal and
Transverse Sections*, 1893
Pen, watercolor, gouache, and gold touches on paper

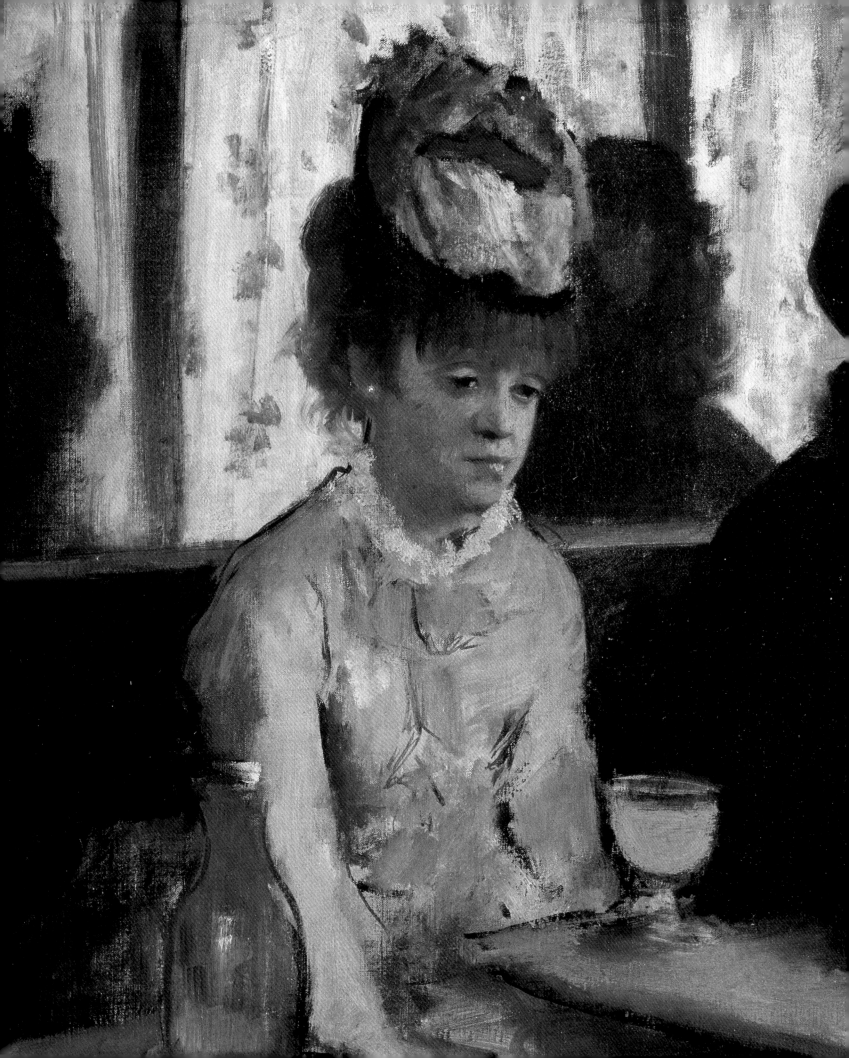

MARY G. MORTON

THE DARK SIDE OF THE CITY OF LIGHT

NOT ALL PARISIANS IN THE SECOND HALF OF THE NINETEENTH CENTURY benefited from modernity. There were many who got the short end of the stick—"floating existences," as Baudelaire wrote—from manual workers with little economic or political protection to disfranchised women compelled to sell their bodies. While some artists celebrated industrial advancement, others conveyed a sense of alienation and fragmentation in their depictions of Parisian life. The poet Charles Valette expressed a very personal negative reaction to Haussmann's urban renewal, addressing the Baron in 1856: "Cruel demolisher, what have you done with the past? / I search in vain for Paris: I search for myself."[1]

The Belgian painter Alfred Stevens exhibited *What Is Called Vagrancy* (page 71) at the Paris Exposition Universelle of 1855. Painted on the large scale of a history painting, the canvas caused a sensation in its clear condemnation of police brutality and human misery. Three armed national guards parade a poor woman and her two small children through the streets, having arrested her for the then-crime of homelessness. The woman's downcast face, her son crying in shame behind her, the sympathetic gesture of a better-off woman passing by, and the bare wintry scene combine to strike a tone of pathos. Stevens was likely inspired by Realist painter Gustave Courbet's revolutionary *The Stonebreakers* (fig. 1), which he most likely saw at the 1851 Brussels Salon. Stevens soon forsook this Realist phase and specialized in picturing fashionable women in the upper registers of Parisian society.

The Franco-Prussian War of 1870–1871, which ended in a humiliating siege of Paris, was a major blow to civic morale. In September 1870, Prussian troops surrounded the capital city, cutting it off from the rest of the country. The siege lasted through a particularly harsh winter, until January 28, 1871, when the city capitulated and an armistice was declared. Pierre Puvis de Chavannes's large pendant paintings, *The Balloon* (page 75) and *The Pigeon* (page 74), commemorate the only means of communication between Paris and the outside world during the siege: messages sent via hot air balloons, with carrier pigeons bringing back word from the provinces. The inscriptions on each frame convey the painting's message: "The Besieged City of Paris Entrusts to the Air Her Call to France," and "Having Escaped the Enemy Talon the Awaited Message Exalts the Heart of the Proud City." Puvis employed radically simplified forms and drained the color from his paintings, creating a severe but powerful effect. *The Balloon* was completed during the siege and *The Pigeon* in the months that followed. Both images were disseminated in lithographic versions, spreading their cathartic function to a wide audience.

In the wake of the Franco-Prussian War, Napoleon III and his Second Empire fell, and the Third Republic was declared. Though the horrors of

Edgar Degas, *Absinthe* (detail), see page 76

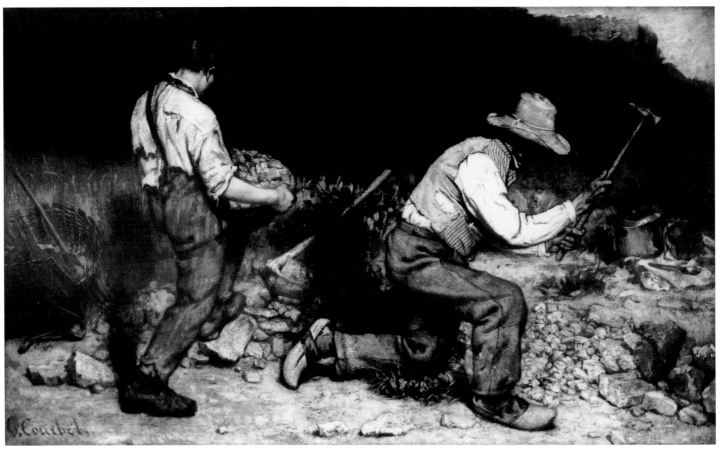

Fig. 1. Gustave Courbet, *The Stonebreakers*, 1849, oil on canvas, Gemaeldegalerie, Staatliche Kunstsammlungen, Dresden, Germany (destroyed 1944).

the war—and the gruesome civil war that followed, known as the Commune—remained fresh in the civic memory, the Parisian economy recovered quickly. The late 1870s brought general prosperity to France, with both industrial production and the earnings of the average Frenchman on the rise. Claude Monet's *Men Unloading Coal* (page 73) and Gustave Caillebotte's *The Floor Scrapers* (page 77) document the grittier side of this industrious decade. Though most of Monet's paintings from the 1870s picture the suburban idylls of Argenteuil, of men and women relaxing along the banks of the Seine, *Men Unloading Coal* is an unusually somber picture of labor.[2] Monet shows a series of coal barges pulled up to the banks of the river under a bustling bridge in Asnières, a Parisian suburb. The dark silhouettes of men hauling coal on narrow planks set up a regular pattern along the right side of the composition. In the figures' uniformity and even spacing, there is a sense of mechanization that some scholars have read as a critical commentary on the dehumanization of industrialization.[3]

Not so unusual within the context of his oeuvre is Caillebotte's *The Floor Scrapers,* included in the second Impressionist exhibition in 1876. Here Caillebotte depicts three men finishing the wood floors of an apartment in one of Haussmann's new buildings. The raised horizon line and plunging perspective focus the composition almost entirely on the floor, where these lean laborers perform their backbreaking work. The stark light and unusual interior composition increase the distinction of this image from the sunlit scenes of pleasure with which the Impressionists are typically associated. While several contemporary critics acknowledged the painting's originality, many accused *The Floor Scrapers* of vulgarity and ugliness. As one critic put it, "*The Floor Scrapers,* who are seen from above, are strange and rather unpleasant."[4]

Some of the most disquieting images of the "dark side" of Parisian modernity come from Edgar Degas, an artist who combined a great respect for the traditional techniques of painting with an uncanny insight into the psychological effects of modern urban life. *Absinthe* (page 76) is one of his early masterpieces. The painting caused a scandal at the 1876 Impressionist exhibition and was reviled as late as 1893 at a Grafton Galleries exhibit in London for its cruel depiction of a "low" subject.[5] Degas strips this bar scene of the light-hearted, bacchanalian aura of Old Master treatments of the theme, presenting the actress Ellen Andrée in an inebriated stupor. Before her sits a glass of absinthe, a fashionable drink of various herbs mixed with fermented wormwood. The viewer is made to feel as if he too is drugged, sitting at an adjacent table, gazing at a woman absorbed in a private world, while all around things float and spin. It is a brilliant image of loneliness in the bright glare of a gaslit café, off the boulevard of a crowded city.

Later in Degas's career, the artist moved away from realistic depictions of urban life, and by end of the century he had turned almost completely to images of dancers and bathers. For realist paintings of the fin de siècle with the level of incision, empathy, and formal innovation characteristic of Degas, we turn to the work of Henri de Toulouse-Lautrec. Though born to an aristocratic family, Toulouse-Lautrec made his home in the marginal milieu of nightclubs and brothels. Both *Redhead* (page 86) and *Alone* (page 87) belong to the artist's series of frank depictions of life in houses of prostitution. The woman in *Redhead* sits on the floor stripped to the waist, seated on towels, her legs spread apart. This is neither an idealized nor eroticized nude, but a skillful color drawing of a woman bathing. In *Alone,* a spindly sex worker is collapsed on a big, soft bed. The flexed hand on her thigh suggests that for a moment, she is her own client. Toulouse-Lautrec does not judge his subjects, and he is not trying to inspire social change by picturing them.[6] His pictures are intimate memorials to the underside of Paris.

NOTES

1. "Le Vieux Paris et le docteur Véron," in Pierre Citron, *La poésie de Paris dans la littérature française de Rousseau à Baudelaire,* vol. 1 (Paris: Éditions de minuit, 1961), p. 335. Quoted in Robert L. Herbert, *Impressionism: Art, Leisure, and Parisian Society* (New Haven: Yale University Press, 1988), p. 3.

2. For a discussion of Monet's paintings of this decade, see Paul Hayes Tucker, *Monet at Argenteuil* (New Haven: Yale University Press, 1982).

3. Ibid., pp. 53–56.

4. G. D'Olby, "Salon de 1876: Avant l'ouverture. Exposition des intransigeants chez M. Durand-Ruel, rue le Peletier, 11," *Le Pays,* April 10, 1876. Quoted in Charles S. Moffett, *The New Painting: Impressionism, 1874–1886* (San Francisco: Fine Arts Museums of San Francisco, 1986), p. 167.

5. See Ronald Pickvance, "*L'Absinthe* in England," *Apollo* 77 (May 1963), pp. 395–398; and Kate Flint, ed., *Impressionists in England: The Critical Reception* (London and Baston: Routledge & Kegan Paul, 1984).

6. See Guy Cogeval, *Post-Impressionists,* trans. Dan Simon and Carol Volk (Secaucus, N.J.: Wellfleet Press, 1988), p. 152; and Richard Thomson et al., *Toulouse-Lautrec* (New Haven: Yale University Press, 1991), p. 412.

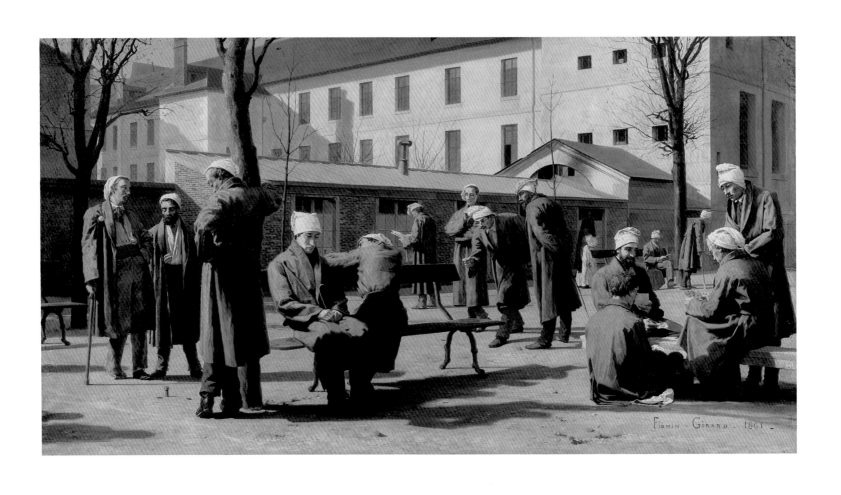

Marie-François Firmin-Girard
The Convalescents, 1861
Oil on canvas

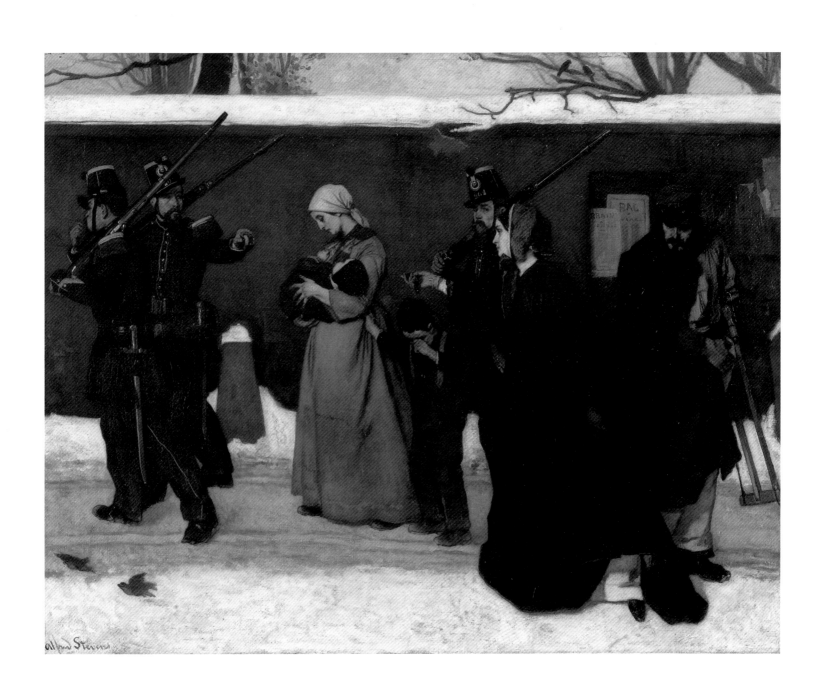

ALFRED STEVENS
What Is Called Vagrancy, 1855
Oil on canvas

HIPPOLYTE LE BAS
The Petite Roquette Prison in Paris, ca. 1831
Watercolor on paper

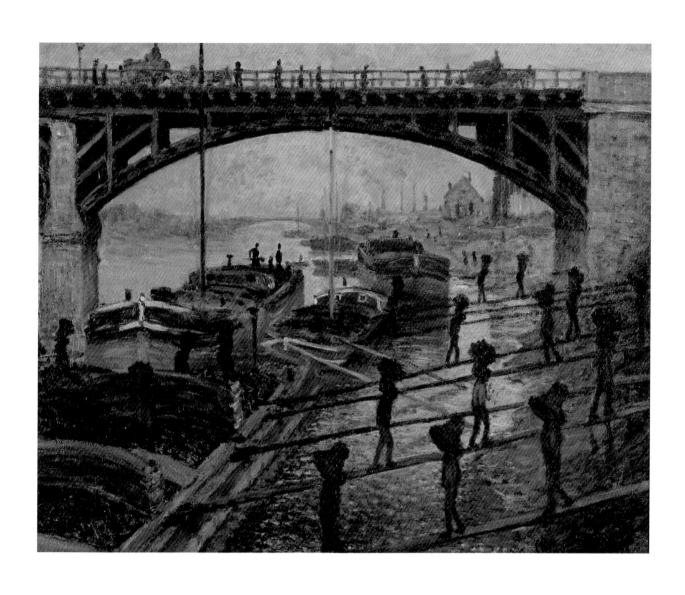

CLAUDE MONET
Men Unloading Coal, 1875
Oil on canvas

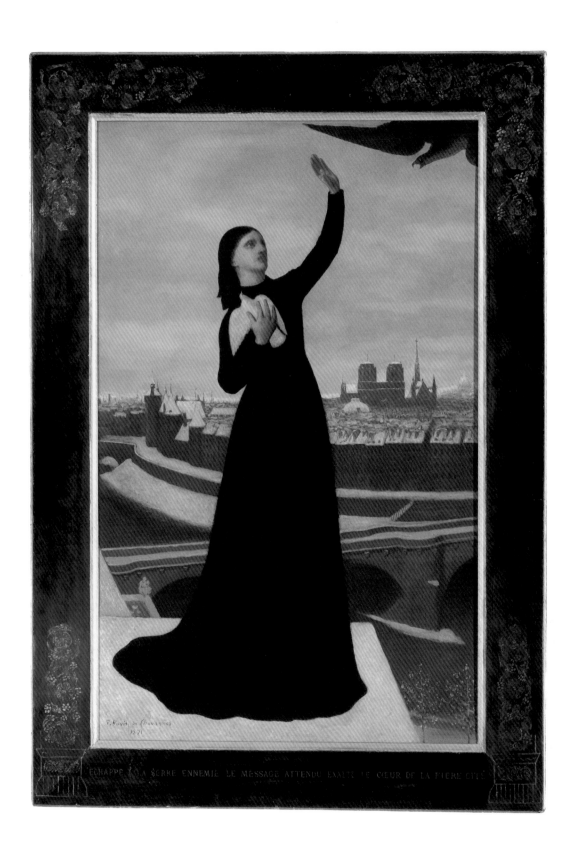

PIERRE PUVIS DE CHAVANNES
The Pigeon, 1871
Oil on canvas

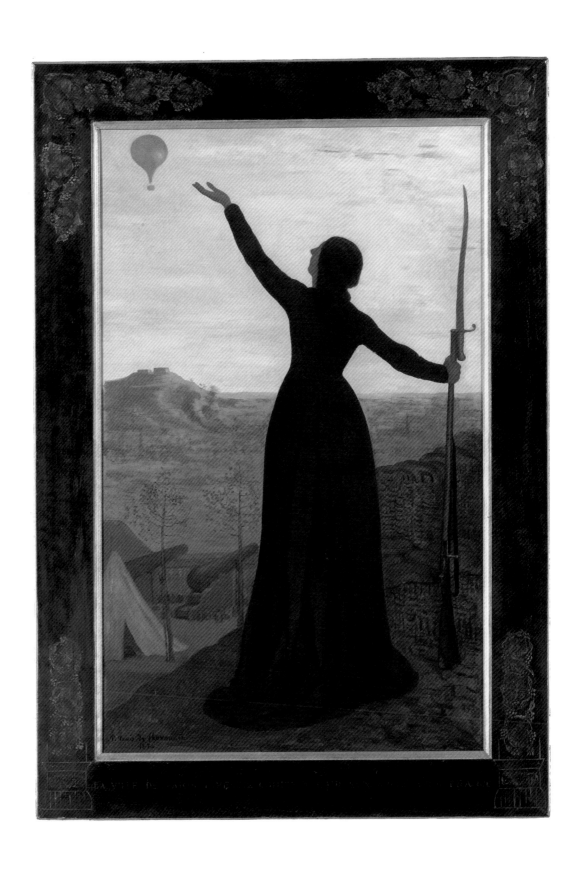

PIERRE PUVIS DE CHAVANNES
The Balloon, 1870
Oil on canvas

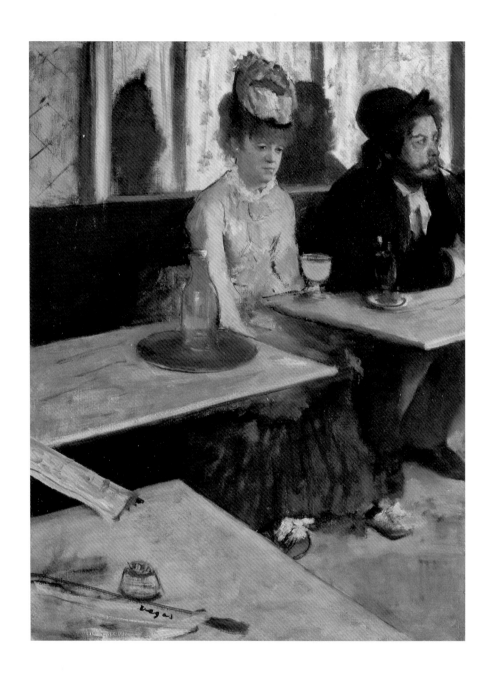

EDGAR DEGAS
Absinthe, ca. 1875–1876
Oil on canvas

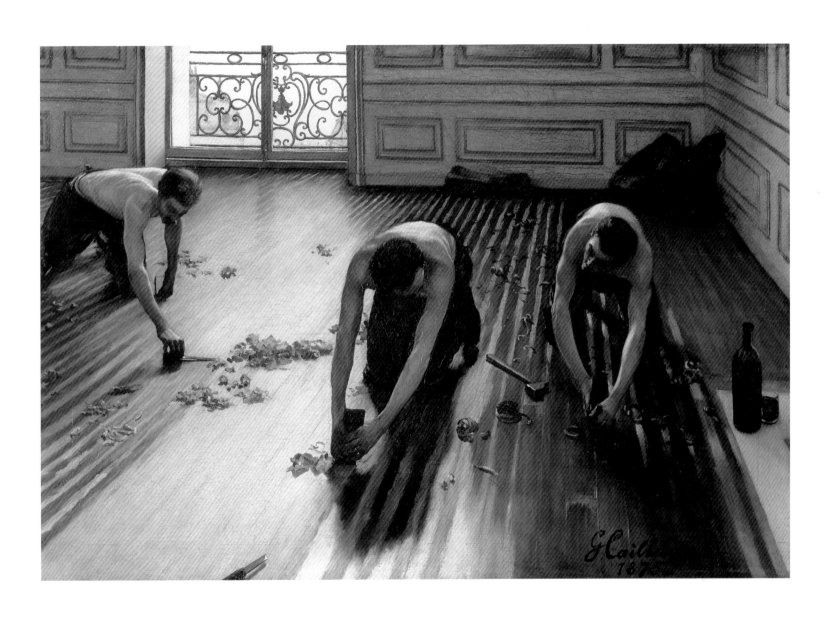

GUSTAVE CAILLEBOTTE
The Floor Scrapers, 1875
Oil on canvas

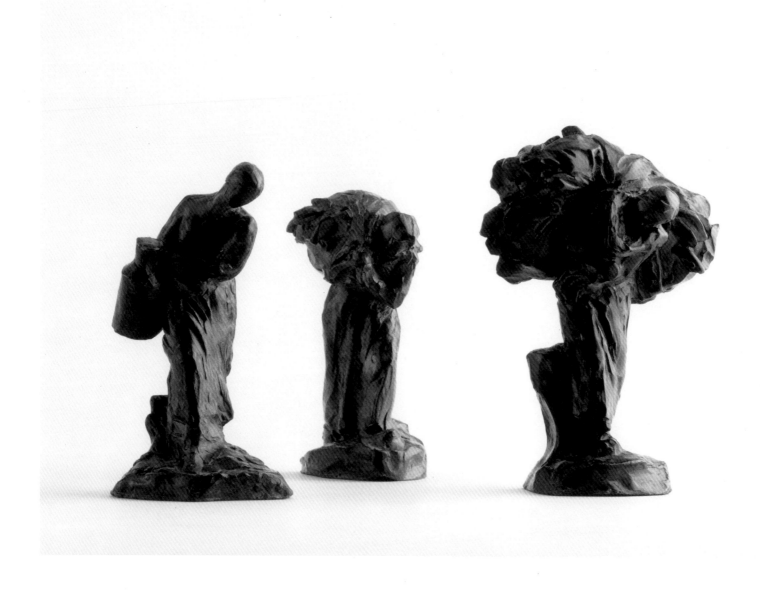

AIMÉ-JULES DALOU
Woman Carrying Milk, 1889–1902
Patinated bronze

AIMÉ-JULES DALOU
Woman Carrying Sheaf, 1889–1902
Patinated bronze

AIMÉ-JULES DALOU
Return from the Fields, 1889–1902
Patinated bronze

AIMÉ-JULES DALOU
Man with Hoe (study for *The Peasant*), 1889–1902
Patinated bronze

AIMÉ-JULES DALOU
Return from the Woods, 1889–1902
Patinated bronze

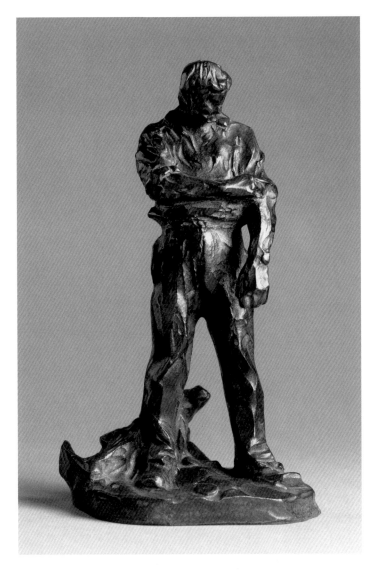

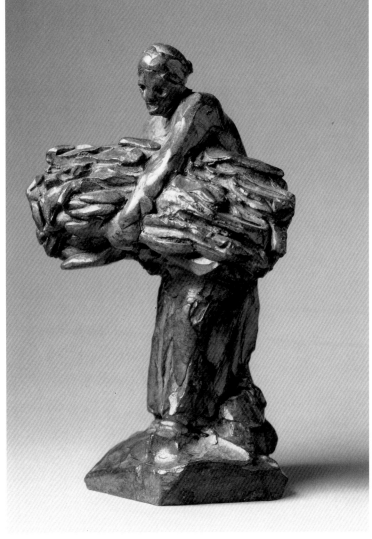

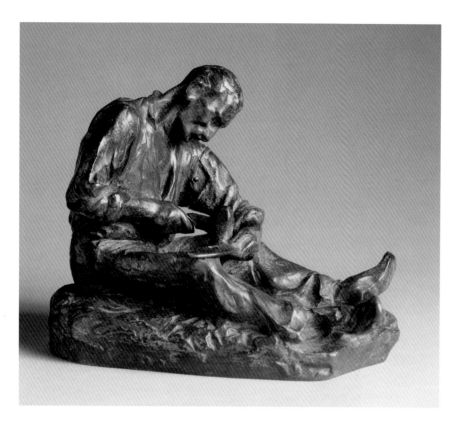

AIMÉ-JULES DALOU
Man Whetting Scythe, 1889–1902
Patinated bronze

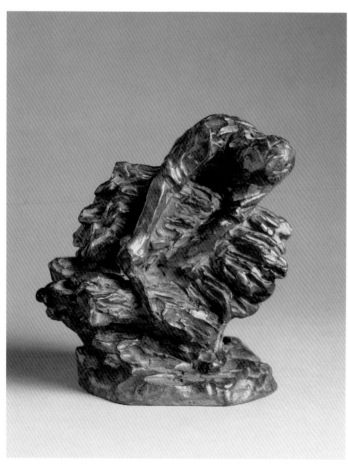

AIMÉ-JULES DALOU
Man Binding Sheaf, 1889–1902
Patinated bronze

AIMÉ-JULES DALOU
Worker Holding a Spade, 1889–1902
Patinated bronze

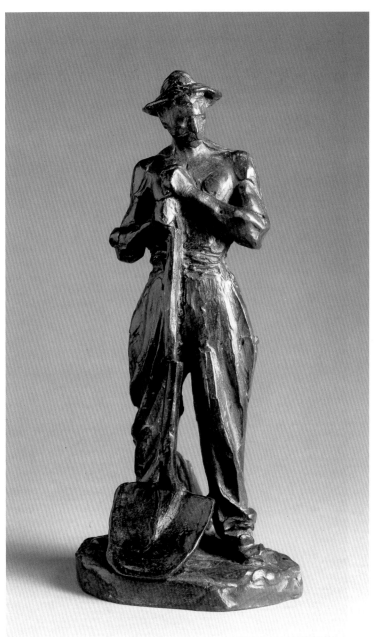

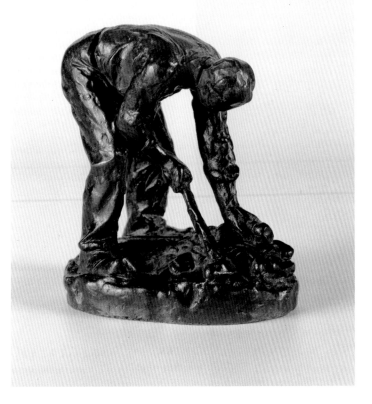

AIMÉ-JULES DALOU
Man Breaking Stone, 1889–1902
Patinated bronze

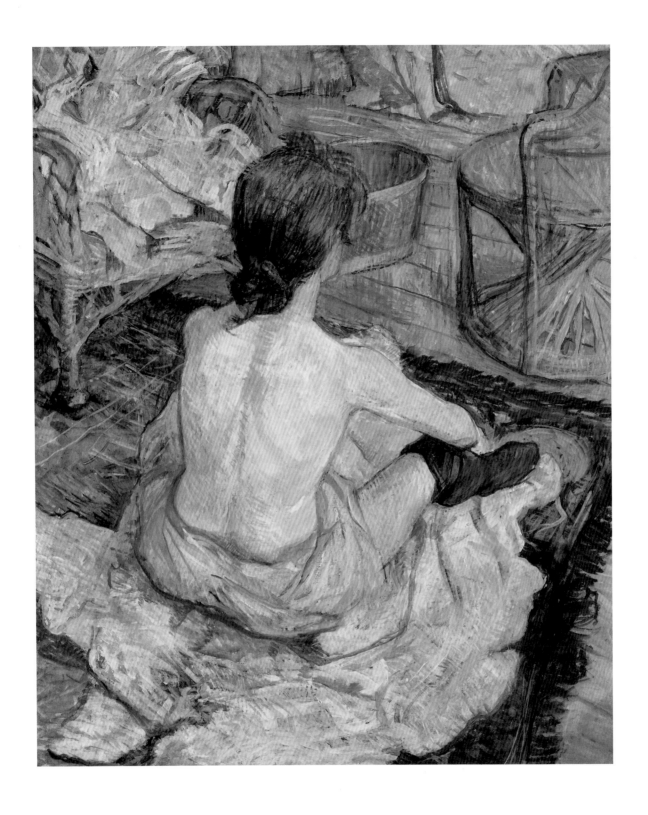

HENRI DE TOULOUSE-LAUTREC
Redhead (The Toilette), 1889
Oil on cardboard

Henri de Toulouse-Lautrec
Alone, 1896
Paint on cardboard

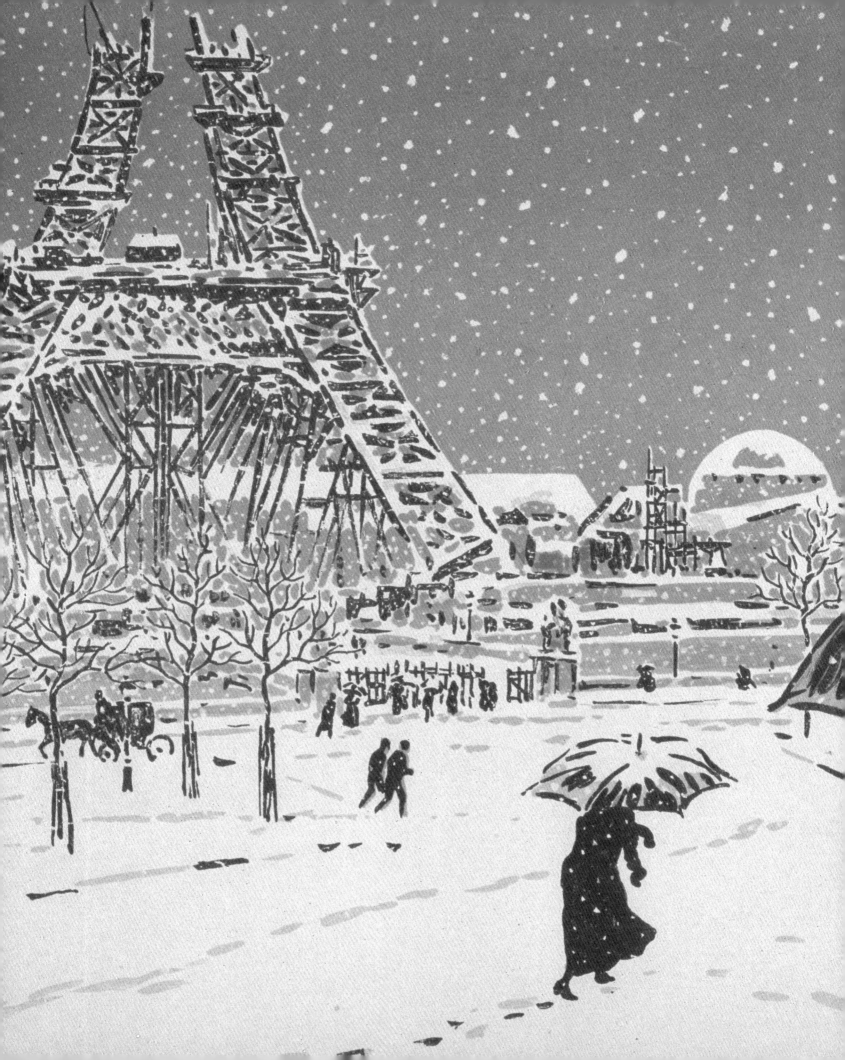

CAROLINE MATHIEU

MR. EIFFEL'S TOWER

"THE TOWER IS MONSIEUR EIFFEL'S PRINCIPAL WORK, AND APPEARS as a symbol of strength and of difficulties overcome."[1] The triumph of the 1889 Exposition Universelle in Paris, the 300-meter (986½-foot) Tower was at the center of all architectural and artistic debates of the time. A decade later, during the preparations for the 1900 Exposition Universelle, there was still talk of demolishing it. All of Gustave Eiffel's energy was required to prevent this from happening, as he emphasized how useful the Tower could prove in scientific, aerodynamic, meteorological, and radio-telegraphic domains.

The idea of a tower of great height "had been stirring obscurely in the minds of engineers for some time, waiting to be born."[2] As early as 1833, the British engineer Richard Trevithick had proposed building an iron openwork column measuring 1,000 feet, and the American engineers Clarke and Reeves came up with a project for a tower of the same height for the Philadelphia Universal Exhibition. In Brussels, the idea of a 200-meter wooden tower was advanced, and in 1863 Allessandro Antonelli erected his 163-meter stonework synagogue, known as the Mole Antonelliana, in Turin. In Paris, the erection of a monumental beacon to illuminate the capital was suggested.

It was in this context that the idea for constructing a 300-meter tower for the 1889 Exposition Universelle was gradually born, a tower to celebrate both the virtues of industry and the centennial anniversary of the French Revolution. As early as 1884, Émile Nouguier and Maurice Koechlin, two engineers in Eiffel's company, were investigating potential attractions for the exhibition. Koechlin designed a plan for a large metal pier. The architect Stephen Sauvestre studied and improved upon the plan, and the tower began to lose its schematic and industrial character, taking on its present shape with the large arches and three platforms he added.

In 1886, Eiffel's project was approved, and the engineer took possession of the land, a large sand square on the Champ-de-Mars facing the old Palais du Trocadéro, where the spectacular construction would rise. The erection of the metal structure caused a great stir: the Tower rose in the Parisian sky almost mathematically, like a gigantic Erector set. All the parts were made in the Levallois-Perret factories, so human workmanship was severely limited. There were never more than 250 workers on-site (189 salaried, their names inscribed on the Tower). There were three accidents, only one fatal.

On March 31, 1889, the Tower was completed, and the tricolor flag was raised to the top of the lightning conductor. From May 15 to November 6, the dates of the Exposition (page 108), the Tower received 1,953,122 visitors, an average of 11,800 a day. The revenue totaled 6,509,901 French francs, which was almost enough to cover the cost of construction, 7,457,000 French gold francs.

Henri Rivière, *The Tower under Construction* (detail), see page 107

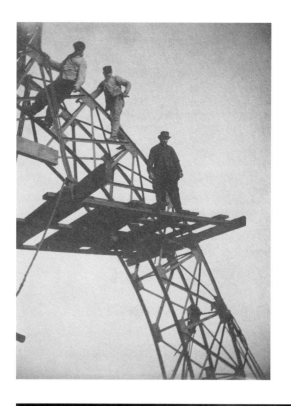

Fig. 1. Henri Rivière, *Album of the Eiffel Tower: Workers on a Girder on an Arch of the "Campanile,"* 1899, gelatin silver print, Musée d'Orsay, Paris, Eiffel Collection.

Fig. 2. Henri Rivière, *The Eiffel Tower seen from Notre-Dame, Paris* from *Thirty-Six Views of the Eiffel Tower,* 1888–1902, color lithograph, Musée d'Orsay, Paris.

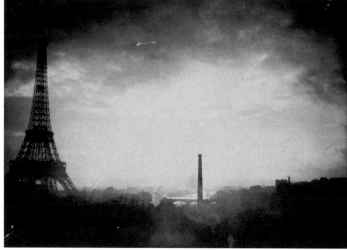

Fig. 3. Louis-Gabriel Loppé, *The Eiffel Tower and the Chimney,* gelatin silver print, Musée d'Orsay, Paris.

It was a brilliant success; however, in 1894, during the preparations for the 1900 Exposition Universelle, the Tower's fate was still undecided. The executive committee gave the architects of the Exposition's buildings carte blanche to transform the Tower. Henri Toussaint dressed it in a kind of metallic skirt surrounded by turrets and flags, making it the Palace of Electricity and Civil Engineering (see page 109).

Images of the Tower

Some artists embraced the Tower as a new motif. Louis-Émile Durandelle photographed its construction in a magnificent album commissioned by Eiffel (pages 94–98). In it he captured the Tower's prodigious modernity, the powerful and floating tangle of metal components that appeared like calligraphy in the Parisian sky. Eiffel also had Théophile Féau systematically photograph the work from the same vantage point on one of the Trocadéro towers, thereby providing valuable historical documents of the building process (pages 92–93). These images show an "organic growth" that confused many Parisians: "As the Tower climbed, rising in tiers, its parts soaring higher, artistically linked to each other, the masterpiece appeared to settle, take on relative proportions, to shrink in some way in its strength and in its power, finally becoming in the eye of the awe-struck spectator the nave of an immense unknown cathedral below, and an arrow of unforeseen and moving audacity above."[3]

Some of the most poetic transcriptions of the Tower, that image of the "modern marvelous," come from Henri Rivière, the painter and engraver, in snapshots he took during the last months of its construction. Human presence is constant, confronted by the void, the winds, seen against the Tower's calligraphic metal

structure (fig. 1, page 105). Smoke and fog envelop the men, shown in their daily work, suspended between sky and land, as if timeless. Later, from 1888 to 1902, Rivière proposed a new vision of the Tower, sometimes framing the images as he had in his photographs, in his *Thirty-Six Views of the Eiffel Tower* (fig. 2, pages 106–107), a collection of color lithographs, a tribute to Hokusai and his *Thirty-Six Views of Mount Fuji* (ca. 1829–1833). It is a poetic evocation, in soft half-tones, of a Paris enveloped by wind, fog, and autumn leaves, with the delicate silhouette of the Tower as a distant sign: "The Eiffel Tower, in all this affair, is but a great stick from which to hang kakemonos."[4]

Louis-Gabriel Loppé, a painter and amateur photographer, made striking images of the Tower: being struck by lightning (page 111), illuminated for the 1900 Exposition Universelle (page 110), crepuscular and melancholic, dominating the rooftops and the factory chimneys (fig. 3). Later, the Bauhaus artists, including the Hungarian photographer László Moholy-Nagy and the German photographers Germaine Krull and Else Thalemann (fig. 4), would depict the Tower as fragmented parts and abstract forms.

Painters, on the other hand, were far less attracted to the Tower as a motif. Paul Gauguin, the only one to praise its "gothic iron lace," devoted neither sketch nor study to the Tower. Only Georges Seurat and Henri (le Douanier) Rousseau showed an interest in it. In 1910, the Tower became the subject of a series of Robert Delaunay's paintings, in which he emphasized the dynamic nature of the Tower, constantly transformed, moving, in contrast to the more sedate Parisian buildings. It was Delaunay who in 1929 wrote these words: *"I think that the Tower has become one of the wonders of the world. For having loved it and for the happiness it has given me, I find no merit in myself to have given it, since 1910, multiple expressions of my love."*[5]

The Tower's success can also be measured in the incredible number of commercial objects and tokens inspired by or representing it: bottles, chandeliers, cigarette cases, matchboxes, and innumerable brooches and bibelots (pages 100–103).

The sculptor Raymond Duchamp-Villon perceived and expressed the beauty and the poetic strength of the Tower, vibrant in the Parisian sky, in 1914: "The tower continued to draw its gray, golden-headed silhouette in the mobile sky, and to raise to the highest its numeric lace, like a desire, like an immobile sign. Living on its strange life, animated by an imperceptible swaying,

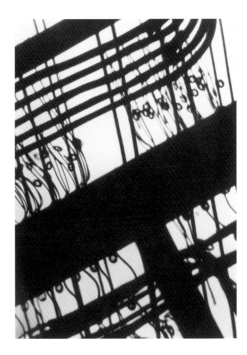

Fig. 4. Else Thalemann, *The Eiffel Tower, Abstract Composition after an Architectural Fragment*, ca. 1925, gelatin silver print, Musée d'Orsay, Paris.

erect in the sunshine, withdrawn under gray skies, glorious and resonant, it has withstood the elements as it has man. Today, it compels our attention, necessary, and we no longer need statistical records to admire it. For this masterpiece of mathematical energy reveals, beyond its reasoned conception, an origin in the subconscious domain of beauty. It is more than a numeral or than a number, since it contains an element of profound life to which our mind must submit if it seeks its emotion in statuary and architecture."[6]

NOTES

1. Gustave Eiffel, unpublished manuscript, Musée d'Orsay, Eiffel Collection.
2. Eugène-Melchior de Vogüé, *Remarques sur l'Exposition du Centenaire* (Paris: Plon, 1889), p. 12.
3. Max Nansouty, *La Tour de 300 mètres érigée au Champ-de-Mars* (Paris: Bernard Tignol, 1889), p. 90.
4. Henri Rivière, *Les Trente-six vues de la Tour Eiffel*, prologue by Arsène Alexandre (Paris: Imprimerie Verneau, 1888–1902). Kakemonos are calligraphic scrolls.
5. Robert Delaunay, in response to the survey "Should the Eiffel Tower be Knocked Down?" ("Faut-il renverser la Tour Eiffel?"), conducted by Gaston Picard for *La Revue Mondiale*, May–June 1929.
6. Raymond Duchamp-Villon, "L'architecture de fer," *Poème et drame*, January–March 1914.

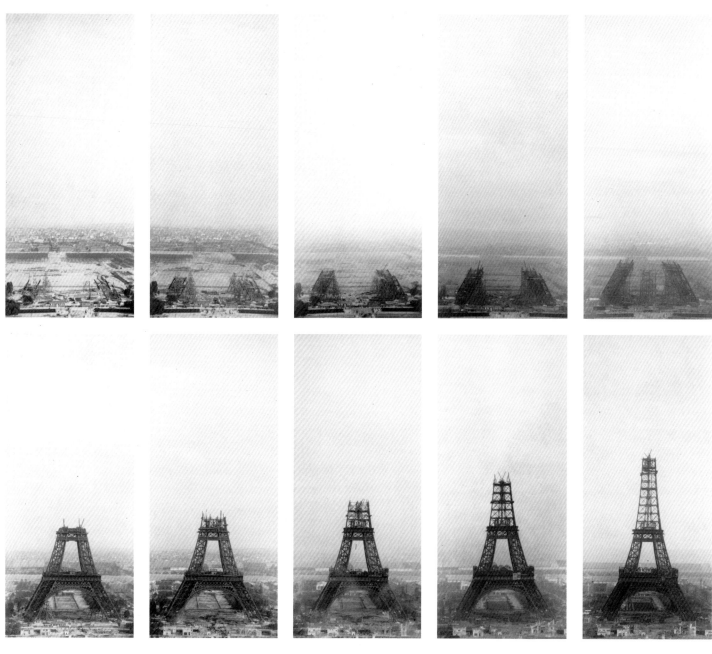

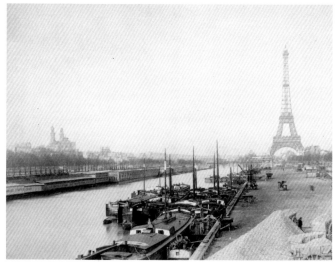

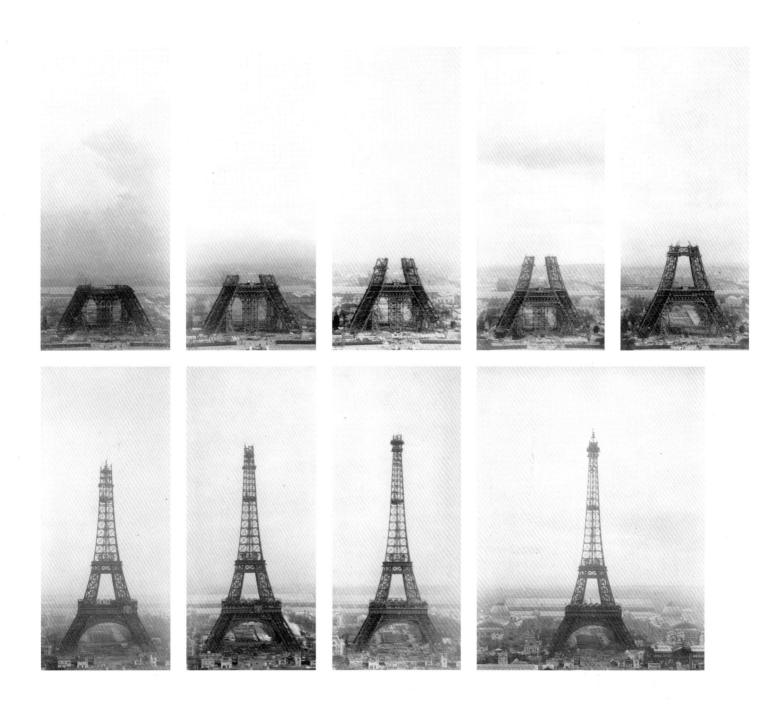

THÉOPHILE FÉAU
The Eiffel Tower under Construction, Views from One of the
Towers of the Palais du Trocadéro, 1887–1889
Photographs glued to cardboard

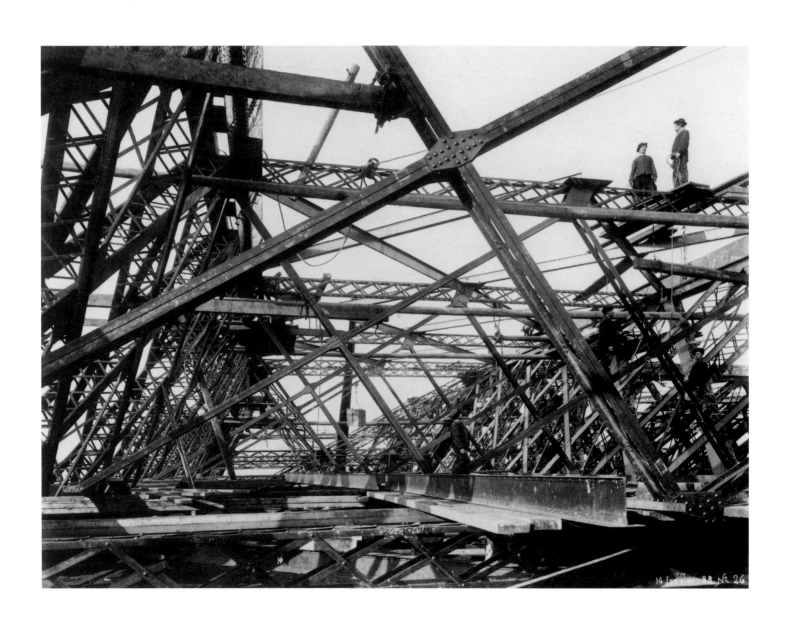

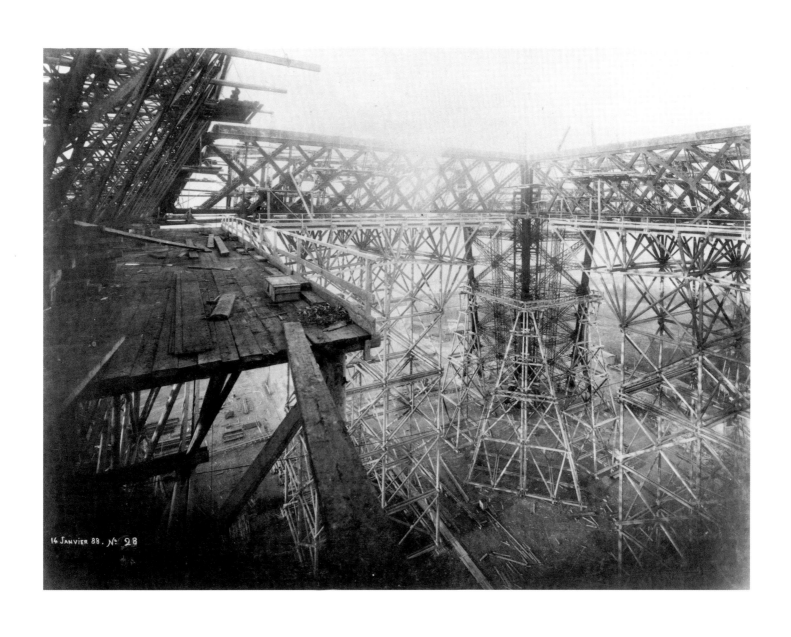

LOUIS-ÉMILE DURANDELLE
Work on the First Platform, January 14, 1888, 1888
Albumen print

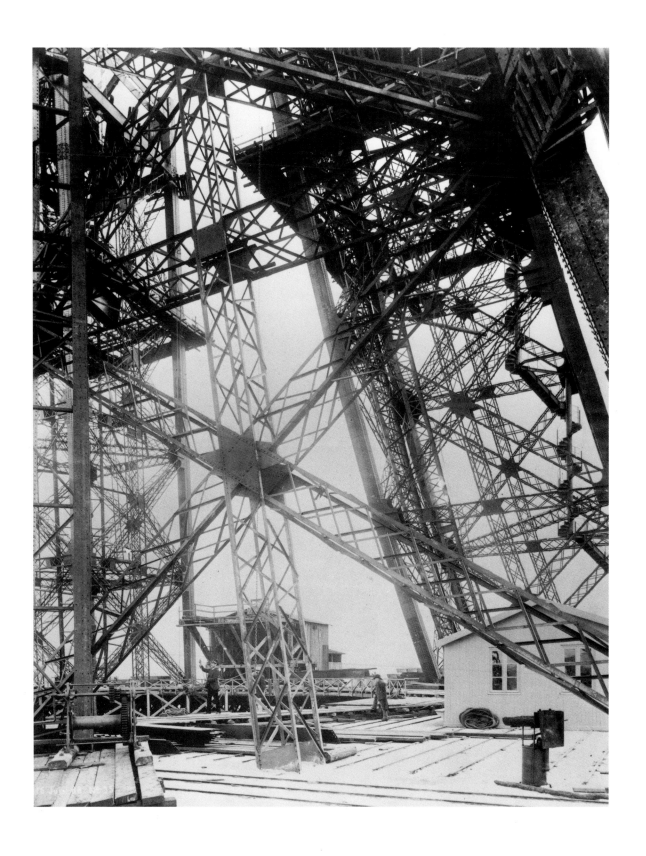

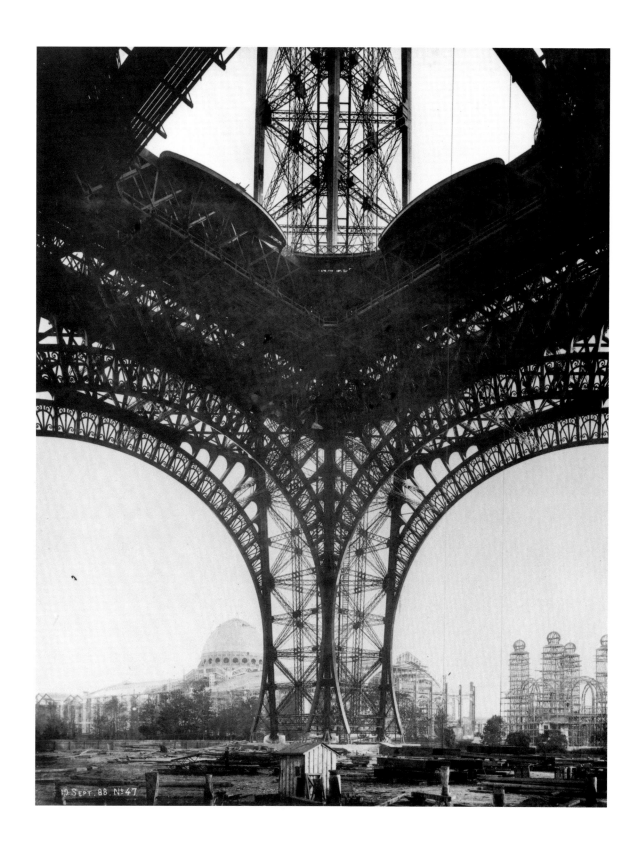

LOUIS-ÉMILE DURANDELLE

The Eiffel Tower, View from the Ground, September 19, 1888, 1888
Albumen print

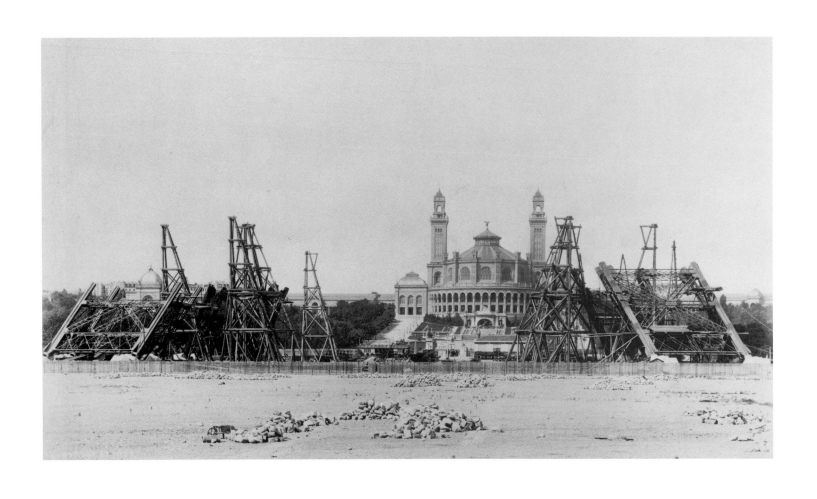

LOUIS-ÉMILE DURANDELLE
The Eiffel Tower under Construction, Facing the Palais du Trocadéro, 1888
Albumen print

GEORGES GAREN
Lighting of the Eiffel Tower for the 1889 Exposition Universelle, 1889
Color lithograph

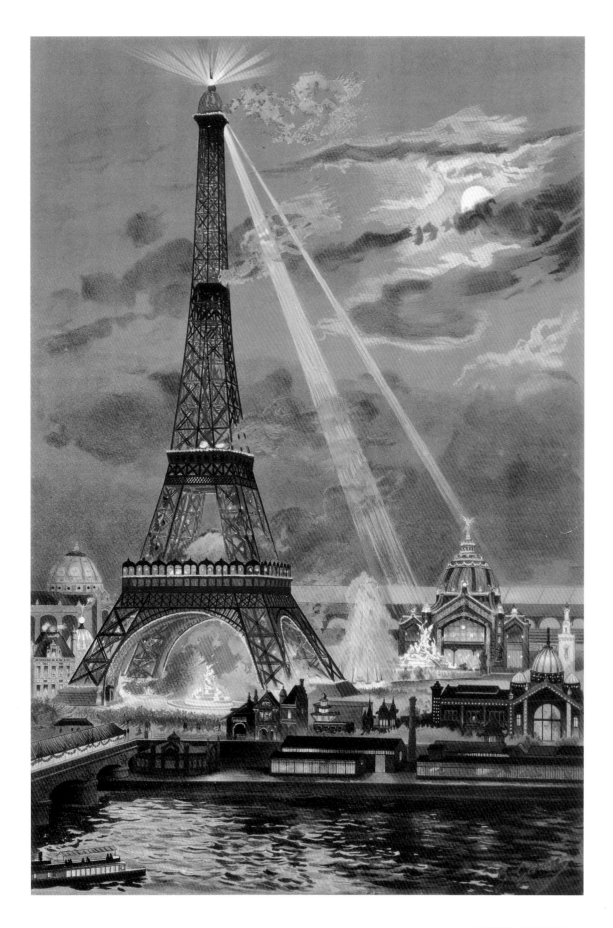

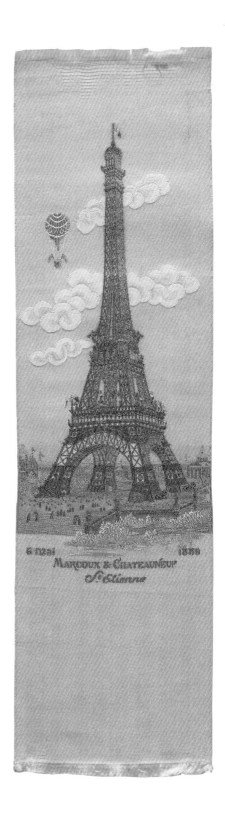

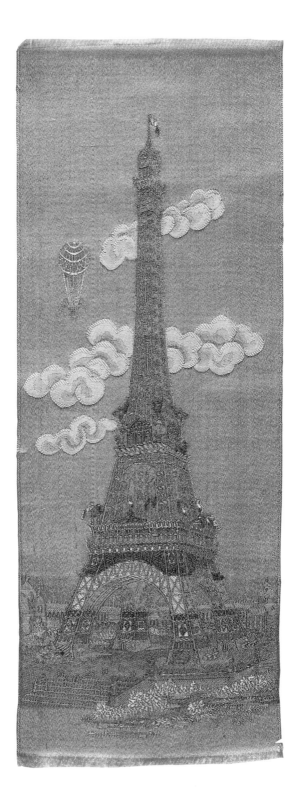

ANONYMOUS
Silk Band Decorated with the Eiffel Tower, 1889
Embroidered silk

ANONYMOUS
Silk Band Decorated with the Eiffel Tower, 1889
Embroidered silk

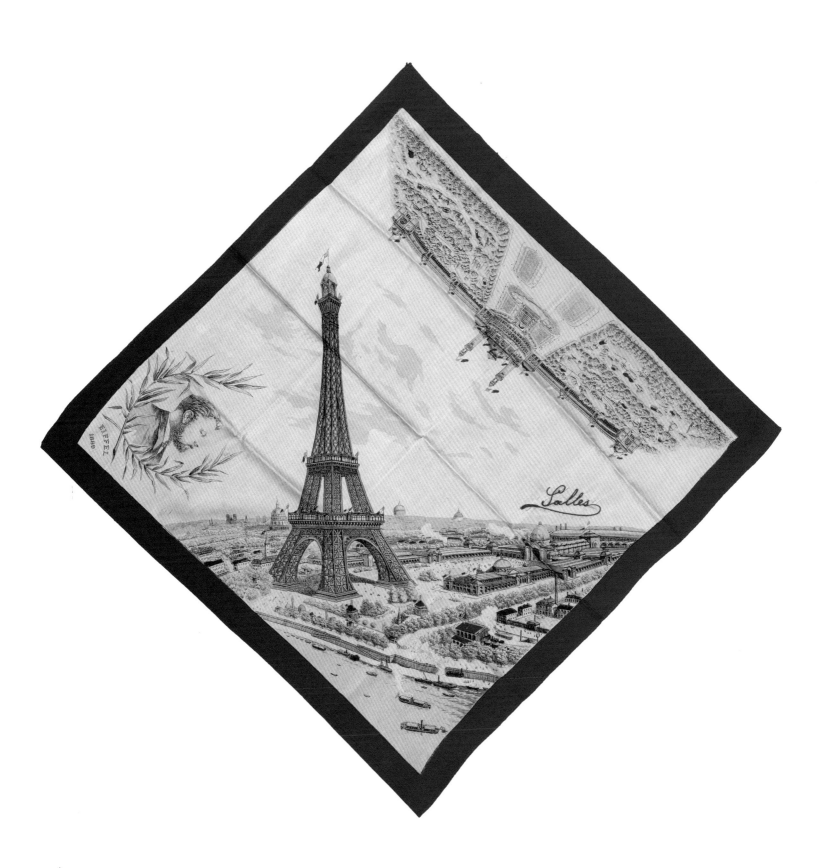

ANONYMOUS
Scarf Decorated with the Eiffel Tower, a Portrait of Gustave Eiffel,
and the Palais du Trocadéro, 1889
Silk

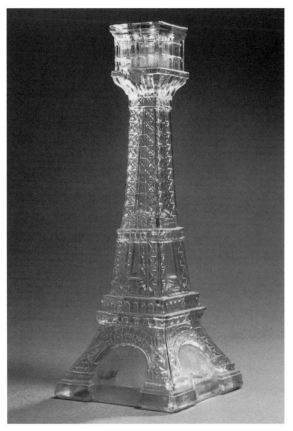

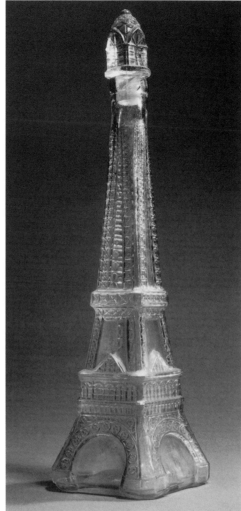

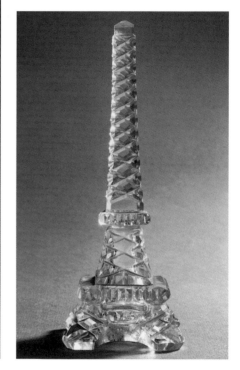

ANONYMOUS
Eiffel Tower Candlestick, 1889
Molded glass

ANONYMOUS
Eiffel Tower Bottle, 1889
Molded glass

ANONYMOUS
Eiffel Tower Perfume Bottle, 1889
Glass

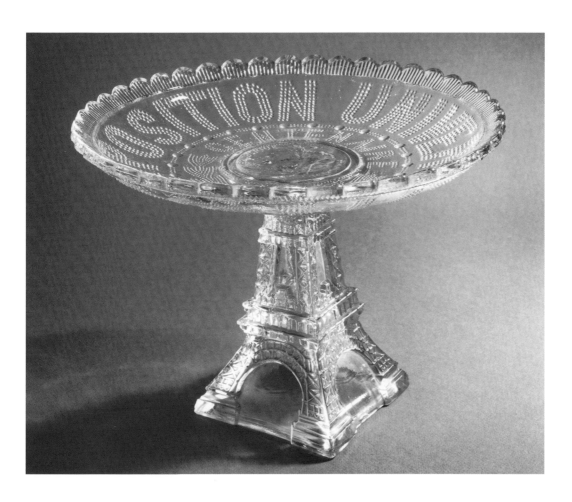

ANONYMOUS
1889 Exposition Universelle Dish with Eiffel Tower Base, 1889
Molded glass

ANONYMOUS
Eiffel Tower Pen Box, 1889
Cardboard, paper, and metal

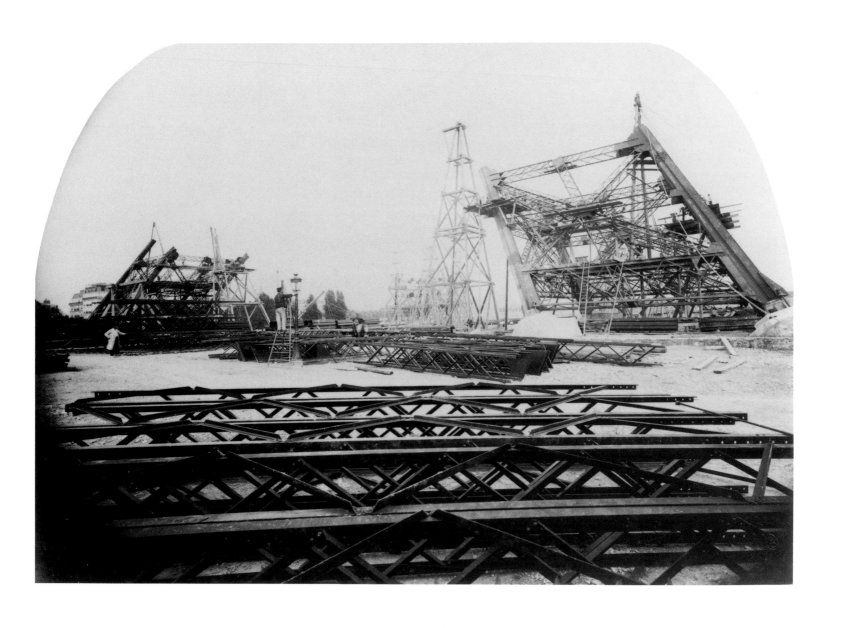

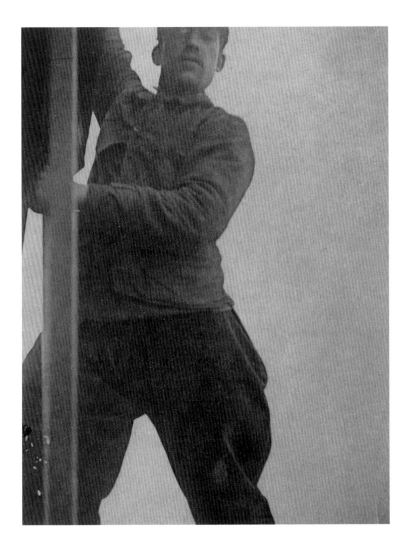

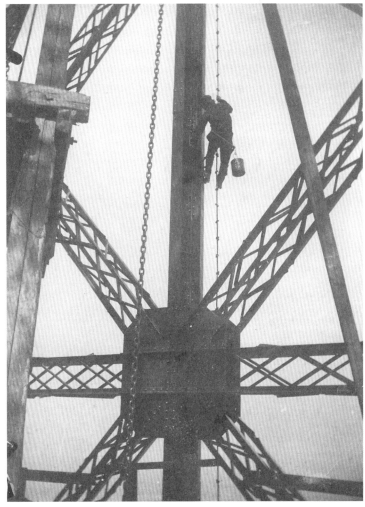

HENRI RIVIÈRE
Worker on the Eiffel Tower, 1889
Gelatin silver print

HENRI RIVIÈRE
Painter on a Knotted Cord along a Vertical Beam, 1889
Gelatin silver print

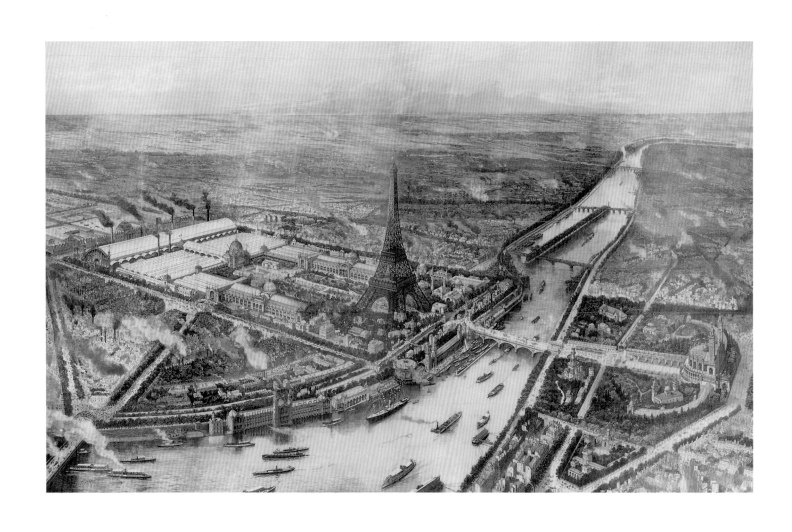

A. DEROY
Engraved by E. A. Tilly
Panoramic View of the 1889 Exposition Universelle, 1889
Engraving

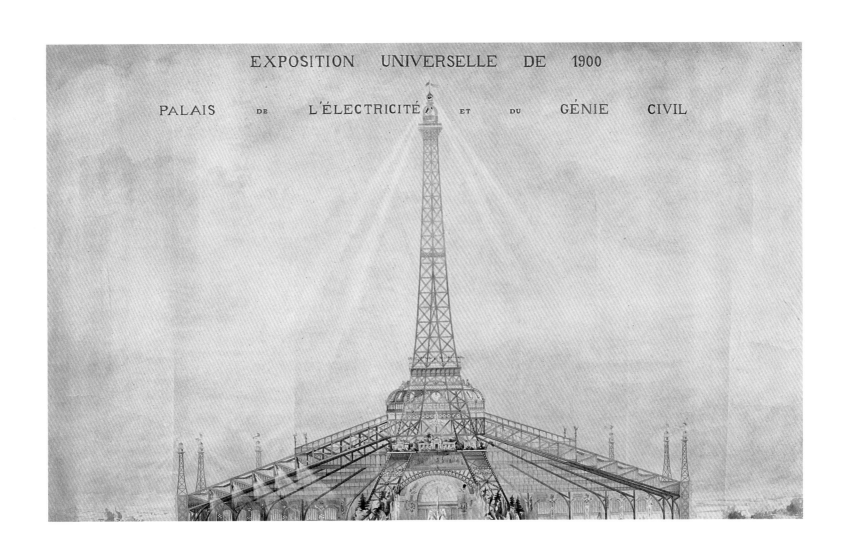

EXPOSITION UNIVERSELLE DE 1900

PALAIS DE L'ÉLECTRICITÉ ET DU GÉNIE CIVIL

HENRI TOUSSAINT
Palais de l'Electricité: Project for the Dressing of the Eiffel Tower
for the 1900 Exposition Universelle, ca. 1894
Gouache over print

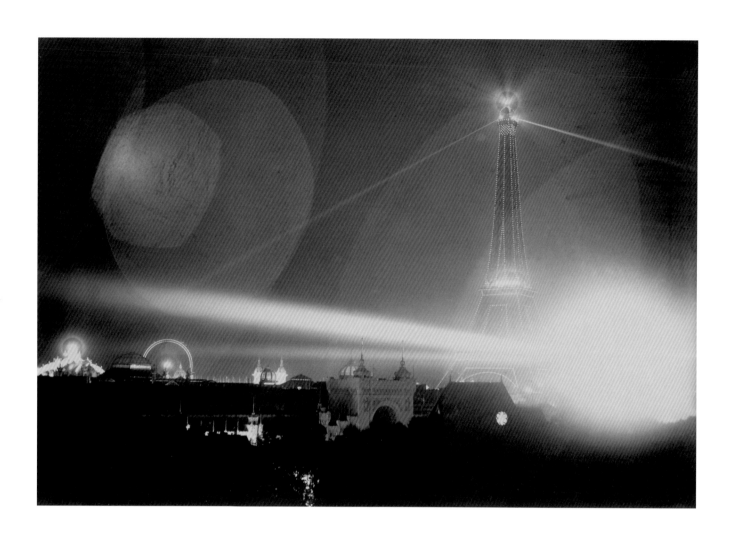

LOUIS-GABRIEL LOPPÉ
Illumination of the Eiffel Tower, ca. 1889
Gelatin silver print

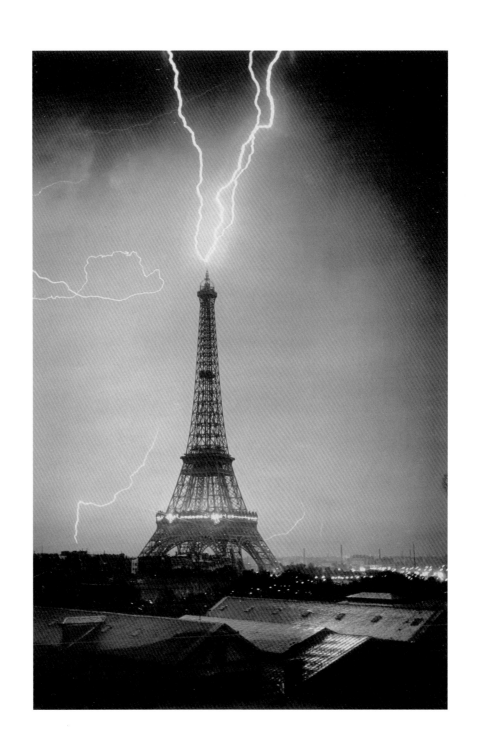

LOUIS-GABRIEL LOPPÉ
The Eiffel Tower Struck by Lightning, 1902
Aristotype

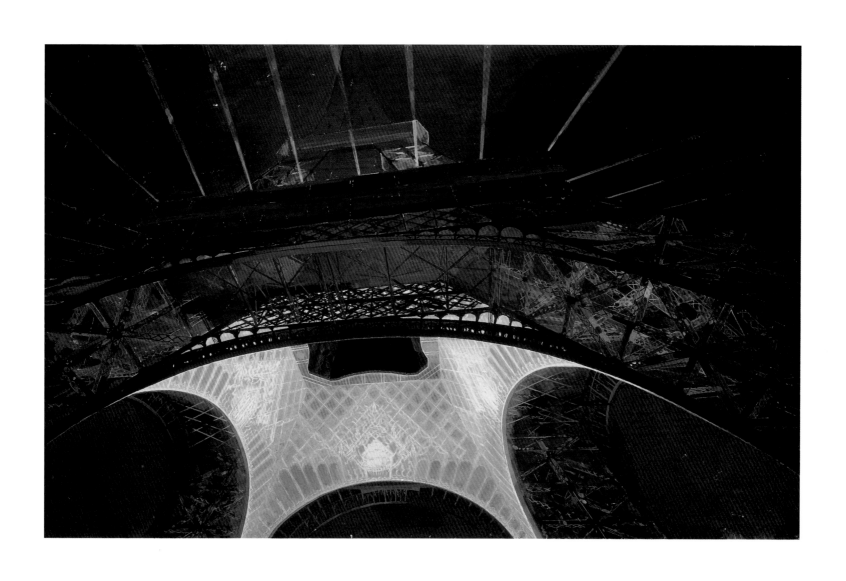

ANDRÉ GRANET
Illumination of the Eiffel Tower for the 1937 Exposition
Universelle, 1937
Gouache on paper

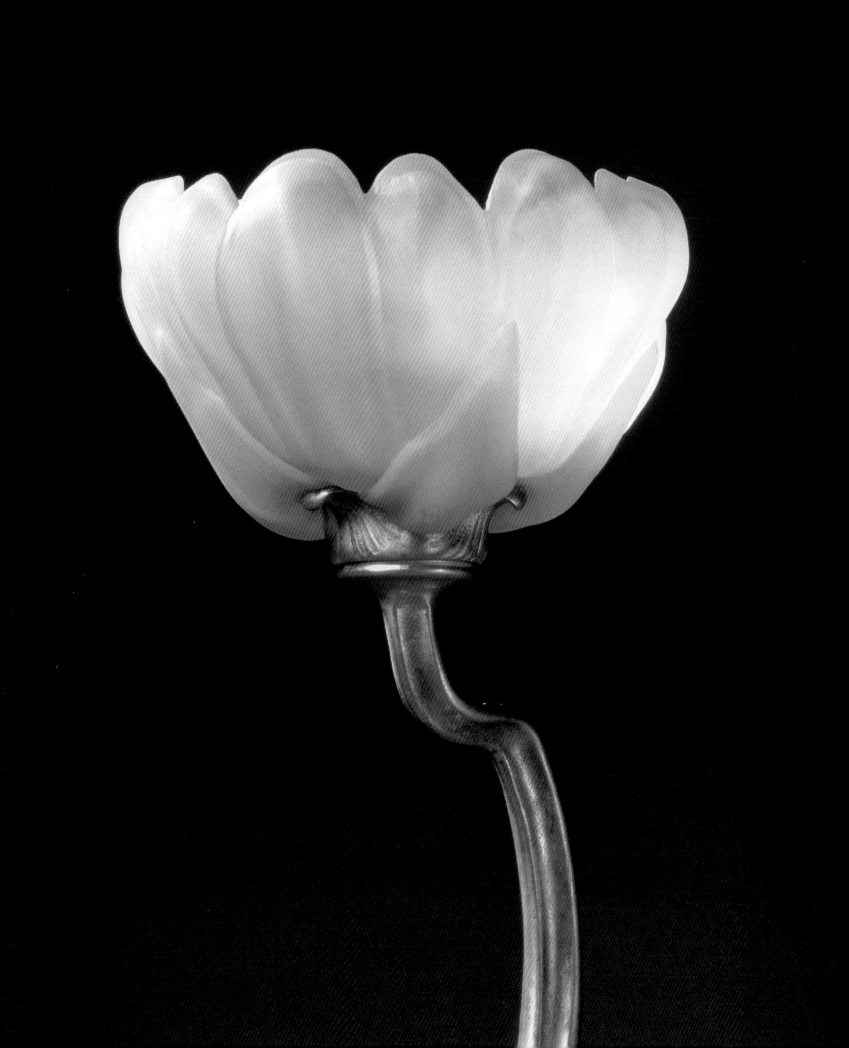

MARC BASCOU

ART NOUVEAU

THE 1889 EXPOSITION UNIVERSELLE IN PARIS MARKED THE BIRTH OF A new decorative style. As interest in creating living environments designed for the new age grew, the number of artists working in the decorative arts increased. In 1891, this trend was advanced by the admission of objets d'art to the annual Salon of the Société Nationale des Beaux-Arts on a par with painting and sculpture. Infused with enthusiasm to create a new art, these artists did not use the expression "Art Nouveau," but "Art Moderne" or "Style Moderne." United in their categorical rejection of the serialized eclecticism produced by industrial manufacturing, they felt the urgent need to clear the table and to innovate.

Who were these pioneers? Sculptors such as Rupert Carabin, Alexandre Charpentier, Jean Dampt, and Jules Desbois (see page 119), whose collaboration was once limited to adding relief and figures to furniture and other objects, now became creators in their own right. Painters joined in as well, and not just minor artists: Paul Gauguin, Émile Bernard and the Nabis, Pierre Bonnard (fig. 1), Édouard Vuillard, Maurice Denis, Paul Ranson, and Ker Xavier Roussel. Even if their projects were not always completed, or were intended exclusively for family and patrons, they clearly indicate a new general desire to explore the relationship between art and life.

With the exception of Émile Gallé, there were few manufacturers involved. Gallé, adding cabinetmaking to his work in ceramic and glass (see page 121), stands out in his ardent efforts to effect a poetic dialogue between natural motifs and a given medium. The strikingly original furniture he built and decorated was directly inspired by nature and reveals the lack of imagination of the Parisian cabinetmakers, whose luxurious neo-Renaissance or neo-Rococo productions seemed antiquated in comparison.

The closer one got to the turn of the century, the more urgent seemed the creative fervor and thirst for rejuvenation. The many art journals flourishing at that time tracked the search for a contemporary style. What was this "modern" style to be? The first requirement, which Eugène Grasset emphasized in a talk about Art Nouveau at the 1897 Union Centrale des Arts Décoratifs, was to establish a unified relationship between function, form, and medium. Achieving a harmony of structure and decoration was the objective shared by all, though the application of these principles took many forms, depending on the impulses of the young creators.

One of the important debates in the midst of this proliferation of new idioms crystallized around the function of decoration: a symbol of strength for Gallé and Louis Majorelle (see page 135), reduced to abstract creases and curves for Hector Guimard, it came to represent the decorator's signature. Gallé conceived of contemporary furniture in terms of animal and vegetal motifs (fig. 2); Guimard treated it in sinuous straps and vigorous knots. But

Fig. 1. Pierre Bonnard, *Project for a Dining Room* (detail), 1891, ink and watercolor on paper, Musée d'Orsay, Paris, gift of Ms. Alice and Marguerite Bowers.

it is the consistent interest in movement that characterized the "Style Moderne" in the amazingly diverse creations made in France and across all of Europe.

When the architect was given preeminence—as master builder, as source of widely accessible material well-being— Art Nouveau revived an ancient tradition. No matter the formula adopted (and there were many), the objective remained the same: reasserting the artist's involvement in everyday life. The prestigious architects were many: Guimard, who designed the Castel Béranger as early as 1894; Henri Sauvage, Charles Plumet, Tony Selmersheim, and Frantz Jourdain in Paris and Émile André in Nancy.

During these same years we see painters, designers, and sculptors assume the role of interior designer and conceive, or collaborate closely on, complete room settings with their furnishings. The Paris of the Belle Époque owes some of its most remarkable decors, public and private, to the decorative talents of Lucien Lévy-Dhurmer, Henri Martin, Henri Bellery-Desfontaines, José Maria Sert and Alphonse Mucha, of Eugène Gaillard, Georges de Feure and Georges Hoentschel, of Jean Dampt and Alexandre Charpentier (fig. 3).

The hierarchical, academic assertion of the supremacy of inventions of the mind over manual labor seemed to be abolished. The will to create a unitary art implies a profound reconsideration of the cultural heritage of Western society. Fighting against the

vanity of pure art became a priority for those believing in social art, intimately intertwined with contemporary life. Art Nouveau reflects a line of thought, regarding the social and economic role of art, put forward by Victor Hugo: "Some lovers of pure art dismiss the formula of Useful Beautiful, fearing that the Useful only deforms the Beautiful. They tremble to see the Muse's arms end in a maidservant's hands. They are wrong. The Useful, far from limiting the Sublime, only enlarges it. . . . With each additional usefulness, there is another beauty."[1]

Modern decorative arts are in a sense a response to a moral crisis in Western society, confronted with the toiling poor of the factories, the lowering of man under the yoke of the machine, and the artistic uniformity imposed by the dictates of mass production. "This is one of the errors," wrote Émile Gallé, "one of the bitter penalties of industrialism, its excessive division of labor, its organization far from the home, the family,

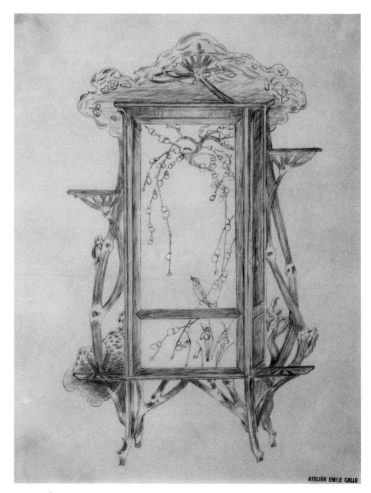

Fig. 2. Émile Gallé, *Design for a Small Wardrobe with Side Shelves*, 1902, pencil, sepia ink on tracing paper, Musée d'Orsay, Paris.

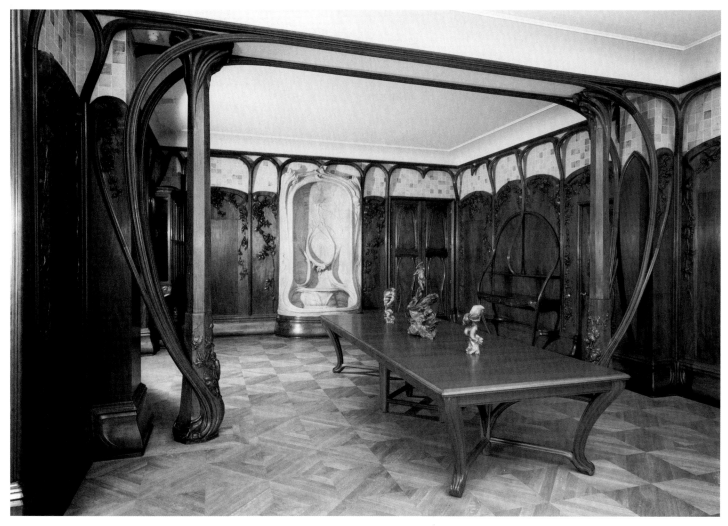

Fig. 3. Alexandre Charpentier (with Alexandre Bigot), *Dining Room
for Mr. and Mrs. Adrien Bernard*, 1901, mahogany and stoneware,
Musée d'Orsay, Paris.

and a natural atmosphere, in one poisoned and artificial."[2] In its
will to restore artistic and creative dignity to the artisan, the will
to reconcile invention and execution, and the will to recognize
the spiritual dimension of craftsmanship, Art Nouveau explicitly
claims to draw its inspiration from the principles of the Arts and
Crafts movement and especially the legacy of William Morris.

Nevertheless, because of the labor demands and the consider-
able expense that fine craftsmanship entails, Art Nouveau rapidly
lost sight of its initial program of "Art for All." Gallé and
Majorelle tried to remedy this by developing a less expensive line
of wares, but they were pale reflections of their earlier creations.

NOTES

1. Victor Hugo, *William Shakespeare* (Paris: 1864), pp. 425–426.
2. Émile Gallé, "Le décor symbolique," *Ecrits pour l'art* (Paris: 1908),
 p. 226.

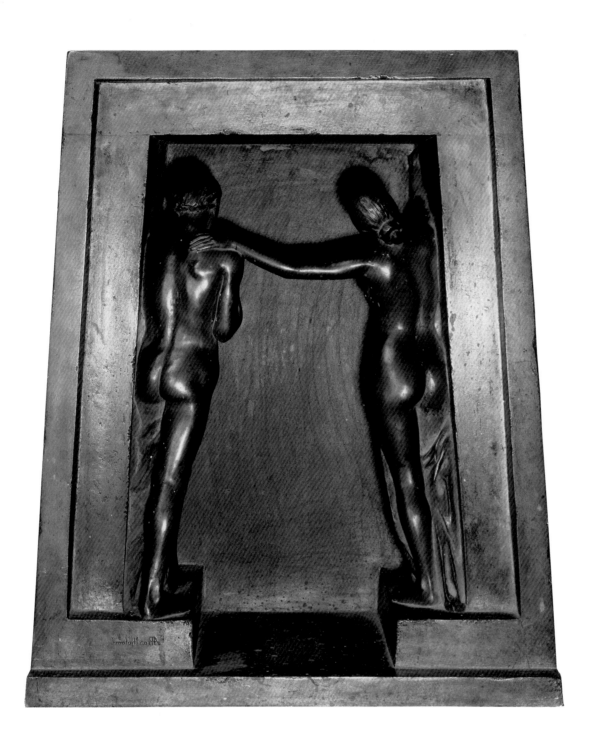

ALBERT BARTHOLOMÉ
Monument to the Dead at Père Lachaise, Central Relief, 1892
Patinated bronze

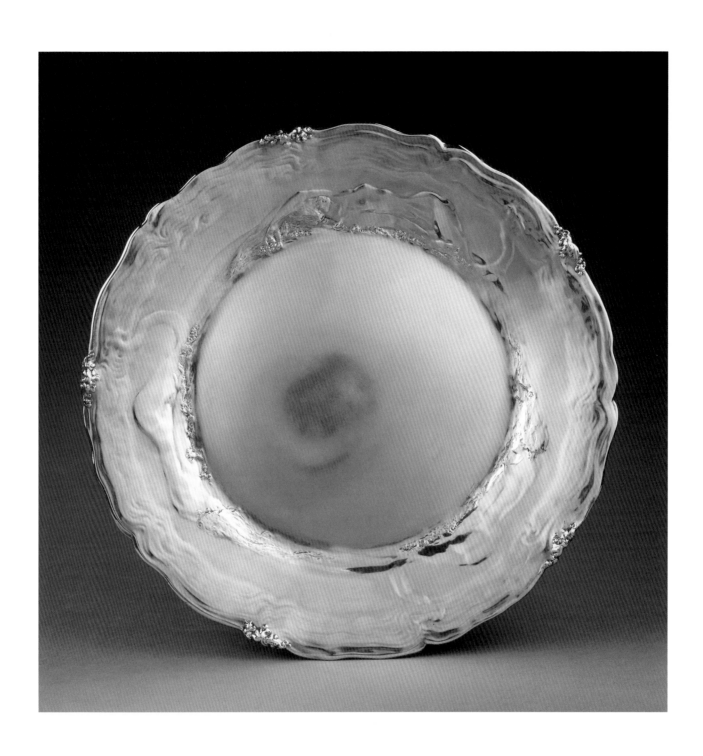

Jules Desbois
Sirens, 1892–1893
Silver

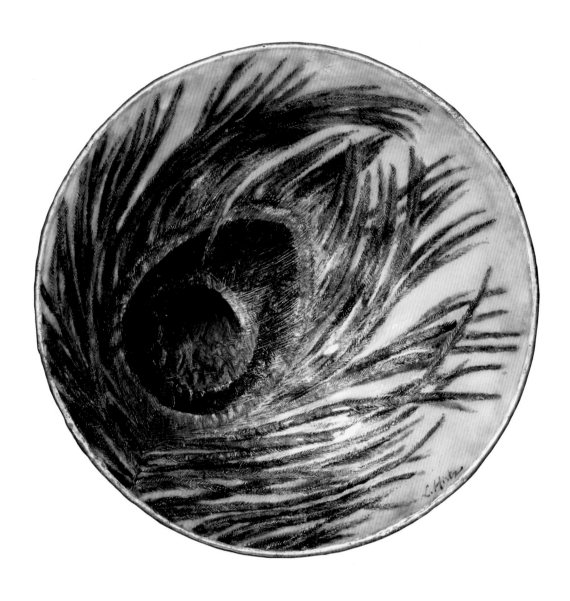

LUCIEN HIRTZ
Peacock Feather Dish, 1896
Enamel on copper

ÉMILE GALLÉ
Balsam Tree Vase, 1895
Hammered and cut crystal with gold inlay

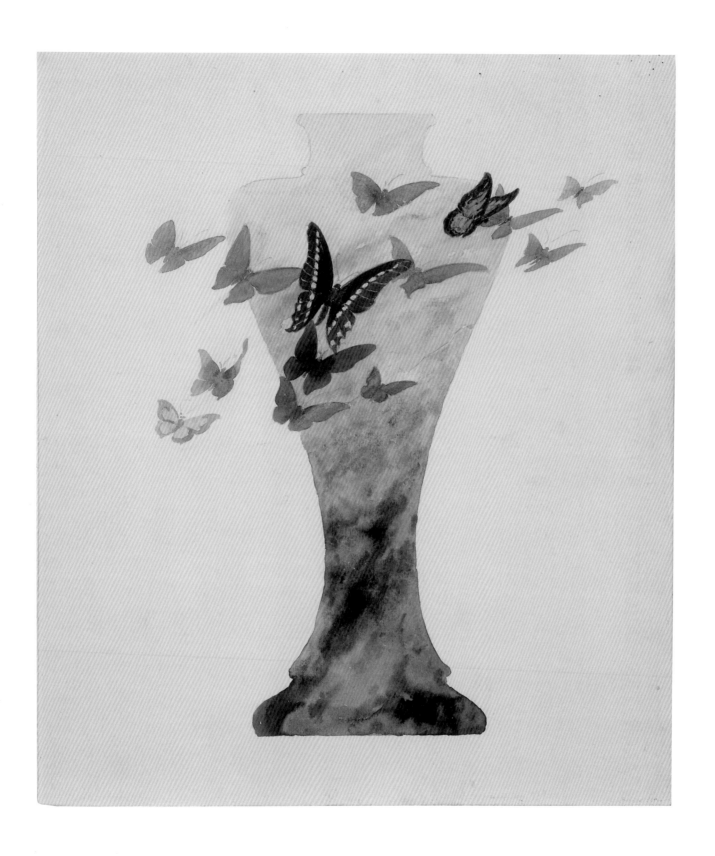

GALLÉ ATELIERS
Vase Decorated with Butterflies in Flight, ca. 1898–1900
Pencil, watercolor, and gouache on paper

GALLÉ ATELIERS

Chinese Vase, ca. 1898–1899

Pencil, watercolor, and gouache on paper

GALLÉ ATELIERS
Vase in the Shape of a Bindweed Corolla, ca. 1900
Pencil, watercolor, and gouache on paper

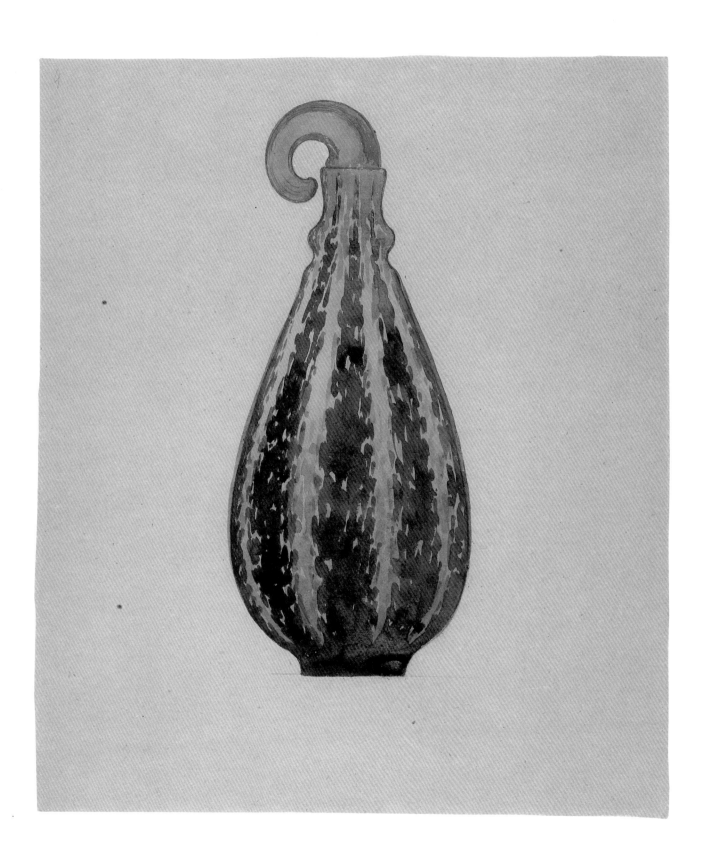

GALLÉ ATELIERS
Bottle in the Shape of a Gourd, ca. 1900
Pencil, watercolor, and gouache on paper

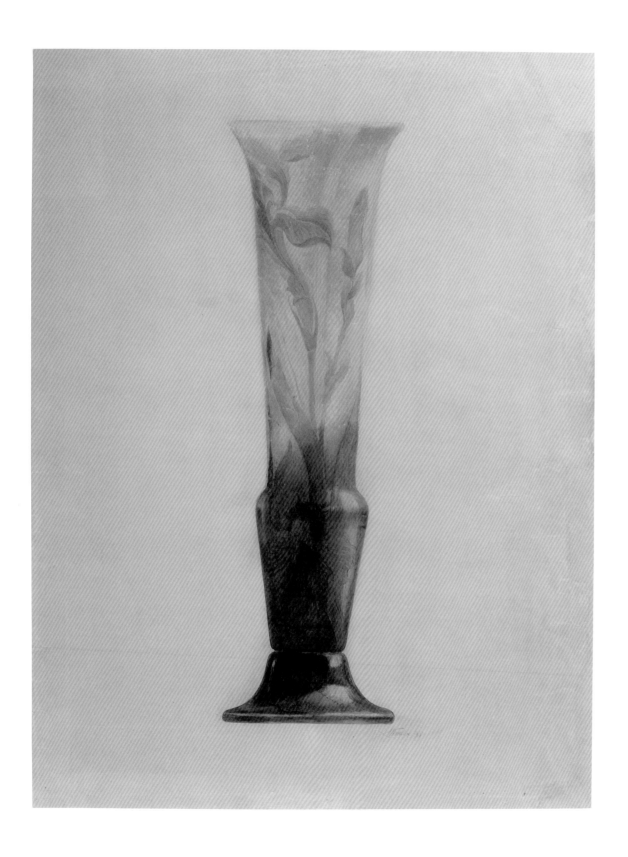

GALLÉ ATELIERS
Vase Decorated with Irises, 1894
Pencil, watercolor, and gouache on paper

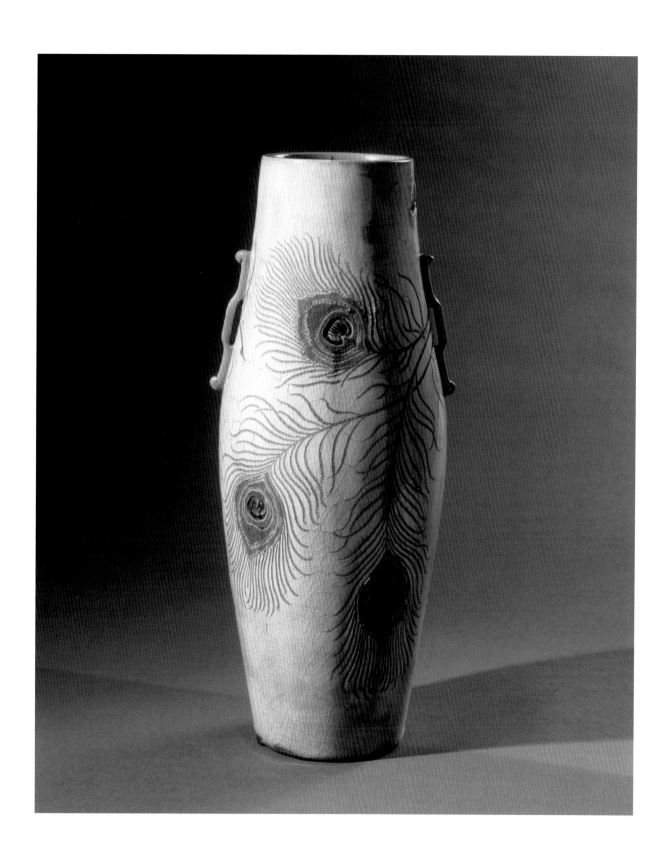

AUGUSTE DELAHERCHE
Peacock Feather Vase, 1889
Enameled stoneware

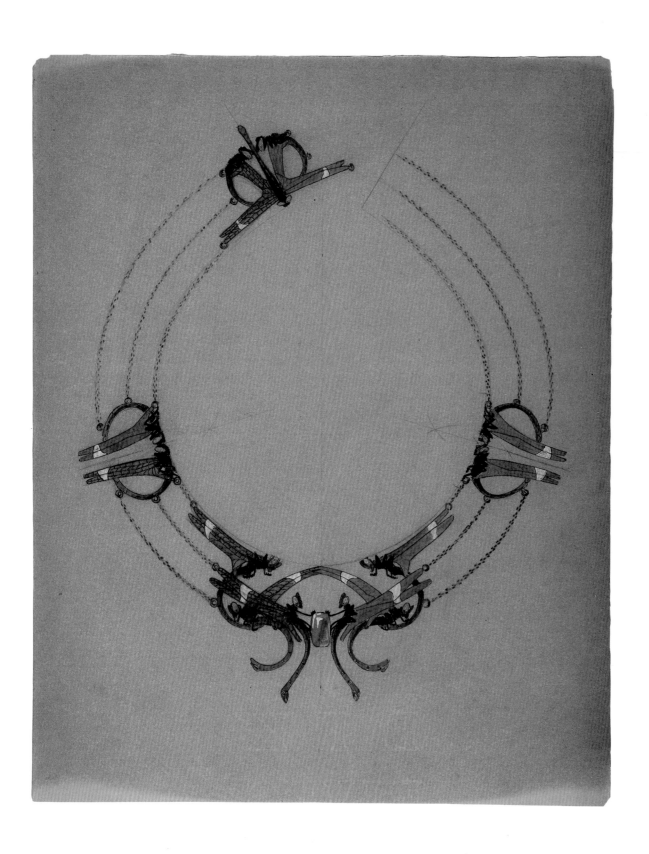

RENÉ LALIQUE
Dragonfly Necklace, ca. 1903–1905
Pencil, ink, watercolor, and gouache on tracing paper

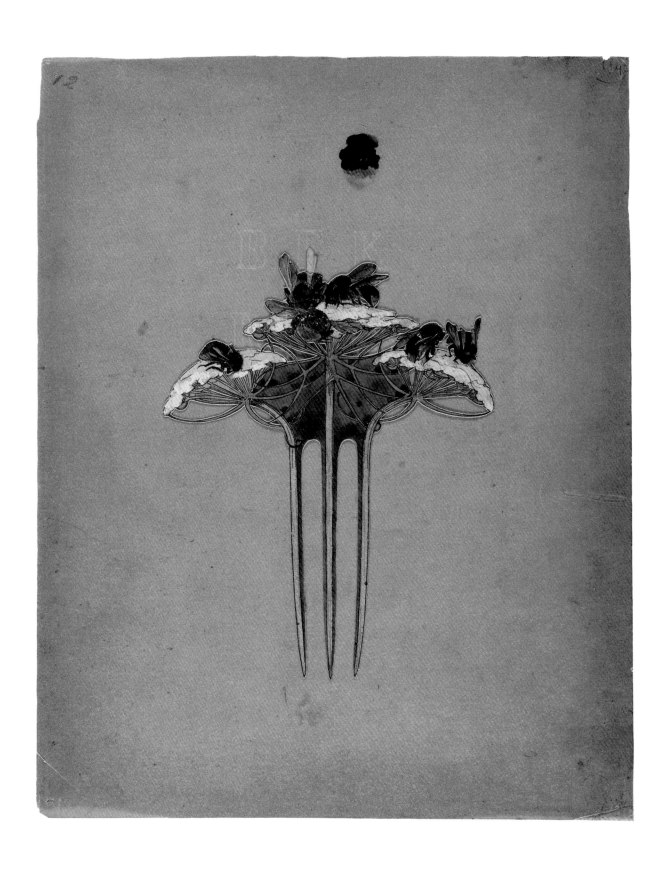

RENÉ LALIQUE
Cow Parsnip and Bumblebee Comb, ca. 1901–1902
Pencil, ink, watercolor, and gouache on tracing paper

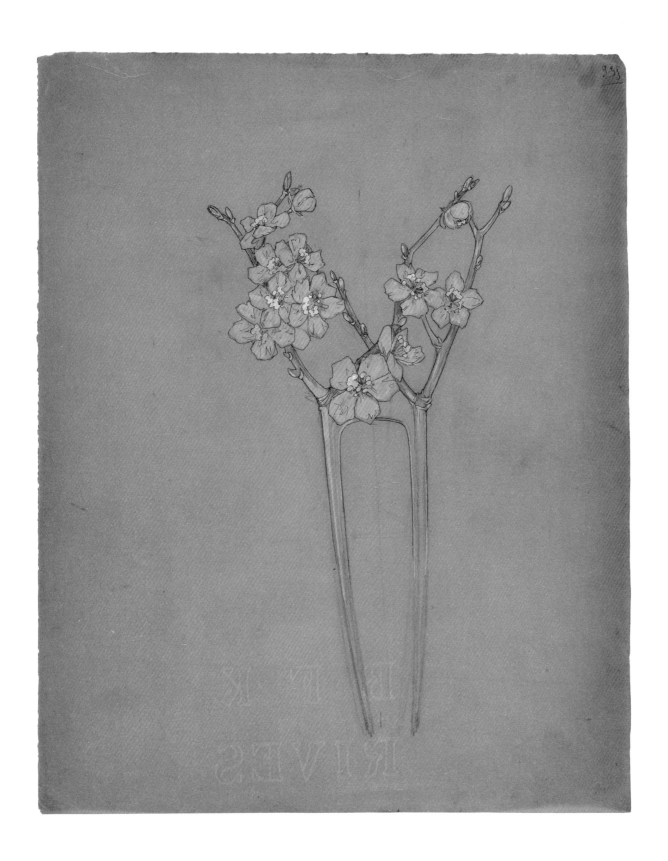

RENÉ LALIQUE
Hawthorn Comb, ca. 1902–1903
Pencil, ink, watercolor, and gouache on tracing paper

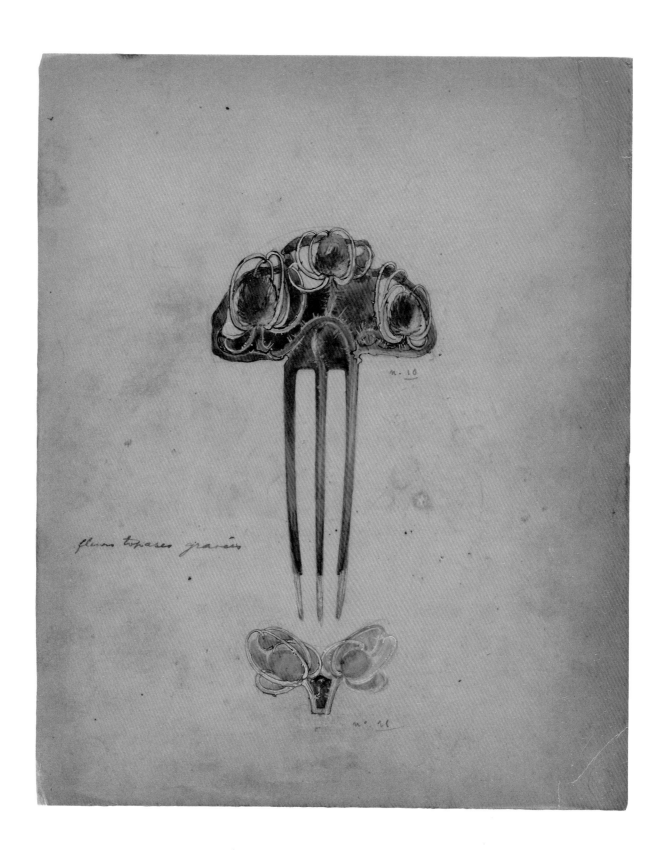

René Lalique

Sea Holly Comb, ca. 1905

Pencil, ink, watercolor, and gouache on tracing paper

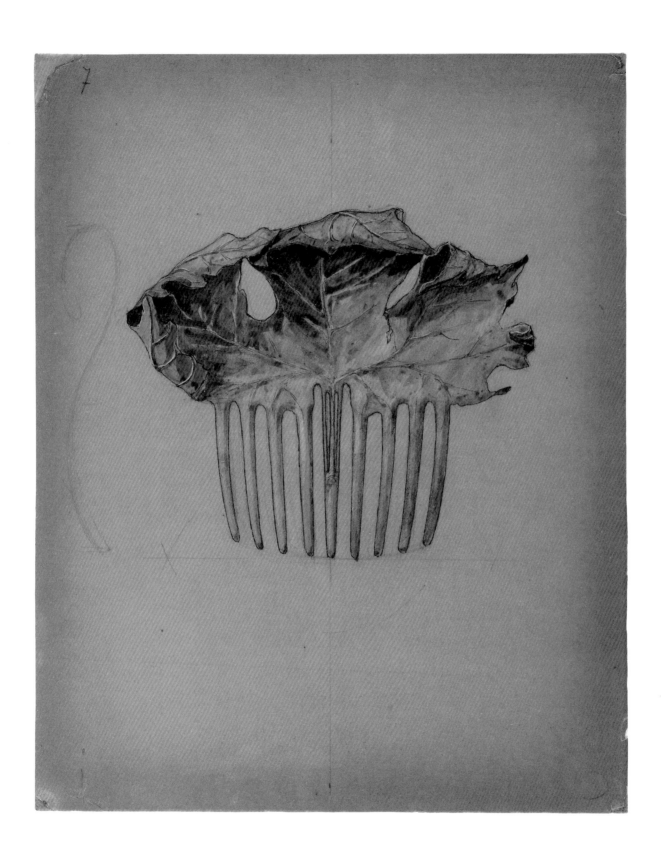

RENÉ LALIQUE
Maple Comb, ca. 1899–1900
Pencil, ink, watercolor, and gouache on tracing paper

RENÉ LALIQUE
Powder Jars, 1908–1909
 Cut and engraved crystal, repoussé and chased silver, and molded glass

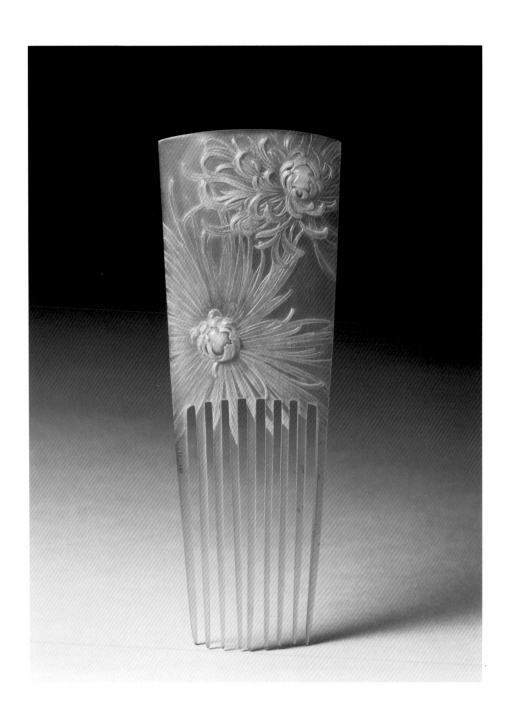

LUCIEN GAILLARD
Chrysanthemum Comb, 1903–1904
Carved horn, opals, and gold

LOUIS MAJORELLE
Manufactured by Daum Frères
Water-Lily Lamp, 1902–1903
Gilded and embossed bronze and pâte de verre

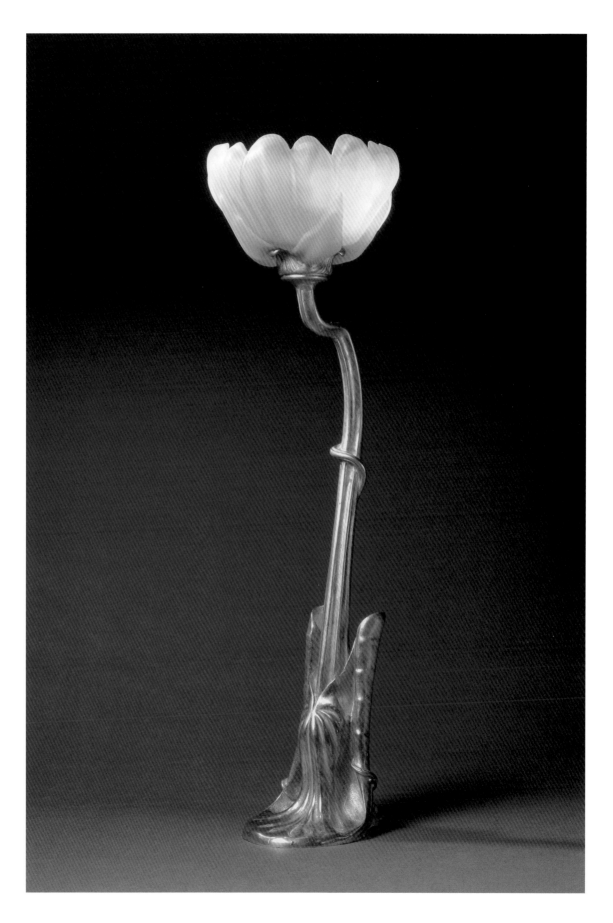

PIERRE BONNARD
Plate, ca. 1906–1910
Faience and brown ink

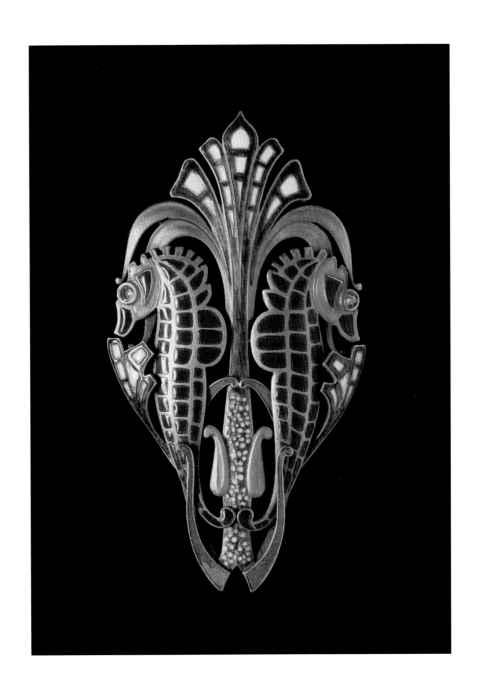

FRÉDÉRIC FORTHUNY
 Manufactured by Henri Dubret
 Seahorse Pendant, 1919–1920
 Gold, enamel, and diamonds

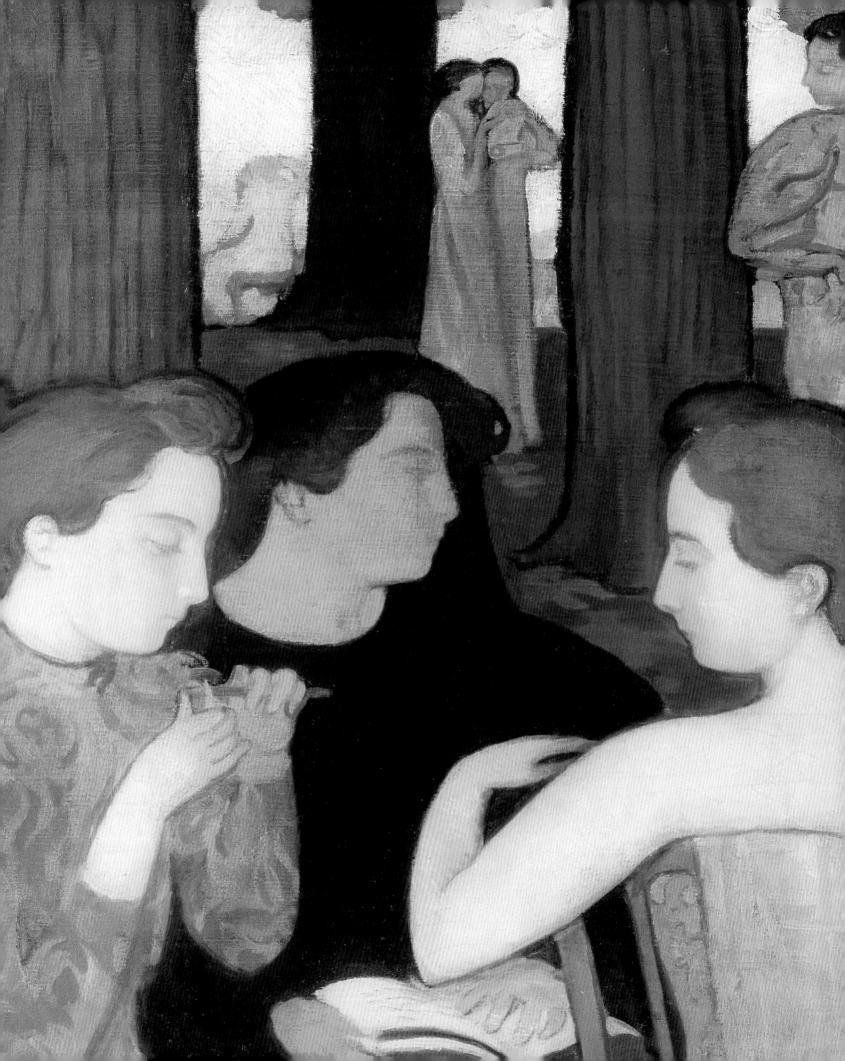

DAVID A. BRENNEMAN

AVANT-GARDE AT CENTURY'S END

IN 1910, THE INFLUENTIAL BRITISH ARTIST AND CRITIC ROGER FRY COINED the term "Post-Impressionism" to describe the artistic tendencies that emerged in Paris at the turn of the century. Although scholars since Fry have found his suggestion that the tendencies belonged to a coherent movement untenable, the term continues to be used to designate work by those French artists who broke away from what they perceived as a superficial emphasis on re-creating the effects of light and atmosphere to pursue different options.

Of all of the Post-Impressionist artists, Fry considered Paul Cézanne the "great originator."[1] The paintings in this exhibition by Cézanne—*Bathers* of 1890–1892 (page 150) and *Apples and Oranges* of 1895–1900 (page 151)— demonstrate, when compared with the delicately touched surfaces of Impressionist paintings, a more solid, architectural approach, featuring patches of parallel brush strokes. They also display Cézanne's willful distortion of the human figure and his disregard for the conventions of perspective. The fruit in his still life, for example, could not possibly be resting on the vertiginous surface of the table. Cézanne was interested in re-creating the sensation of looking, not in the faithful reproduction of his subjects. During Cézanne's lifetime, only a handful of critics and collectors, mostly the artist's friends (fig. 1), appreciated his revolutionary style, and it was only after his death in 1906 that a wider audience began to appreciate his work.

Although he exhibited with the Impressionists, Georges Seurat developed an approach to painting that was characterized by the application of paint in small, discrete dots of unmixed color. Seurat held radical political beliefs, and his scientific, positivist approach to painting derived from his conviction that society should be governed by a set of socially equalizing, rational laws. Seurat's small painting *The Little Peasant in Blue* (page 142) is an early experiment in Pointillism in which the artist used a network of uniform, unblended brush strokes to build the picture surface. Henri-Edmond Cross was a later convert to Pointillism, and his painting *The Head of Hair* (page 149), executed in the early 1890s, shows that style in its most developed and carefully controlled state. Seurat died in 1891 and did not see the spreading influence of the movement he created. In the 1890s, Pointillism inspired a group of Belgian artists, including Théo van Rysselberghe (see page 148), who carried the movement beyond France.

Along with Émile Bernard, Paul Gauguin looked to Japanese woodblock prints as well as medieval stained glass and enameled jewelry for inspiration. The movement they created was called "Cloisonnism" or "Synthetism." Stylistic hallmarks include areas of unmodulated, saturated color and heavy contour lines, which can be seen in an early Synthetist work such as Bernard's *Still Life with Orange* (fig. 2). These artists sought to fill their art with an expressive symbolism. In *The Alyscamps* (page 144), Gauguin turned to the

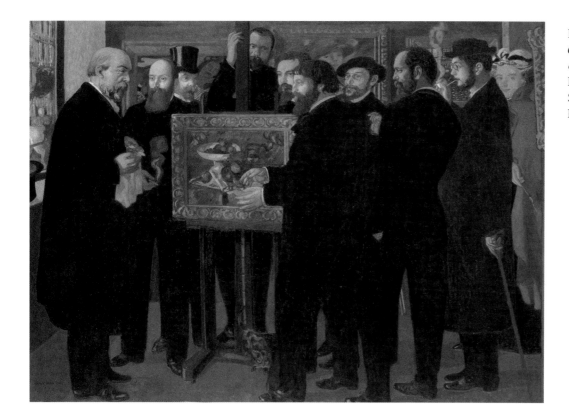

Fig. 1. Maurice Denis, *Homage to Cézanne*, 1900, oil on canvas, Musée d'Orsay, Paris. Pictured are Vollard, Redon, Vuillard, Mellerio, Denis, Sérusier, Ranson, Bonnard, and Madame Denis.

peasants of the southern French city of Arles, while Bernard's *Breton Women with Parasols* (page 145) depicts inhabitants of Brittany who maintained customs and dress dating to the Middle Ages. For Gauguin and Bernard, these peasants embodied Jean-Jacques Rousseau's notion that traditional cultures were morally and spiritually pure because they had not succumbed to the corrupting influences of modern society.

Vincent van Gogh admired the Impressionists, but he arrived in Paris too late to participate in their group exhibitions. Like Gauguin and Bernard, into whose circle he was tightly woven in the late 1880s, van Gogh was interested in producing paintings that were spiritually redemptive. His brand of symbolism is evident in his paint surfaces, which are characterized by bold color juxtapositions and heavily impastoed paint strokes. A failed missionary, van Gogh sought sympathetic subjects from society's underclass, such as an anonymous Italian woman whom he imbued with radiant warmth and energy (page 143).

The Nabis (derived from the Hebrew word for "prophet") were artists who formed a loose association in the early 1890s. Like the Synthetists, the Nabis were inspired by medieval European and Japanese art. Maurice Denis's paintings, with their heavy outlines, convey something of the pictorial quality

of stained glass (page 147), while Pierre Bonnard's large work *Twilight* (page 146) betrays the influence of Japanese woodblock prints in the picture's flat, decorative arrangement of forms and colors. The Nabis became identified with the subject of domestic interiors. As in the poetic interiors of seventeenth-century Dutch painter Johannes Vermeer, paintings such as Édouard Vuillard's *Breakfast* (page 158) represent a turning away from the outside world exemplified by the inviting landscapes of the Impressionists.

In the latter decades of the nineteenth century, avant-garde sculptors reacted against the sensuous classicism and revivalism that was prevalent in the Academy and the Salon. The leader in this regard was Auguste Rodin, who turned sculpture on its head through his boldly modeled, monumental treatment of the human form (see page 156). Edgar Degas, a leading avant-garde painter, experimented privately with sculpture, producing radically innovative compositions. In *The Tub* (page 153), Degas presents us with a piece that is meant to be viewed from above, a viewing angle that was unheard of in academic circles.

At the close of the nineteenth century, some artists took the idea of artistic independence to its extreme and pursued their own goals. One of the most interesting cases is that of Henri

Rousseau, a tollgate keeper in Paris. Rousseau did not receive much, if any, formal artistic training. He painted charmingly naive portraits, such as that of Madame M. (page 157), as well as imaginative renderings of exotic scenes. Although seemingly unintentional, Rousseau's neglect of the rules of perspective and niceties of draftsmanship placed him in the ranks of the avant-garde, and he was appreciated and supported by artists such as Félix Vallotton (see page 159).

At the Paris Salon d'Automne of 1905, Rousseau exhibited works alongside a group of young artists that included André Derain and Henri Matisse. These artists absorbed the movements of the 1880s and 1890s and formed the avant-garde of the first decade of the twentieth century. They were dubbed *les Fauves* ("wild beasts") for their seemingly uncontrolled use of color and drawing. In painting *Charing Cross Bridge* (page 160) in 1906, Derain almost completely abandoned objectivity and instead presented the viewer with a riot of bold colors and forms. When Roger Fry organized the first English showing of the Fauves in 1912, he anticipated a public outcry by acknowledging the revolutionary nature of their art in the introduction to the exhibition catalogue.[2] Fry understood the nature of avant-garde art and was prepared for a battle to bring modern French art to other parts of the world, a battle that he and other critics and artists in Europe and the United States eventually won.

Fig. 2. Émile Bernard, *Still Life with Orange*, 1887, oil on board mounted on canvas, High Museum of Art, Atlanta.

NOTES

1. Roger Eliot Fry, *Vision and Design* (New York: Brentano's, 1921), p. 241.
2. Ibid., p. 237.

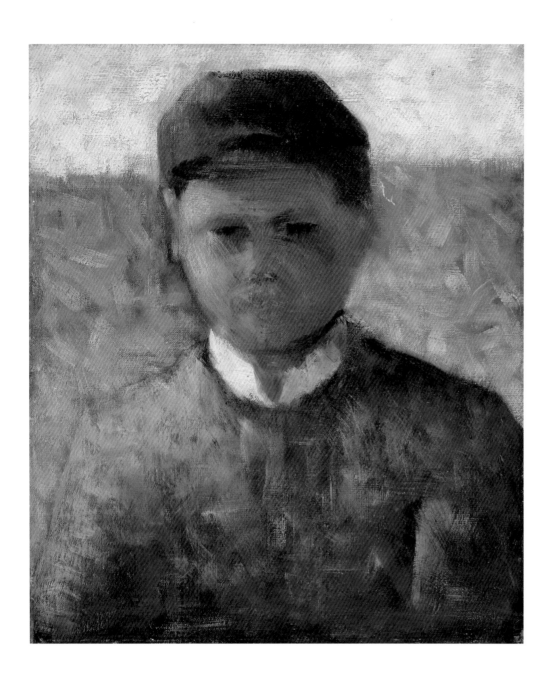

GEORGES SEURAT
The Little Peasant in Blue, ca. 1882
Oil on canvas

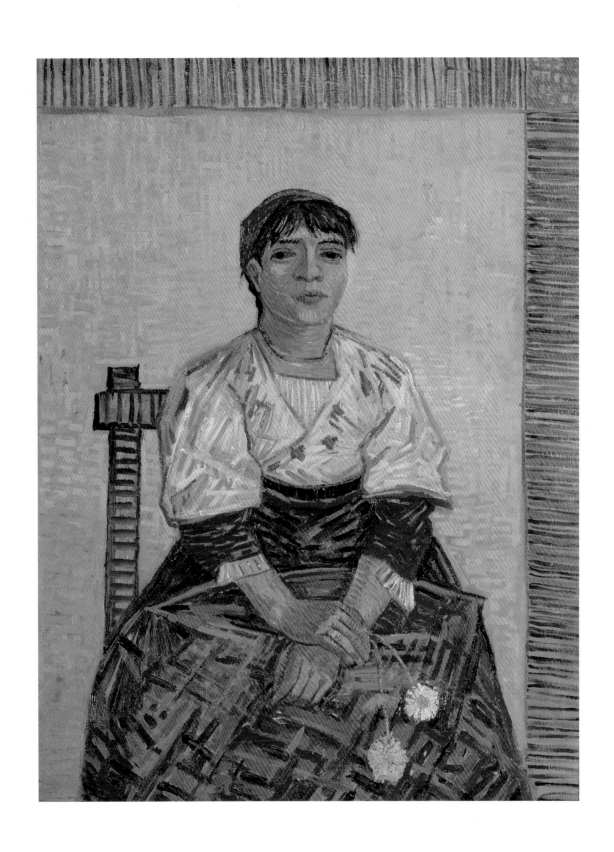

VINCENT VAN GOGH
The Italian Woman, 1887
Oil on canvas

PAUL GAUGUIN
The Alyscamps, 1888
Oil on canvas

ÉMILE BERNARD
Breton Women with Parasols, 1892
Oil on canvas

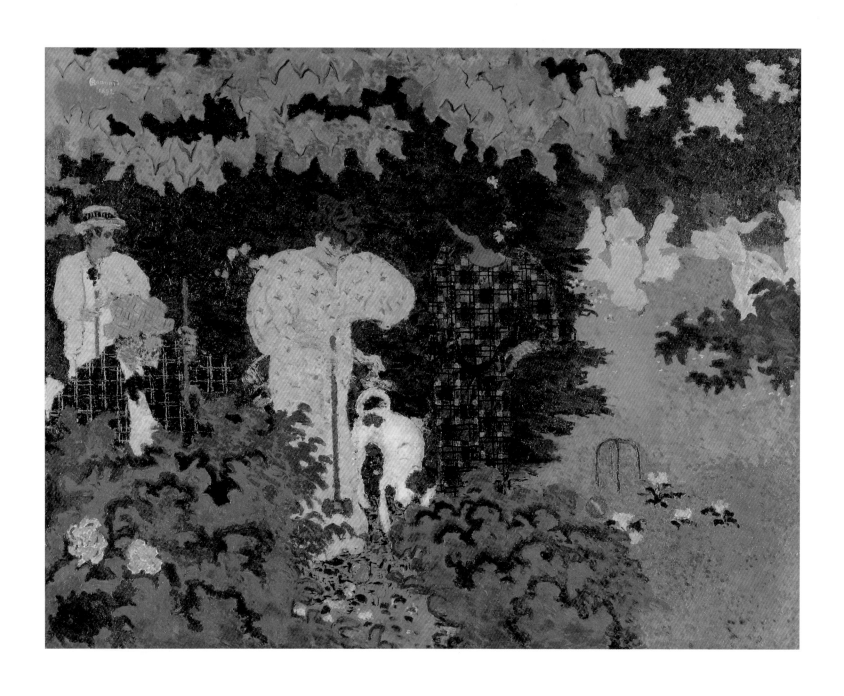

PIERRE BONNARD
Twilight (The Croquet Party), 1892
Oil on canvas

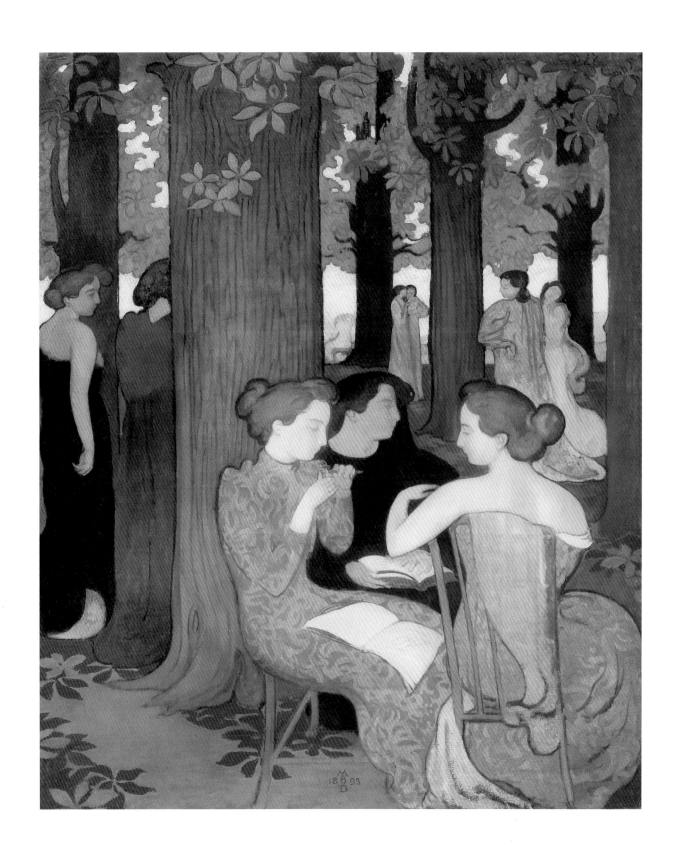

MAURICE DENIS

The Muses, 1893

Oil on canvas

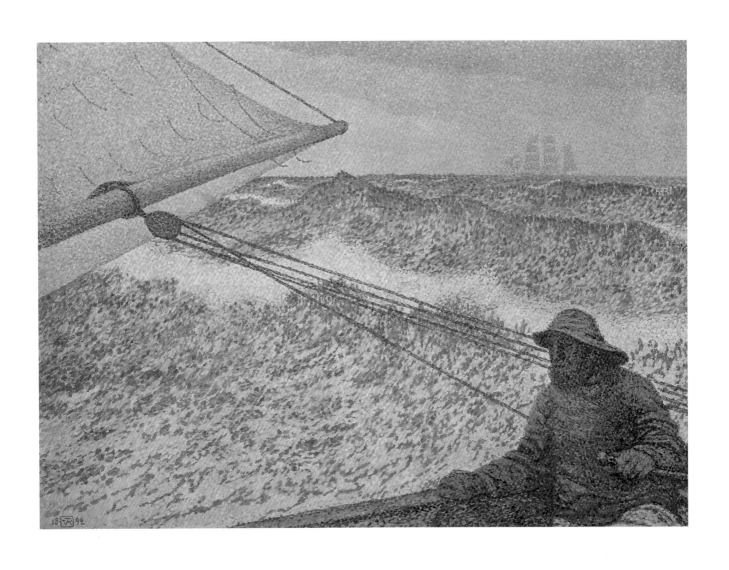

THÉO VAN RYSSELBERGHE
Man at the Helm, 1892
Oil on canvas

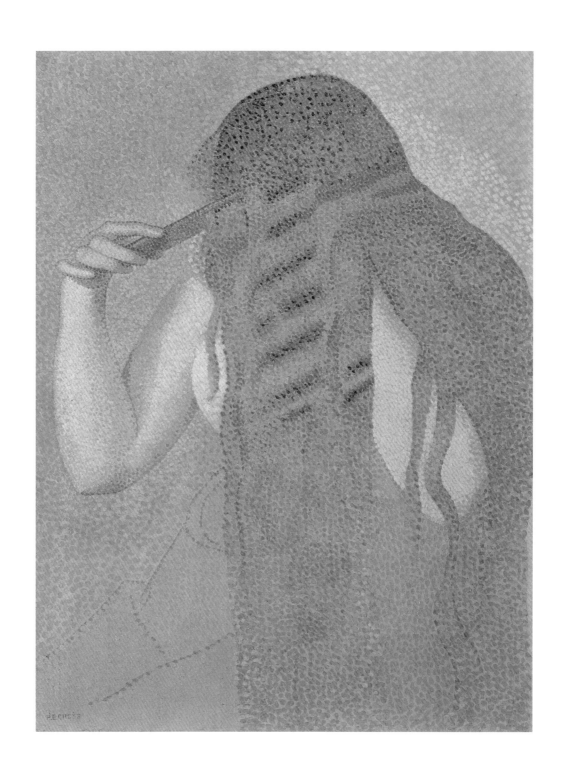

Henri-Edmond Cross
The Head of Hair, ca. 1892
Oil on canvas

PAUL CÉZANNE
Bathers, ca. 1890–1892
Oil on canvas

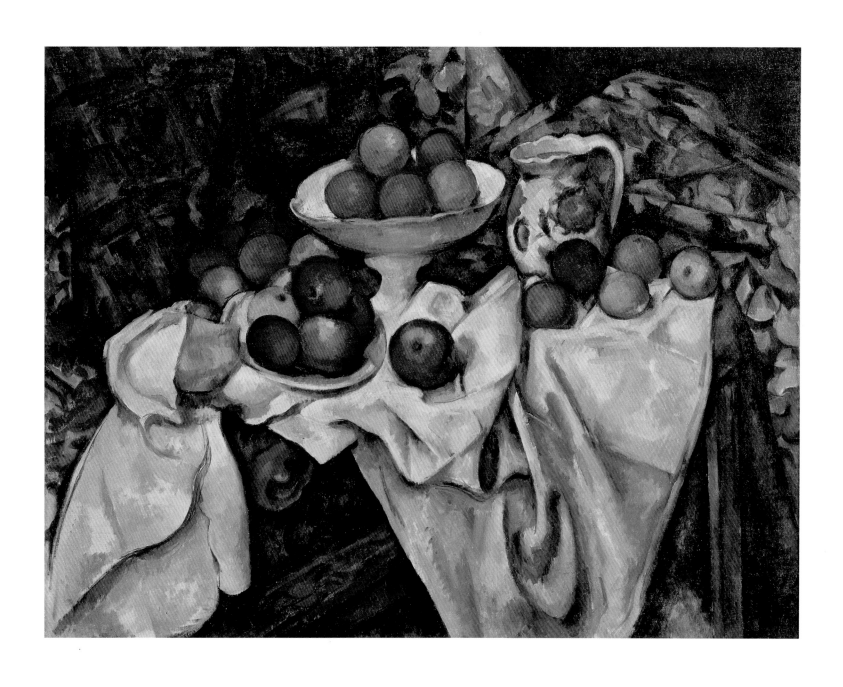

Paul Cézanne
Apples and Oranges, ca. 1895–1900
Oil on canvas

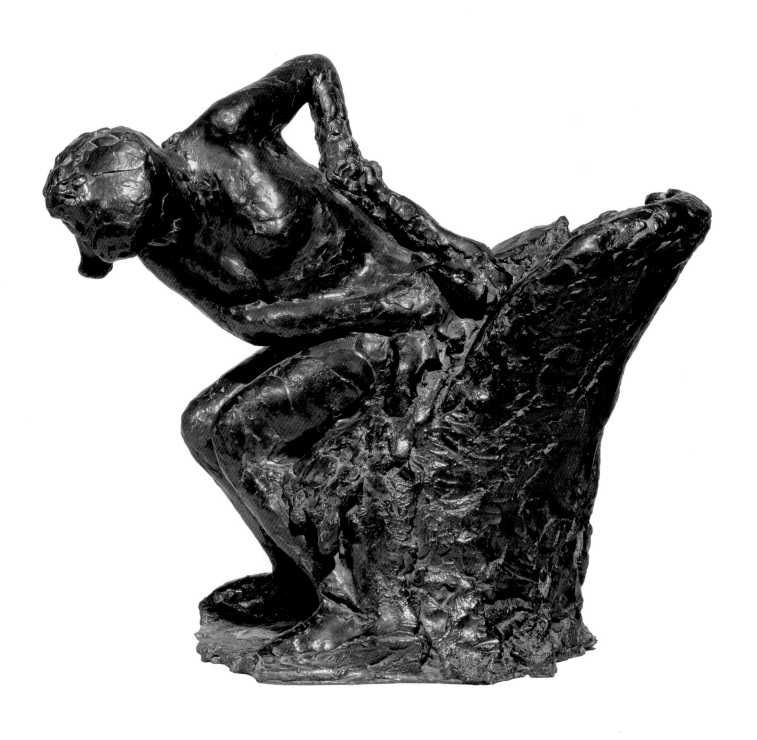

EDGAR DEGAS
Seated Woman Drying Herself, 1896–1911
Bronze

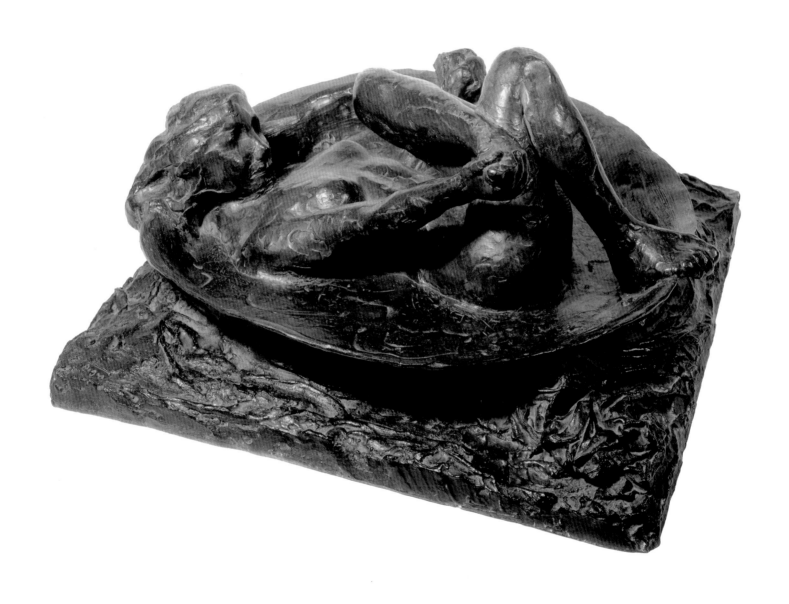

EDGAR DEGAS
The Tub, 1888–1889
Bronze

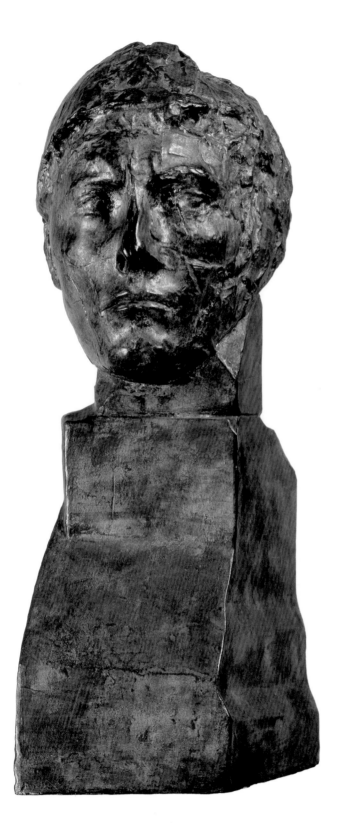

ÉMILE-ANTOINE BOURDELLE
Head of Apollo, 1900–1909
Gilt bronze

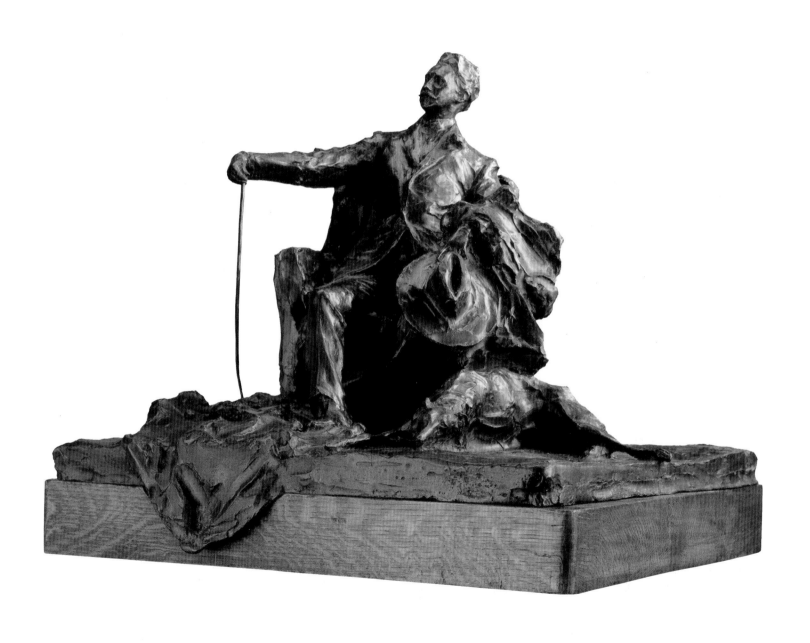

PAUL TROUBETSKOY
Comte Robert de Montesquiou, 1907
Patinated bronze

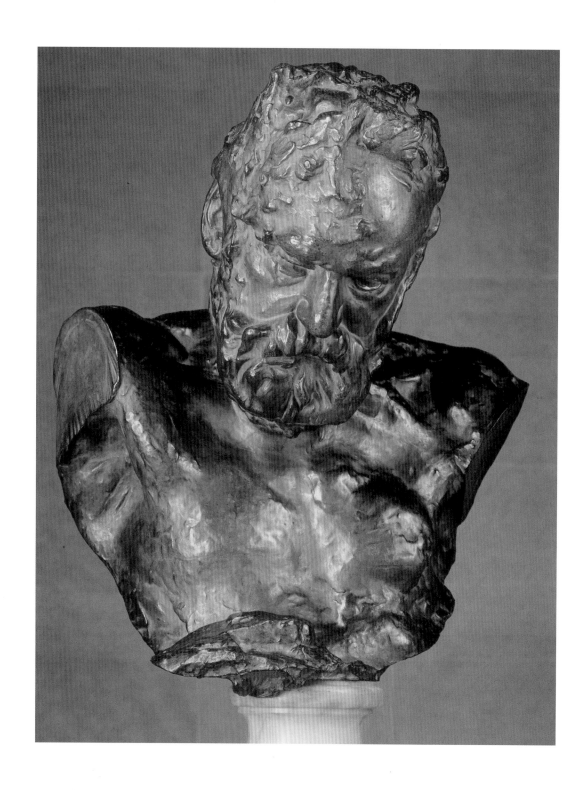

AUGUSTE RODIN
Heroic Bust of Victor Hugo, 1897
Patinated bronze

HENRI ROUSSEAU
Portrait of Madame M., ca. 1897
Oil on canvas

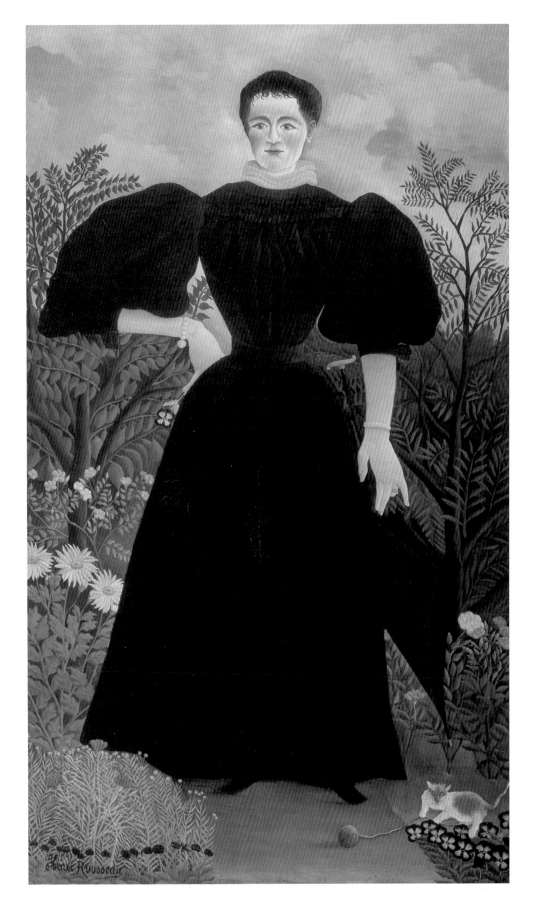

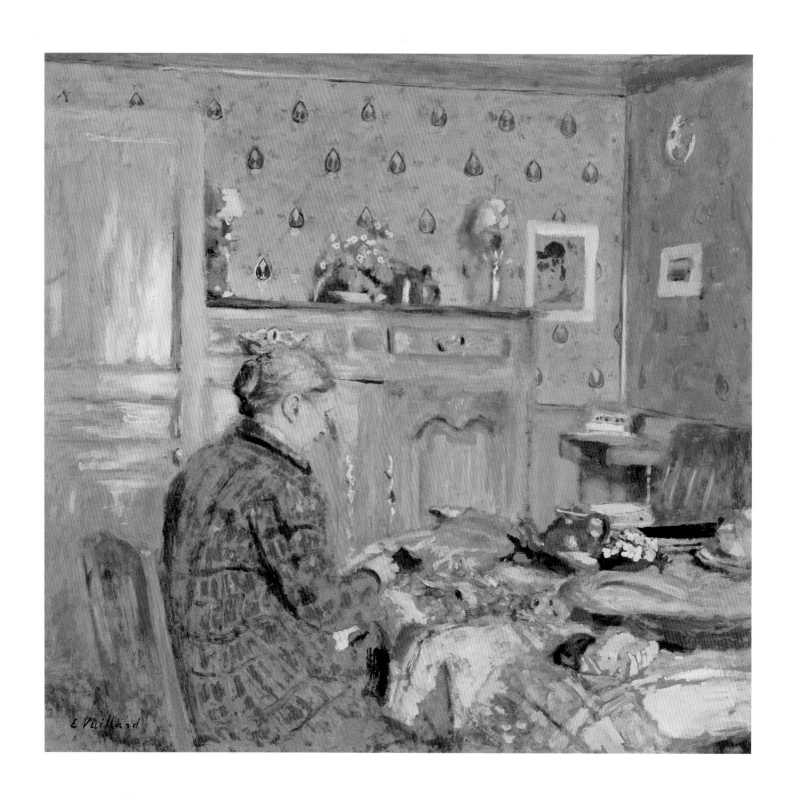

ÉDOUARD VUILLARD
Breakfast, ca. 1900
Oil on cardboard

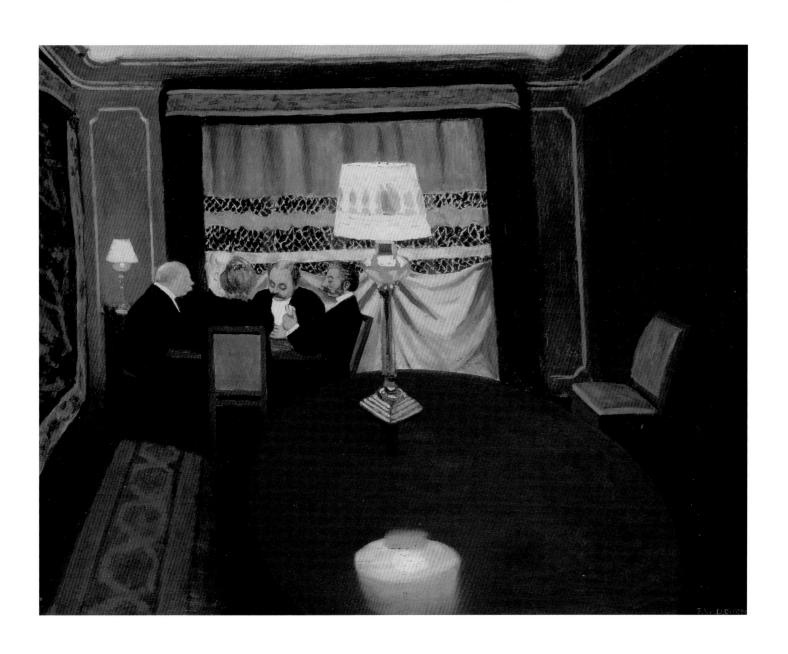

Félix Vallotton
Poker, 1902
Oil on canvas

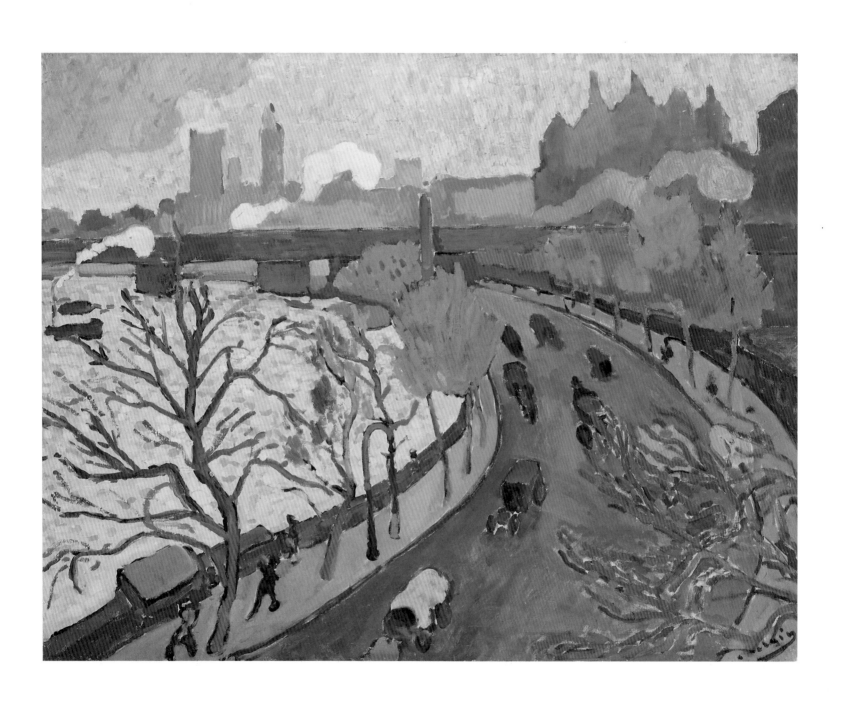

ANDRÉ DERAIN
Charing Cross Bridge, ca. 1906
Oil on canvas

CHECKLIST OF THE EXHIBITION

Works are listed alphabetically by artist. Unless otherwise noted, dimensions are given height before width before depth.

ADOLPHE ALPHAND
Grenoble 1817–Paris 1891

JEAN DARCEL
born 1823

ÉMILE REIBER
Sélestat 1826–Paris 1893

Project for a Cast-Iron Tower for the Artesian Wells in Passy, 1857
Watercolor with white gouache touches on paper, 38½ × 26⅜ inches
Musée d'Orsay, Paris
Page 28

ANONYMOUS

Project for the Monument to be Built on the Site of the Palais des Tuileries, ca. 1880–1885
Pencil, black ink, and watercolor on paper, 16⅜ × 21⅛ inches
Musée d'Orsay, Paris
Page 29

ANONYMOUS

Construction of the Eiffel Tower, 1888
Albumen print, 10¾ × 14½ inches
Musée d'Orsay, Paris
Eiffel Collection, gift of Mlle. Solange Granet, Mme. Bernard Granet and her children, descendants of Gustave Eiffel, 1981
Page 104

ANONYMOUS

1889 Exposition Universelle Dish with Eiffel Tower Base, 1889
Molded glass, 7¼ × 10 inches
Musée d'Orsay, Paris
Eiffel Collection, gift of Mlle. Solange Granet, Mme. Bernard Granet and her children, descendants of Gustave Eiffel, 1981
Page 103

ANONYMOUS

Eiffel Tower Bottle, 1889
Molded glass, 14⅛ × 3⅝ × 3⅝ inches
Musée d'Orsay, Paris
Eiffel Collection, gift of Mlle. Solange Granet, Mme. Bernard Granet and her children, descendants of Gustave Eiffel, 1981
Page 102

ANONYMOUS

Eiffel Tower Candlestick, 1889
Molded glass, 10 × 3¾ × 3¾ inches
Musée d'Orsay, Paris
Eiffel Collection, gift of Mlle. Solange Granet, Mme. Bernard Granet and her children, descendants of Gustave Eiffel, 1981
Page 102

ANONYMOUS

Eiffel Tower Pen Box, 1889
Cardboard, paper, and metal, 3 × 2 × 1 inches
Musée d'Orsay, Paris
Eiffel Collection, gift of Mlle. Solange Granet, Mme. Bernard Granet and her children, descendants of Gustave Eiffel, 1981
Page 103

ANONYMOUS

Eiffel Tower Perfume Bottle, 1889
Glass, 6 × 2¼ × 2¼ inches
Musée d'Orsay, Paris
Eiffel Collection, gift of Mlle. Solange Granet, Mme. Bernard Granet and her children, descendants of Gustave Eiffel, 1981
Page 102

ANONYMOUS

Scarf Decorated with the Eiffel Tower, a Portrait of Gustave Eiffel, and the Palais du Trocadéro, 1889
Silk, 16¼ × 16¼ inches
Musée d'Orsay, Paris
Eiffel Collection, gift of Mlle. Solange Granet, Mme. Bernard Granet and her children, descendants of Gustave Eiffel, 1981
Page 101

ANONYMOUS

Silk Band Decorated with the Eiffel Tower, 1889
Embroidered silk, 15⅝ × 4¼ inches
Musée d'Orsay, Paris
Eiffel Collection, gift of Mlle. Solange Granet, Mme. Bernard Granet and her children, descendants of Gustave Eiffel, 1981
Page 100

ANONYMOUS

Silk Band Decorated with the Eiffel Tower, 1889
Embroidered silk, 15⅝ × 4¼ inches
Musée d'Orsay, Paris
Eiffel Collection, gift of Mlle. Solange Granet, Mme. Bernard Granet and her children, descendants of Gustave Eiffel, 1981
Page 100

ANONYMOUS

Model of the Facade and the Veranda for the Théâtre de la Porte Saint-Martin, 1892
Aluminum, brass, and glass on wooden core,
34¼ × 35½ × 12½ inches
Musée d'Orsay, Paris
Gift of the Société des Amis of the Musée d'Orsay, 1990
Page 61

EUGÈNE ATGET
Libourne 1857–Paris 1927

La Villette, Rue Asselin, Prostitute Waiting in Front of Her Door, 1921
Gelatin silver print, 8¾ × 7 inches
Musée d'Orsay, Paris
Gift of Mme. Marie-Thérèse Jammes and M. André Jammes through the intermediary of the Société des Amis of the Musée d'Orsay, 1990
Page 85

VICTOR BALTARD
Paris 1805–Paris 1874

The Saint-Augustin Church in Paris, Elevation of the Principal Facade, ca. 1867–1868
Pen and black ink, watercolor touches, and gold on paper, 23¾ × 16⅝ inches
Musée d'Orsay, Paris
Gift of Mme. Arnould-Baltard to the Musée du Louvre, 1890
Page 38

ALBERT BARTHOLOMÉ
Thiverval, Seine-et-Oise 1848–Paris 1928

Monument to the Dead at Père Lachaise, Central Relief, 1892
Patinated bronze, 22¾ × 18 × 11 inches
Musée d'Orsay, Paris
Page 118

JEAN BÉRAUD
Saint-Petersburg, Russia 1849–France 1936

A Party, 1878
Oil on canvas, 25¾ × 45⅝ inches
Musée d'Orsay, Paris
Free transfer by the General Direction of Customs and Indirect Rights, 1994
Page 53

JEAN BÉRAUD
Saint-Petersburg, Russia 1849–France 1936

Waiting, Rue de Chateaubriand, Paris, ca. 1890
Oil on canvas, 22 × 15½ inches
Musée d'Orsay, Paris
Anonymous gift, 1935
Page 84

ÉMILE BERNARD
Lille 1868–Paris 1941

Breton Women with Parasols, 1892
Oil on canvas, 32 × 41⅜ inches
Musée d'Orsay, Paris
Page 145

PIERRE BONNARD
Fontenay-aux-Roses 1867–Le Cannet 1947

Twilight (The Croquet Party), 1892
Oil on canvas, 51⅛ × 64 inches
Musée d'Orsay, Paris
Gift of Daniel Wildenstein through the intermediary of the Société des Amis of the Musée d'Orsay, 1985
Page 146

PIERRE BONNARD
Fontenay-aux-Roses 1867–Le Cannet 1947

Plate, ca. 1906–1910
Faience and brown ink, 10 inches in diameter
Musée d'Orsay, Paris
Gift of M. Jean-Claude Romand through the intermediary of the Société des Amis of the Musée d'Orsay, 1998
Page 136

ÉMILE-ANTOINE BOURDELLE
Montauban 1861–Le Vésinet 1929

Head of Apollo, 1900–1909
Gilt bronze, 26½ × 10¾ × 10 inches
Musée d'Orsay, Paris
Acquired by endowment, 1989
Page 154

ALEXANDRE CABANEL
Montpellier 1823–Paris 1889

Comtesse de Keller, 1873
Oil on canvas, 39 × 30 inches
Musée d'Orsay, Paris
Gift of the Marquis and the Marquise de Saint Yves d'Alveydre, subject to usufruct, 1889; entered the national collections, 1909
Page 48

GUSTAVE CAILLEBOTTE
Paris 1848–Gennevilliers 1894

The Floor Scrapers, 1875
Oil on canvas, 40¼ × 57½ inches
Musée d'Orsay, Paris
Gift of the artist's heirs through the intermediary of Auguste Renoir, his executor, 1894
Page 77

GUSTAVE CAILLEBOTTE
Paris 1848–Gennevilliers 1894

Rooftops in the Snow, 1878
Oil on canvas, 25¼ × 32¼ inches
Musée d'Orsay, Paris
Gift of Martial Caillebotte, the artist's brother, 1894
Page 31

JEAN-BAPTISTE CARPEAUX
Valenciennes 1827–Courbevoie 1875

The Spirit of Dance, ca. 1865–1869
Bronze, 39 × 19 × 16 inches
Musée d'Orsay, Paris
Master models from the Susse Foundry, seized for illicit export and returned to the Musée d'Orsay in 1990
Page 59

PAUL CÉZANNE
Aix-en-Provence 1839–Aix-en-Provence 1906

Bathers, ca. 1890–1892
Oil on canvas, 23⅝ × 32¼ inches
Musée d'Orsay, Paris
Gift of Baroness Eva Gebhard-Gourgaud, 1965
Page 150

PAUL CÉZANNE
Aix-en-Provence 1839–Aix-en-Provence 1906

Apples and Oranges, ca. 1895–1900
Oil on canvas, 29⅛ × 36⅝ inches
Musée d'Orsay, Paris
Bequest of Count Isaac de Camondo, 1911
Page 151

ALPHONSE-NICOLAS CRÉPINET
Paris 1826–Paris 1892

Nouvel Opéra, Perspective View, 1861
Graphite and watercolor on paper, 20 × 27⅛ inches
Musée d'Orsay, Paris
Page 60

HENRI-EDMOND CROSS
Douai 1856–Saint-Clair 1910

The Head of Hair, ca. 1892
Oil on canvas, 24 × 18 inches
Musée d'Orsay, Paris
Page 149

AIMÉ-JULES DALOU
Paris 1838–Paris 1902

Man Binding Sheaf, 1889–1902
From *Nine Small Figures for a Monument to Workers*
Patinated bronze, 4½ × 4 × 4¼ inches
Musée d'Orsay, Paris
Master models from the Susse Foundry, seized
for illicit export and returned to the Musée
d'Orsay in 1990
Page 80

AIMÉ-JULES DALOU
Paris 1838–Paris 1902

Man Breaking Stone, 1889–1902
From *Nine Small Figures for a Monument to Workers*
Patinated bronze, 3¾ × 2¾ × 3¼ inches
Musée d'Orsay, Paris
Master models from the Susse Foundry, seized
for illicit export and returned to the Musée
d'Orsay in 1990
Page 81

AIMÉ-JULES DALOU
Paris 1838–Paris 1902

Man Whetting Scythe, 1889–1902
From *Nine Small Figures for a Monument to Workers*
Patinated bronze, 5¼ × 4¾ × 6½ inches
Musée d'Orsay, Paris
Master models from the Susse Foundry, seized
for illicit export and returned to the Musée
d'Orsay in 1990
Page 80

AIMÉ-JULES DALOU
Paris 1838–Paris 1902

Man with Hoe (study for *The Peasant*), 1889–1902
From *Nine Small Figures for a Monument to Workers*
Patinated bronze, 5¾ × 3¾ × 2½ inches
Musée d'Orsay, Paris
Master models from the Susse Foundry, seized
for illicit export and returned to the Musée
d'Orsay in 1990
Page 79

AIMÉ-JULES DALOU
Paris 1838–Paris 1902

Return from the Fields, 1889–1902
From *Nine Small Figures for a Monument to Workers*
Patinated bronze, 5¼ × 3¾ × 3 inches
Musée d'Orsay, Paris
Master models from the Susse Foundry, seized
for illicit export and returned to the Musée
d'Orsay in 1990
Page 78

AIMÉ-JULES DALOU
Paris 1838–Paris 1902

Return from the Woods, 1889–1902
From *Nine Small Figures for a Monument to Workers*
Patinated bronze, 5⅛ × 3½ × 3¼ inches
Musée d'Orsay, Paris
Master models from the Susse Foundry, seized
for illicit export and returned to the Musée
d'Orsay in 1990
Page 79

AIMÉ-JULES DALOU
Paris 1838–Paris 1902

Woman Carrying Milk, 1889–1902
From *Nine Small Figures for a Monument to Workers*
Patinated bronze, 4⅝ × 2⅜ × 2⅝ inches
Musée d'Orsay, Paris
Master models from the Susse Foundry, seized
for illicit export and returned to the Musée
d'Orsay in 1990
Page 78

AIMÉ-JULES DALOU
Paris 1838–Paris 1902

Woman Carrying Sheaf, 1889–1902
From *Nine Small Figures for a Monument to Workers*
Patinated bronze, 4¼ × 2⅛ × 2¼ inches
Musée d'Orsay, Paris
Master models from the Susse Foundry, seized
for illicit export and returned to the Musée
d'Orsay in 1990
Page 78

AIMÉ-JULES DALOU
Paris 1838–Paris 1902

Worker Holding a Spade, 1889–1902
From *Nine Small Figures for a Monument to Workers*
Patinated bronze, 7⅞ × 4¾ × 3 inches
Musée d'Orsay, Paris
Master models from the Susse Foundry, seized
for illicit export and returned to the Musée
d'Orsay in 1990
Page 81

AIMÉ-JULES DALOU
Paris 1838–Paris 1902

The Peasant, after 1899
Bronze, 44 × 15⅜ × 15¼ inches
Musée d'Orsay, Paris
Master models from the Susse Foundry, seized
for illicit export and returned to the Musée
d'Orsay in 1990
Page 83

ALPHONSE-ALEXANDRE DEFRASSE
Paris 1860–Paris 1939

*Project for the Nouvelle Sorbonne, Elevation on the
Rue Saint-Jacques*, 1882
Black ink, watercolor, and wash-drawing on paper,
28⅛ × 102⅜ inches
Musée d'Orsay, Paris
Pages 32–33

EDGAR DEGAS
Paris 1834–Paris 1917

The Orchestra of the Opéra, 1870
Oil on canvas, 22¼ × 18 inches
Musée d'Orsay, Paris
Collection of Désiré Dihâu, Paris; acquired from
Mlle. Dihâu, his sister, subject to usufruct, 1923;
entered the national collections, 1935
Page 46

EDGAR DEGAS
Paris 1834–Paris 1917

Absinthe, ca. 1875–1876
Oil on canvas, 36¼ × 26¾ inches
Musée d'Orsay, Paris
Bequest of Count Isaac de Camondo, 1911
Page 76

EDGAR DEGAS
Paris 1834–Paris 1917

The Tub, 1888–1889
Bronze, 8⅞ × 17¼ × 18 inches
Musée d'Orsay, Paris
Acquired through the generosity of the artist's
heirs and of the foundry Hébrard, 1930
Page 153

EDGAR DEGAS
Paris 1834–Paris 1917

Seated Woman Drying Herself, 1896–1911
Bronze, 17½ × 12 × 12 inches
Musée d'Orsay, Paris
Acquired through the generosity of the artist's
heirs and of the foundry Hébrard, 1930
Page 152

AUGUSTE DELAHERCHE
Beauvais 1857–Paris 1940

Peacock Feather Vase, 1889
Enameled stoneware, 15 inches high
Musée d'Orsay, Paris
Gift of Mme. René Bureau in memory of her
husband through the intermediary of the Société
des Amis of the Musée d'Orsay, 1993
Page 127

MAURICE DENIS
Granville 1870–Paris 1943

The Muses, 1893
Oil on canvas, 67½ × 54⅛ inches
Musée d'Orsay, Paris
Page 147

ANDRÉ DERAIN
Châtou 1880–Garches 1954

Charing Cross Bridge, ca. 1906
Oil on canvas, 31⅞ × 39⅜ inches
Musée d'Orsay, Paris
Donation of Max and Rosy Kaganovitch, 1973
Page 160

A. DEROY
Paris ca. 1825–Paris 1906
Engraved by E. A. Tilly

Panoramic View of the 1889 Exposition Universelle,
1889
From *L'Illustration*, supplement no. 2410, May 4,
1889
Engraving, 27¾ × 43½ inches
Musée d'Orsay, Paris
Eiffel Collection, gift of Mlle. Solange Granet,
Mme. Bernard Granet and her children,
descendants of Gustave Eiffel, 1981
Page 108

JULES DESBOIS
Parcay 1851–Paris 1935

Sirens, 1892–1893
Silver, 16 inches in diameter
Musée d'Orsay, Paris
Page 119

LOUIS-ÉMILE DURANDELLE
Verdun 1839–Bois-Colombes 1917

*The Eiffel Tower under Construction, Facing the
Palais du Trocadéro*, 1888
No. 23 from *Construction Work on the Eiffel Tower,
from April 8, 1887, to March 31, 1889*
Albumen print, 11½ × 17½ inches
Musée d'Orsay, Paris
Eiffel Collection, gift of Mlle. Solange Granet,
Mme. Bernard Granet and her children,
descendants of Gustave Eiffel, 1981
Page 98

LOUIS-ÉMILE DURANDELLE
Verdun 1839–Bois-Colombes 1917

Work on the First Platform, January 14, 1888, 1888
No. 26 from *Construction Work on the Eiffel Tower,
from April 8, 1887, to March 31, 1889*
Albumen print, 13½ × 17¼ inches
Musée d'Orsay, Paris
Eiffel Collection, gift of Mlle. Solange Granet,
Mme. Bernard Granet and her children,
descendants of Gustave Eiffel, 1981
Page 94

LOUIS-ÉMILE DURANDELLE
Verdun 1839–Bois-Colombes 1917

Work on the First Platform, January 14, 1888, 1888
No. 28 from *Construction Work on the Eiffel Tower,
from April 8, 1887, to March 31, 1889*
Albumen print, 13¼ × 17½ inches
Musée d'Orsay, Paris
Eiffel Collection, gift of Mlle. Solange Granet,
Mme. Bernard Granet and her children,
descendants of Gustave Eiffel, 1981
Page 95

LOUIS-ÉMILE DURANDELLE
Verdun 1839–Bois-Colombes 1917

On the First Platform, June 16, 1888, 1888
No. 35 from *Construction Work on the Eiffel Tower,
from April 8, 1887, to March 31, 1889*
Albumen print, 17½ × 13½ inches
Musée d'Orsay, Paris
Eiffel Collection, gift of Mlle. Solange Granet,
Mme. Bernard Granet and her children,
descendants of Gustave Eiffel, 1981
Page 96

LOUIS-ÉMILE DURANDELLE
Verdun 1839–Bois-Colombes 1917

*The Eiffel Tower, View from the Ground,
September 19, 1888*, 1888
No. 47 from *Construction Work on the Eiffel Tower,
from April 8, 1887, to March 31, 1889*
Albumen print, 17½ × 13¼ inches
Musée d'Orsay, Paris
Eiffel Collection, gift of Mlle. Solange Granet,
Mme. Bernard Granet and her children,
descendants of Gustave Eiffel, 1981
Page 97

HENRI FANTIN-LATOUR
Grenoble 1836–Buré 1904

The Dubourg Family, 1878
Oil on canvas, 57¾ × 67⅛ inches
Musée d'Orsay, Paris
Donation of Mme. Fantin-Latour, the artist's wife,
subject to usufruct, 1921; entered the national
collections, 1926
Page 52

THÉOPHILE FÉAU
Orleans 1839–Paris 1892

*The Eiffel Tower under Construction, Views from
One of the Towers of the Palais du Trocadéro*,
1887–1889
20 photographs glued to 11 sheets of cardboard,
9½ × 104⅜ inches
Musée d'Orsay, Paris
Eiffel Collection, gift of Mlle. Solange Granet,
Mme. Bernard Granet and her children,
descendants of Gustave Eiffel, 1981
Pages 92–93

MARIE-FRANÇOIS FIRMIN-GIRARD
Poncin 1838–Montluçon 1921

The Convalescents, 1861
Oil on canvas, 41⅜ × 73¼ inches
Musée d'Orsay, Paris
Page 70

FRÉDÉRIC FORTHUNY
Rouen 1895–Galaţi, Romania 1919
Manufactured by Henri Dubret

Seahorse Pendant, 1919–1920
Gold, enamel, and diamonds, 2¾ × 1½ × ¼ inches
Musée d'Orsay, Paris
Page 137

FERNAND FREGNIOT-ARNAL

Road Layers on a Parisian Boulevard, 1905
Carbon print, 4½ × 6½ inches
Musée d'Orsay, Paris
Page 85

LUCIEN GAILLARD
Paris 1861–Paris 1942

Chrysanthemum Comb, 1903–1904
Carved horn, opals, and gold, 8⅛ × 2⅞ × ½ inches
Musée d'Orsay, Paris
Page 134

ÉMILE GALLÉ
Nancy 1846–Nancy 1904

Balsam Tree Vase, 1895
Hammered and cut crystal with gold inlay,
18⅜ × 5⅜ inches
Musée d'Orsay, Paris
Page 121

GALLÉ ATELIERS

Vase Decorated with Irises, 1894
Pencil, watercolor, and gouache on paper,
20 × 14½ inches
Musée d'Orsay, Paris
Gift of M. and Mme. Jean Bourgogne, 1986
Page 126

GALLÉ ATELIERS

Chinese Vase, ca. 1898–1899
Pencil, watercolor, and gouache on paper,
10¾ × 8⅜ inches
Musée d'Orsay, Paris
Gift of M. and Mme. Jean Bourgogne, 1986
Page 123

GALLÉ ATELIERS

Vase Decorated with Butterflies in Flight,
ca. 1898–1900
Pencil, watercolor, and gouache on paper,
14¾ × 12½ inches
Musée d'Orsay, Paris
Gift of M. and Mme. Jean Bourgogne, 1986
Page 122

GALLÉ ATELIERS

Bottle in the Shape of a Gourd, ca. 1900
Pencil, watercolor, and gouache on paper,
11⅞ × 9⅞ inches
Musée d'Orsay, Paris
Gift of M. and Mme. Jean Bourgogne, 1986
Page 125

GALLÉ ATELIERS

Vase in the Shape of a Bindweed Corolla, ca. 1900
Pencil, watercolor, and gouache on paper,
11½ × 8⅞ inches
Musée d'Orsay, Paris
Gift of M. and Mme. Jean Bourgogne, 1986
Page 124

GEORGES GAREN
France, born 1854

*Lighting of the Eiffel Tower for the 1889 Exposition
Universelle*, 1889
Color lithograph, 25⅝ × 17⅞ inches
Musée d'Orsay, Paris
Eiffel Collection, gift of Mlle. Solange Granet,
Mme. Bernard Granet and her children,
descendants of Gustave Eiffel, 1981
Page 99

PAUL GAUGUIN
Paris 1848–Atuona, Marquesas Islands 1903

The Seine at the Pont d'Iéna, 1875
Oil on canvas, 25½ × 36½ inches
Musée d'Orsay, Paris
Bequest of Paul Jamot, 1941
Page 30

PAUL GAUGUIN
Paris 1848–Atuona, Marquesas Islands 1903

The Alyscamps, 1888
Oil on canvas, 35¾ × 28⅜ inches
Musée d'Orsay, Paris
Gift of Countess Vitali in memory of her brother,
Viscount Guy de Cholet, 1923
Page 144

PAUL GÉNIAUX
Rennes 1875–Paris after 1914

Students on the Day of la Mi-Carême, ca. 1900
Aristotype, 5⅛ × 7 inches
Musée d'Orsay, Paris
Page 34

ANDRÉ GRANET
Paris 1881–Paris 1974

*Illumination of the Eiffel Tower for the 1937
Exposition Universelle*, 1937
Gouache on paper, 32¼ × 49½ inches
Musée d'Orsay, Paris
Eiffel Collection, gift of Mlle. Solange Granet,
Mme. Bernard Granet and her children,
descendants of Gustave Eiffel, 1981
Page 113

LOUIS WELDEN HAWKINS
Esslingen, Germany 1849–Paris 1910

The Eiffel Tower, View from the Trocadéro,
ca. 1900
Oil on canvas, 21⅝ × 17¾ inches
Musée d'Orsay, Paris
Gift of the Société des Amis of the Musée
d'Orsay, 1983
Page 112

LUCIEN HIRTZ
Nancy 1864–Paris 1928

Peacock Feather Dish, 1896
Enamel on copper, 1 × 5¼ inches
Musée d'Orsay, Paris
Gift of M. Jacques Hirtz, the artist's son, 1986
Page 120

RENÉ LALIQUE
Ay-sur-Marne 1860–Paris 1945

Maple Comb, ca. 1899–1900
Pencil, ink, watercolor, and gouache on tracing
paper, 11 × 8⅝ inches
Musée d'Orsay, Paris
Page 132

RENÉ LALIQUE
Ay-sur-Marne 1860–Paris 1945

Cow Parsnip and Bumblebee Comb, ca. 1901–1902
Pencil, ink, watercolor, and gouache on tracing
paper, 11 × 8¾ inches
Musée d'Orsay, Paris
Page 129

RENÉ LALIQUE
Ay-sur-Marne 1860–Paris 1945

Hawthorn Comb, ca. 1902–1903
Pencil, ink, watercolor, and gouache on tracing
paper, 10⅞ × 8½ inches
Musée d'Orsay, Paris
Page 130

RENÉ LALIQUE
Ay-sur-Marne 1860–Paris 1945

Dragonfly Necklace, ca. 1903–1905
Pencil, ink, watercolor, and gouache on tracing
paper, 11 × 8⅝ inches
Musée d'Orsay, Paris
Page 128

RENÉ LALIQUE
Ay-sur-Marne 1860–Paris 1945

Sea Holly Comb, ca. 1905
Pencil, ink, watercolor, and gouache on tracing
paper, 11 × 8¾ inches
Musée d'Orsay, Paris
Page 131

RENÉ LALIQUE
Ay-sur-Marne 1860–Paris 1945

Powder Jars, 1908–1909
Cut and engraved crystal, repoussé and chased
silver, and molded glass, 4½ × 3⅞ inches and
2¾ × 2¾ inches
Musée d'Orsay, Paris
Page 133

HIPPOLYTE LE BAS
Paris 1782–Paris 1867

The Petite Roquette Prison in Paris, ca. 1831
Watercolor on paper, 13¾ × 18¾ inches
Musée d'Orsay, Paris
Page 72

HENRI LEMOINE
Paris 1848–Paris 1924

Les Halles, ca. 1900
Gelatin silver print, 3⅜ × 4⅛ inches
Musée d'Orsay, Paris
Page 35

HENRI LEMOINE
Paris 1848–Paris 1924

Secondhand Booksellers on the Quai Conti, ca. 1900
Gelatin silver print, 2⅞ × 3⅞ inches
Musée d'Orsay, Paris
Page 35

LOUIS-GABRIEL LOPPÉ
Montpellier 1825–Paris 1913

Illumination of the Eiffel Tower, ca. 1889
Gelatin silver print, 5 × 7 inches
Musée d'Orsay, Paris
Gift of the Société des Amis of the Musée d'Orsay,
1989
Page 110

LOUIS-GABRIEL LOPPÉ
Montpellier 1825–Paris 1913

Gare d'Orsay at Night, ca. 1900
Gelatin silver print, 5⅛ × 7 inches
Musée d'Orsay, Paris
Gift of the Société des Amis of the Musée d'Orsay,
1985
Page 39

LOUIS-GABRIEL LOPPÉ
Montpellier 1825–Paris 1913

The Eiffel Tower Struck by Lightning, 1902
Aristotype, 6⅞ × 4⅞ inches
Musée d'Orsay, Paris
Eiffel Collection, gift of Mlle. Solange Granet,
Mme. Bernard Granet and her children,
descendants of Gustave Eiffel, 1981
Page 111

MAXIMILIEN LUCE
Paris 1858–Paris 1941

Quai Saint-Michel and Notre-Dame, 1901
Oil on canvas, 28¾ × 23⅝ inches
Musée d'Orsay, Paris
Gift of Christian Humann through the
intermediary of the Lutèce Foundation, 1981
Page 40

AUGUSTE-JOSEPH MAGNE
Etampes 1816–Eaubonne 1885

*Théâtre du Vaudeville, Elevation of the Principal
Facade*, 1870
Graphite, gray ink wash-drawing, watercolor, and
pen and black ink, with gouache touches, on paper,
32 × 19⅝ inches
Musée d'Orsay, Paris
Entered the Musée du Louvre on the occasion of
an exhibit of architecture drawings, 1900
Page 62

LOUIS MAJORELLE
Toul 1859–Nancy 1926
Manufactured by Daum Frères

Water-Lily Lamp, 1902–1903
Gilded and embossed bronze and pâte de verre,
23¾ × 6½ inches
Musée d'Orsay, Paris
Page 135

ÉDOUARD MANET
Paris 1832–Paris 1883

Woman with Fans (Nina de Callias), 1873
Oil on canvas, 44¾ × 65½ inches
Musée d'Orsay, Paris
Gift of M. and Mme. Ernest Rouart, 1930
Page 50

CONSTANTIN MEUNIER
Brussels, Belgium 1831–Brussels, Belgium 1905

Docker at the Port d'Anvers, 1885–1890
Patinated bronze, 19 × 9¼ × 7⅞ inches
Musée d'Orsay, Paris
Acquired by the State, 1890
Page 82

CLAUDE MONET
Paris 1840–Giverny 1926

Madame Louis Joachim Gaudibert, 1868
Oil on canvas, 85½ × 54½ inches
Musée d'Orsay, Paris
Acquired on the arrears of an anonymous
Canadian donation, 1951
Page 47

CLAUDE MONET
Paris 1840–Giverny 1926

Men Unloading Coal, 1875
Oil on canvas, 21¼ × 26 inches
Musée d'Orsay, Paris
Acquired by endowment, 1993
Page 73

CLAUDE MONET
Paris 1840–Giverny 1926

Gare Saint-Lazare, 1877
Oil on canvas, 29¾ × 41 inches
Musée d'Orsay, Paris
Bequest of Gustave Caillebotte, 1894
Page 36

CLAUDE MONET
Paris 1840–Giverny 1926

Rue Montorgueil, Paris, Festival of June 30, 1878,
1878
Oil on canvas, 31⅞ × 19⅞ inches
Musée d'Orsay, Paris
Acquired by endowment, 1982
Page 37

CAMILLE PISSARRO
St. Thomas, West Indies 1830–Paris 1903

The Seine and the Louvre, 1903
Oil on canvas, 18 × 21⅝ inches
Musée d'Orsay, Paris
Enriqueta Alsop bequest in the name of
Dr. Eduardo Mollard, 1972
Page 41

PIERRE PUVIS DE CHAVANNES
Lyon 1824–Paris 1898

The Balloon, 1870
Oil on canvas, 65⅝ × 45⅞ inches
Musée d'Orsay, Paris
Gift of the Acquavella Gallery, New York, 1987
Page 75

PIERRE PUVIS DE CHAVANNES
Lyon 1824–Paris 1898

The Pigeon, 1871
Oil on canvas, 65⅝ × 45⅞ inches
Musée d'Orsay, Paris
Gift of the Acquavella Gallery, New York, 1987
Page 74

PIERRE-AUGUSTE RENOIR
Limoges 1841–Cagnes-sur-Mer 1919

Madame Georges Hartmann, 1874
Oil on canvas, 72 × 49¼ inches
Musée d'Orsay, Paris
Gift of General Bourjat, executor for
Georges Hartmann, through the intermediary
of Durand-Ruel, 1902
Page 49

HENRI RIVIÈRE
Paris 1864–Paris 1951

At the Top of the Tower, 1888–1902
From *Thirty-Six Views of the Eiffel Tower*
Color lithograph, 6⅝ × 8½ inches
Musée d'Orsay, Paris
Gift of Mme. Bernard Granet, 1990
Page 107

HENRI RIVIÈRE
Paris 1864–Paris 1951

Painter of the Tower, 1888–1902
From *Thirty-Six Views of the Eiffel Tower*
Color lithograph, 8¼ × 6⅝ inches
Musée d'Orsay, Paris
Gift of Mme. Bernard Granet, 1990
Page 106

HENRI RIVIÈRE
Paris 1864–Paris 1951

*The Tower under Construction, View from the
Trocadéro*, 1888–1902
From *Thirty-Six Views of the Eiffel Tower*
Color lithograph, 6⅝ × 8⅜ inches
Musée d'Orsay, Paris
Gift of Mme. Bernard Granet, 1990
Page 107

HENRI RIVIÈRE
Paris 1864–Paris 1951

Couple Entering a Public Building, ca. 1889
Gelatin silver print, 4¾ × 3⅛ inches
Musée d'Orsay, Paris
Gift of Mlle. Geneviève Noufflard and
Mme. Guy-Loe, 1987
Page 34

HENRI RIVIÈRE
Paris 1864–Paris 1951

Painter on a Knotted Cord along a Vertical Beam,
1889
Gelatin silver print, 4¾ × 3⅛ inches
Musée d'Orsay, Paris
Eiffel Collection, gift of Mlle. Solange Granet,
Mme. Bernard Granet and her children,
descendants of Gustave Eiffel, 1981
Page 105

HENRI RIVIÈRE
Paris 1864–Paris 1951

Worker on the Eiffel Tower, 1889
Gelatin silver print, 4⅝ × 3⅜ inches
Musée d'Orsay, Paris
Gift of Mlle. Geneviève Noufflard and
Mme. Guy-Loe, 1986
Page 105

AUGUSTE RODIN
Paris 1840–Meudon 1917

Heroic Bust of Victor Hugo, 1897
Patinated bronze, 27¾ × 24¼ × 22⅜ inches
Musée d'Orsay, Paris
Page 156

HENRI ROUSSEAU
Laval 1844–Paris 1910

Portrait of Madame M., ca. 1897
Oil on canvas, 78 × 45¼ inches
Musée d'Orsay, Paris
Donation of Baroness Eva Gebhard-Gourgaud,
1965
Page 157

HENRI SCHMIT
Reims 1851–1904

*Project for the Nouvel Opéra-Comique de Paris,
Lateral Facade on the Rue Favart*, 1893
Pen, watercolor, gouache, and gold touches on
paper, 25½ × 39⅜ inches
Musée d'Orsay, Paris
Gift of the Société des Amis of the Musée d'Orsay,
1994
Page 64

HENRI SCHMIT
Reims 1851–1904

*Project for the Nouvel Opéra-Comique de Paris,
Longitudinal and Transverse Sections*, 1893
Pen, watercolor, gouache, and gold touches on
paper, 25½ × 39⅜ inches
Musée d'Orsay, Paris
Gift of the Société des Amis of the Musée d'Orsay,
1994
Page 65

HENRI SCHMIT
Reims 1851–1904

*Project for the Nouvel Opéra-Comique de Paris,
Principal Facade on the Place Boïeldieu and
Perspective View*, 1893
Pen, watercolor, gouache, and gold touches on
paper, 39⅜ × 25½ inches
Musée d'Orsay, Paris
Gift of the Société des Amis of the Musée d'Orsay,
1994
Page 63

GEORGES SEURAT
Paris 1859–Paris 1891

The Little Peasant in Blue, ca. 1882
Oil on canvas, 18 × 15 inches
Musée d'Orsay, Paris
Gift of M. Robert Schmit, 1982
Page 142

GABRIEL BERNARD SEURRE
Paris 1795–Paris 1867

*Project for the Crowning of the Arc de Triomphe de
l'Étoile*, 1833
Graphite, black ink, wash-drawing, and watercolor
on paper, 34¾ × 22½ inches
Musée d'Orsay, Paris
Page 26

ALFRED STEVENS
Brussels, Belgium 1823–Paris 1906

What Is Called Vagrancy, 1855
Oil on canvas, 51⅛ × 65 inches
Musée d'Orsay, Paris
Bequest of the painter Léon Lhermitte, 1926
Page 71

JAMES TISSOT
Nantes 1836–Chenecey-Bullion 1902

The Ball, ca. 1885
Oil on canvas, 35½ × 19¾ inches
Musée d'Orsay, Paris
Ordered by William Vaughan; bequest of
William Vaughan, 1919
Page 51

HENRI DE TOULOUSE-LAUTREC
Albi 1864–Château de Malromé 1901

Redhead (The Toilette), 1889
Oil on cardboard, 26⅜ × 21¼ inches
Musée d'Orsay, Paris
Bequest of Pierre Goujon, 1914
Page 86

HENRI DE TOULOUSE-LAUTREC
Albi 1864–Château de Malromé 1901

Alone, 1896
Paint on cardboard, 12¼ × 15¾ inches
Musée d'Orsay, Paris
Gift of the Florence J. Gould Foundation, 1984
Page 87

HENRI TOUSSAINT
Paris 1849–Paris 1911

*Palais de l'Electricité: Project for the Dressing of
the Eiffel Tower for the 1900 Exposition Universelle*,
ca. 1894
Gouache over print, 32⅞ × 48⅛ inches
Musée d'Orsay, Paris
Eiffel Collection, gift of Mlle. Solange Granet,
Mme. Bernard Granet and her children,
descendants of Gustave Eiffel, 1981
Page 109

EUGÈNE TRAIN
Toul 1832–Annecy 1903

Collège Chaptal in Paris, Bird's-Eye View, 1875
Pen and black ink and watercolor on paper,
21 × 29 inches
Musée d'Orsay, Paris
Gift of Mme. Maurice Train, 1983
Page 27

PAUL TROUBETSKOY
Intra, Italy 1866–Suna, Italy 1938

Comte Robert de Montesquiou, 1907
Patinated bronze, 22 × 24½ × 22¼ inches
Musée d'Orsay, Paris
Gift of R. de Montesquiou to his parlor maid;
acquired in 1980
Page 155

FÉLIX VALLOTTON
Lausanne, Switzerland 1865–Paris 1925

Poker, 1902
Oil on canvas, 20⅝ × 26½ inches
Musée d'Orsay, Paris
Gift of D. David-Weill, 1935
Page 159

VINCENT VAN GOGH
Groot Zunder, Netherlands 1853–
Auvers-sur-Oise 1890

The Italian Woman, 1887
Oil on canvas, 31⅞ × 23⅝ inches
Musée d'Orsay, Paris
Gift of Baroness Eva Gebhard-Gourgaud, 1965
Page 143

THÉO VAN RYSSELBERGHE
Ghent, Belgium 1862–Saint-Clair 1926

Man at the Helm, 1892
Oil on canvas, 23¾ × 31⅝ inches
Musée d'Orsay, Paris
Collection of Paul Signac; donation of
Mme. Ginette Signac, his daughter, subject
to usufruct, 1977
Page 148

ÉDOUARD VUILLARD
Cuiseaux, Saône-et-Loire 1868–La Baule 1940

Breakfast, ca. 1900
Oil on cardboard, 22½ × 23⅝ inches
Musée d'Orsay, Paris
Page 158

INDEX OF ARTISTS

PHOTOGRAPHY CREDITS

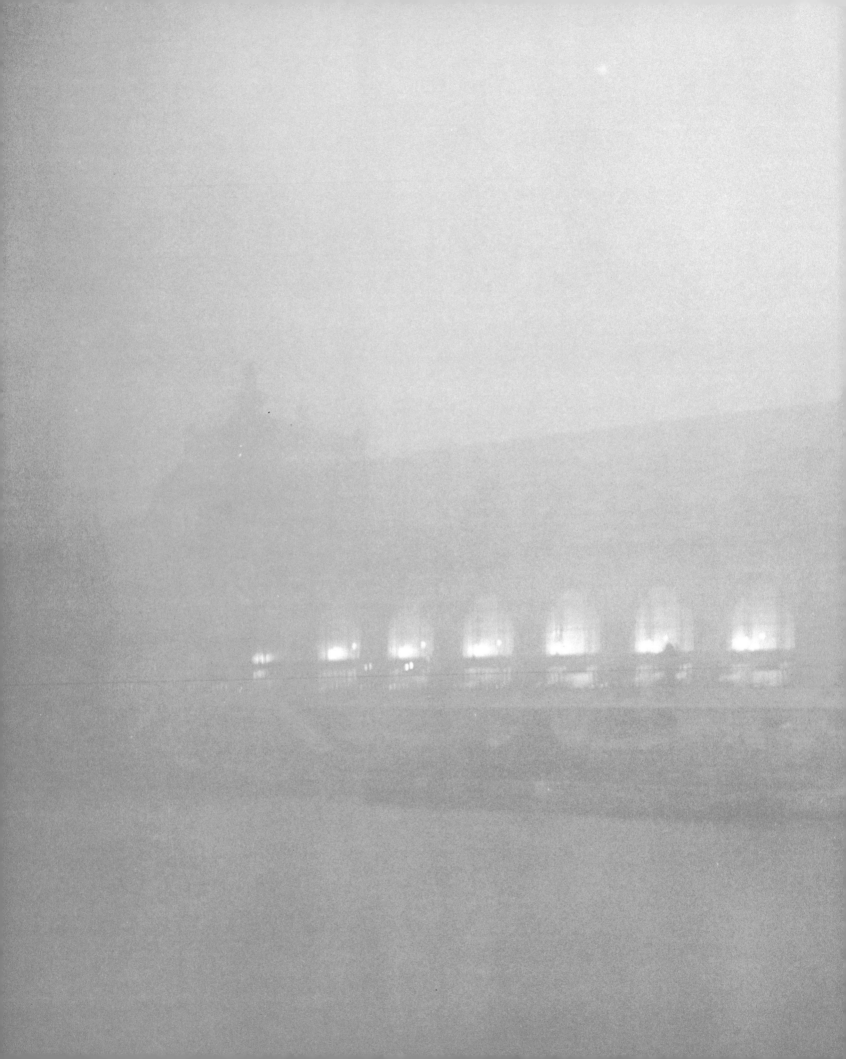